KB002271

WOOLGA CHOI BLACK WHITE

—

Editor

Lee DeaHyung

—

Essays

Nakahara Yuske

Bummo Youn

Alain P. Donald

Yoon JinSup

M. chunder

Yoo GeunOh

Kimura Sigenobu

Kho ChungHwan

Jean Piere Taldare

F.SIEFFERT

M, GALERNEAU

Lee JaeEon

Park YoungTaek

Lee HeeYoung

Ha GyueHoon

Oh SeGwon

Kim JongGeun

Shin JiUng

Lim ChangSeop

Shin HangSeop

Yun HyoYeon

Seo SeongRok

CONTENTS

The imagery of Choi Woolga's painting, hovering between imagination and observation, is reduced completely to cartoonish lines. A water melon, big eyes, a dog and many more everyday objects float in the air, finally becoming unstable and disordered. This chaotic style has been influenced by the artist's struggling nomadic life from Seoul to Paris and New York where the inevitability of poverty was a part of his perception of the world. From this in-between journey as a Korean artist, Choi discovered four animal natures. The first is that of a dog, the second a wolf, the third a fox and the fourth a hyena. Therefore, all the images converge on a dog-like creature. This interplay between humanity and the world of animals ultimately provided a wider context for the artist to decide his future narrative, style and mode of creation. The legacy of Basquiat invades his painting, but Choi's audacious use of black and white pigment leads the viewer to see a playfulness which is galvanized by the spectacle of energy passing through a strange metamorphosis."

WORK NOTE

Another World acquired from Thirst

Artists tend to be tenacious enough to dig into one of the numerous thoughts conceived on this earth regardless whether it is recognized by others or not. I am no exception. For the last decades, I have stealthily dreamt of projecting 'Primitif' on my painting to be recognized by others. However, I could not but be indulged in the sweetness of the modern civilization secretly, living a contradictory life quite irrelevant to my intention, and thus, I could hardly deliver a consistent message to my spectators.

I had experienced lots of changes through 80s, 90s and 2000s. It is a sheer fact that my life as artist in Paris and New York had been more or less conspicuous and futuristic because I could afford to have my thirst or cultural hydrodipomania quenched more or less, unlike those who had stayed in Korea. Nevertheless, just as our modern men are well aware, unlike those who lived in Galileo's age that the earth is round, so I was well aware that the expression of 'Primitif' I had pursued was limited. Regardless of our will to return to the nature, the primitive forests in Amazon and Africa are being more and more devastated due to the encroaching modern civilization, while the fever released from our human desire is reddening our earth. Since I also existed as a small terrorist in this civilization, I was supposed to overlook such a serious problem. What was more serious, however, was the fact that I felt like being insensitive to the problem. As an artist I feel that what is important is not how to advocate or express but what to think about reasonably and how to project such a thought onto the painting.

There are numerous artists who produce good-looking and flavory paintings with excellent skills. However, it seems to be very difficult for an artist to advocate and systemize his or her own spiritual 'ism.' Namely, artists will realize a high wall in their ways. An art that does not remain in an expression itself but overcomes

the category of expression will attract the people to the crater of 'an ism' and thereby, will be gushed out together with 'the ism.' We do not live in an age of Impressionism. We are no longer fascinated by lighting, telephone or radio. The Mars that is far away from the earth is being explored, and every corner of the world is being monitored real-time with a tiny mobile. In this age, what am I indulged in?

OIL PAINTING!

It would seem that I am really stupid. If I am aware that I am stupid, should I work out a more advanced high-end media or a cool installation? Then, people will be fascinated by such work of mine, won't they? Nevertheless, why are people attracted instinctively to the cave wall paintings from the Paleolithic age? Why do people read and learn Buddha's words as old as 2,500 years? Human beings are a medium possessing a physical life, but we can feel how much our life is limited and how fast time passes.

Furthermore, we use language. The actual human beings are very shabby. We cannot but feel the iceberg even in this advanced modern civilization. Our human beings have little changed over long time. We feel hollow for our life during a given time. We feel pleased, consoled and healed second by second for the expressions. All arts may well be medicines for us. What is important is the undeniable fact that we live in an age when any expression or behavior surmountable beyond our mental threshold can be sublimed into an art. In particular, the contemporary arts are too extensive and vast to be distinguished from each other clearly. However, our reality is that we artists as well as our spectators are supposed to give life and artistry to the contemporary arts. In this regard, we should admit that we live in an age when any genre of art cannot be specified definitely.

PAINTING! Stupid!

At a glance, it would seem a little vintage, but the XP black & white painting must urge us to look back upon ourselves because it can express the spiritual aspects of our age first of all and thus, can surmount the limits of its obsolete materials and after all, can express the problems of our reality in a 'primitif' way. Although it remains 'oil' on the canvas, we feel intense for it because the 'primitif' spirit urges us to feel a color as it is.... The sense of color not mixed but sustained intact... Since the rigid and natural monotones not separated from the nature and their lines are put up onto the black and white or the beginning and ending of every color on this earth, it is believed that our human beings living in this age who are eager to escape from this world will sympathize with the free and real-time expressions instinctively.

Another symbols that will make you feel free most on the canvas are the minimal forms on four corners. They act as door-keepers for the primitif subjects to play freely. 'Free' and 'rigid' may seem to lie on the extremes of the spectrum, but I think that they may well be unified into one. What is important is the painting itself, but what is more important is – it struck me this morning – that the artist himself or herself who makes a long journey with the painting can always look at his or her behavior reflected on the mirror. If we cannot see our own problems, it will be difficult for us as artists to have our own ways. As mentioned before, our contemporary art is obscure in its beginning and ending.

Here, the key is who will express a behavior and raise an issue in his or her own way and thereby, attract people's attention. As there exist human beings, every genre of arts is required and worked out to meet our expectations or attract our attention. In this age, who can dare to assess and judge an artist's work in his or her own way? In this context, I see people. Because every genre of arts is born in them... It is the only key to the judgement of his artistry. At a school in front of an apartment building in New York... In a Sunday morning when kids' boisterous voices are not heard...

Dec. 6, 2010
Woolga Choi

Woman of Night, pastel on paper, 21x29.5cm, 1979

Woolga Choi's anarchic world

Nakahara Yuske
[art critic]

I visited Rascaux cave in France and Altamira cave in Spain eight years ago to see the famous cave paintings. These two caves are known to the world by the famous cave paintings estimated to be done in the Paleolithic period. As both cave paintings had been introduced so many times to us in the form of photographs, it was easy to understand that the general forms of the depicted animals were described in a kind of abstract form, but the surface features, such as texture or feeling, were hard to see in detail from the photographs. If they were oil paintings, I could have possibly estimated the surface features from the photographs, as I had seen plenty of oil paintings. However, as I had never seen cave paintings in reality before then, it had been extremely difficult to estimate the surface features. I cannot say that the sole purpose of the trip was to find out the surface texture of the cave paintings, but I was strongly intrigued by the unusual surface features. The Paleolithic cave paintings are the first paintings created by human beings who lived tens of thousands of years ago. They are especially significant in the art history as it is known that Neanderthal men, who lived in the same period as Cromagnon men, did not leave any paintings. Rascaux and Altamira cave paintings depict mainly animals such as horses and bison. The following three techniques were found. Firstly, they scratched the calcareous surface of the cave with a sharp stone to depict the outline of the animals. Secondly, they drew the outline of the animals with powdered oxidized metals such as zinc oxides as a pigment. Thirdly, they painted the whole body of the animals with oxidized metallic pigments.

In other words, the first technique can be called line carving or engraving, the second technique drawing, and the third technique painting. While Rascaux cave painting consists of all of the three techniques, Altamira painting is based on the painting technique as the dominant technique. Therefore, I dare to declare that these three main artistic techniques already appeared in the Paleolithic period.

When I visited Woolga Choi's studio, many pieces of his work reminded me of those

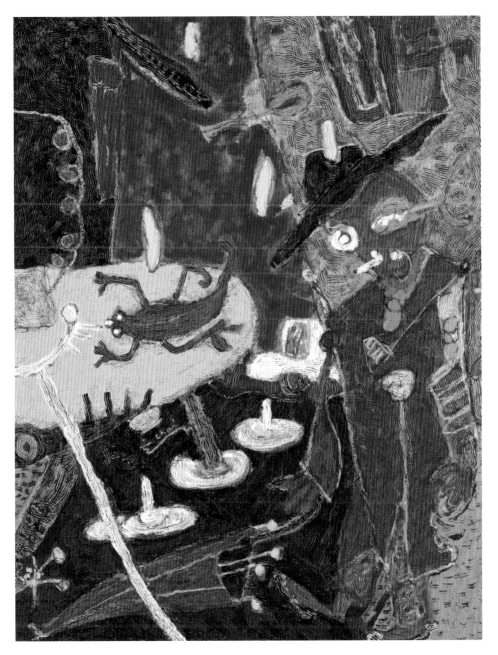

A Rainy Day
Acrylic on Korean paper, 51x69cm
1994

cave paintings. It was not because I knew that Choi's art was based on <primitivism> but because the surface features of Choi's work in front of me were similar enough to remind me of the cave paintings. I do not mean at all that the three techniques are too simple or rudimentary because they are found in the Paleolithic cave paintings. Drawing and painting techniques, carving or engraving techniques still prevail in the present art practice. Considering the appearance of the three techniques as a process of the development from a lower level of technique to a higher level of technique, it may mean that painting is the highest level of technique and drawing is one-step lower level of a technique. According to this logic, it may also mean that oriental paintings in Indian ink are lower than oil paintings as the oriental paintings in Indian ink, which origin from China, is based on drawing technique. Those inferences do not make sense at all.

Although Choi uses oil paints and acrylic paints, pencils, and pastels, drawing is certainly the most fundamental technique found in his work. I think the reason why Choi uses Korean paper rather than cloth is closely associated with the drawing technique. Without a doubt, the combination of the drawing technique and the use of Korean paper show that the artist is from Korea where the drawing technique has a long history as an artistic basis.

However, I do not adhere to the idea that human beings invented the drawing technique in the Paleolithic period and that it should be considered in relation with a specific region. The reason why Choi's work reminded me of cave paintings was that the drawing technique used in his work was very impressive.

The word used to summarize Choi's artistic world based on the drawing technique is a strikingly "anarchic" world. I describe Choi's artistic world with the word "anarchic" as various images which appear in Choi's work do not have a hierarchical order at all. Images, such as people, houses, cars, boats, realistic or imaginary animals and plants, clothes, domestic appliances, and pistols, appear in his work without order according to the significance. Also, realistic sizes and criteria for comparison are completely ignored. Nevertheless, Choi's anarchic art gives us a mysterious mood of freedom, which might be the cause of the anarchic nature. According to the present classification of fine arts, Choi's work belongs to expressionism and the art of Cobra, an experimental group, appears to be similar to Choi's. However, Choi's work is expressionism with a very bright mood. If it was expressed by the painting technique rather than the drawing technique, it is doubtful that the results would be this bright.

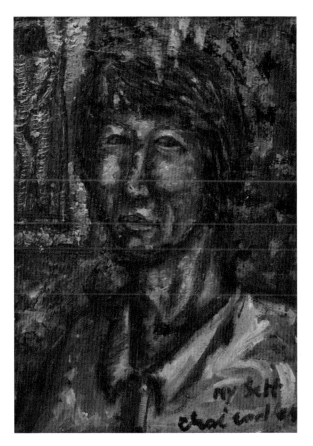

Self-Portrait
oil on paper, 25x32cm
1981

Choi worked in France for a long time and then moved to New York. Choi's oil paintings created in the late 1890's already showed an anarchic tendency, but the tendency became even stronger when he moved to France. I do not know what experiences Choi had and how his artistic world has changed in detail, but it is obvious that the experiences in France provided an enormous influence for his art. Recently, some of Choi's work has shown a certain degree of order in his anarchic world. Some images of geometrical forms have appeared in his recent work for the first time. The inclusion of a certain degree of order might cause a change in the expressionism nature of Choi's work even though this part is difficult to predict.

Choi's art is very colorful and this factor makes his anarchic world even more pronounced. Along with the color factor, lots of fine lines occupying the entire canvas are a feature of Choi's work. So far, I have used the word 'anarchic' multiple times. I am not sure that there are any other artists who have such an anarchic trend in Korea. Choi's work seems extremely unique to my eye. Finally, in reference to the cave paintings previously mentioned, a herd of animals depicted in the caves are also extremely anarchic. This is certainly because they were painted or drawn by different people across a few generations and also because the realistic size and proportional rules are completely ignored. Although they do not have as bright of a feeling as Choi's work, this is mainly due to the appearance of only three colors, which are red, black, and brown. However, it is very intriguing that the Paleolithic techniques are vividly alive in Choi's art and that they are reflected as a unique bright and cheerful mood in his artistic world.

Nudo Woman
pencil on paper, 20x28cm
1980

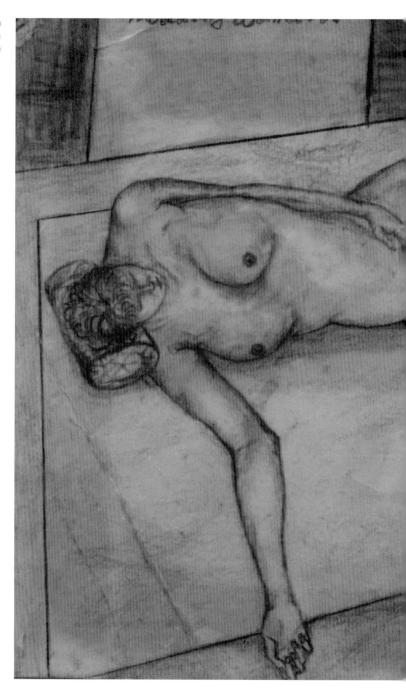

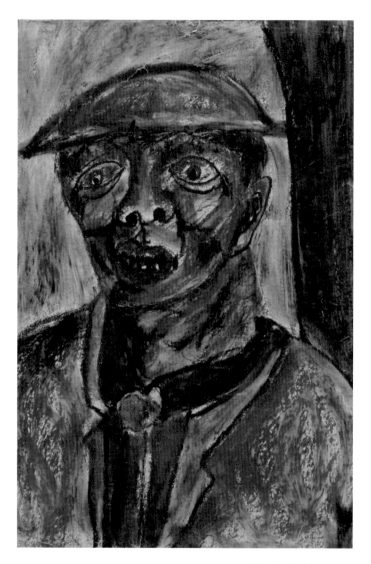

Portrait of a Man
crayon on paper, 25x32cm
1981

A Buddhist Nun
oil on canvas, 23x33cm
1982

My Younger Brother
oil on canvas, 32x42cm
1982

A Country Girl
oil on canvas, 41x32cm
1983

A Silent Man
oil on canvas, 38x45cm
1983

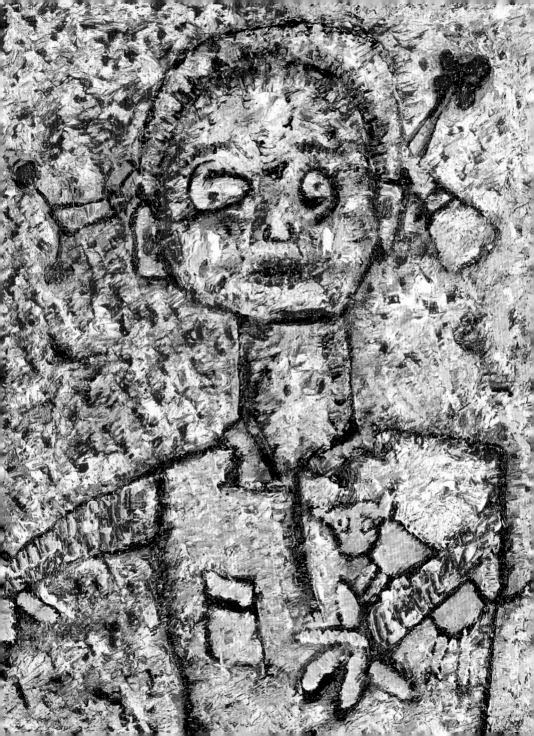

Agonizing People

oil on canvas, 72x54cm
1984

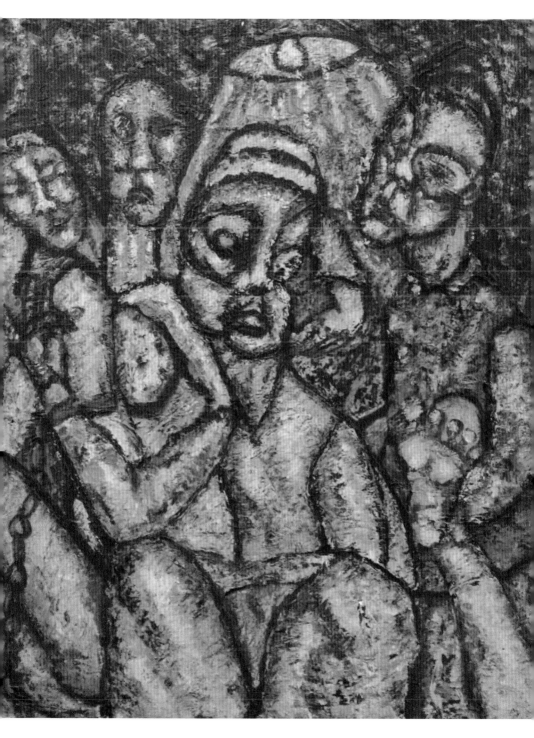

Inside of My Atelier

Feast of Lines and Rhythm of Freedom

Alain P. Donald

[art critic]

Wildly dancing lines, a feast of lines, a trace of movement made in a barely conscious world, absolute freedom, and an inner rhythm created by the lines. These are the features of Woolga Choi's recent work.

I can feel a kind of vibration from Choi's recent work. Straight lines usually give us sharp and stiff feelings but Choi's lines create different feelings from usual straight lines due to a certain degree of variation the artist organizes. Choi places a circle which suddenly appears to be among the lines or places rectangular planes on the both edges of a canvas. The rectangular planes seem to act as a regulator to control the ultimate freedom created by the lines. They act as a bank or shield to stop an overflow from the centre. The contrast between the lines and rectangles adds some weight to the entire painting.

Choi had previously used various primary colors, but recently makes an effort to put some control on the choice of the colors and on the treatment of the surface of the paintings. Even though continuous lines, which appear to be unconsciously scribbled, are freely filling a canvas, there can be a certain balance found and inner rhythm that the free lines create. The lines give the audience a similar impression to that of sharp metallic sounds of contemporary music. At the same time, they also lead us to a soft mood. This is because Choi's work is based on primitivism and the mutual balance among images is considered important.

The theme of Choi's recent work can be called "enjoyment of freedom". They are the results of his attitude to pursue a purely primitive world. Choi intended to work blank minded as if he had the same level of intelligence as that of a Paleolithic man. Choi also intended to express the natural state without any frills. One of his favorite words is probably "primitive". It seems that Choi attempts to express primitive soul in his art as primitive men did in their cave paintings. From a certain angle, Choi's work looks

like unconscious scribbles. Perhaps, it is expression of the world interpreted through the eyes of children, which is the world without any prejudice or judgment. This effect might be consistent with the attitude of Jean Dubuffet.

It took Choi a long time and lots of experiences to reach the recent artistic world. He recently came home after about five years of an exploration around the world. As a result, he attained a formative method based on new materials and techniques. Contrasted with his previous tendency of painting bright primary colors on a flat screen, he recently has shown a more controlled, simplified art. By doing so, he became able to balance between his existing themes and a newly achieved methodology to express a primitive world. Choi is not fond of a shallow effect of acrylic paints and, therefore, applied a thick layer of paint to the surface in order to create a thick monochromic texture. Choi treated the background as a single space and created images by scratching the background. The effect of a feast of lines was achieved through this process and crayon chalks were used to create small dots as objects.

Another feature of Choi's recent work is an attempt to create a three dimensional painting by giving 5 to 15 cm thickness to the side of the frame. The thick side of the painting was attempted to break an imperative idea created by a traditional framing. The thick side of painting guides audience's eyes naturally from the front to the side, so that they can sense the infinity of the painting. The natural, continuous eye movement from the front to the side results in the expansion of the view. Though the work on the side of the painting using the simplicity feature of lines, Choi attempted to endow the painting with tension and relax.

Another feature of Choi's oil painting is the usage of a generous amount of oil paints. Oil paints take longer than twenty days generally and longer than one month in the winter time to dry properly. Choi learned a fast way to dry oil paint. As Choi applies a thick layer of oil paint, the discovery of short drying process came to play a critical role in his performance and productivity of work.Why Choi paints and what he pursues through his work is well explained by the following paragraphs quoted from an interview conducted in 1991.

"In my early twenties, I worked on realistic paintings. In my late twenties and early thirties, I was suffering from financial difficulty and attempted to express the life and art of socially ignored and poor people. After my thirties, I tried to express the life

and thoughts about nature and people that exist in pure nature which is completely separated from civilization. However, criticism about the theme occurred in my mind again because we, human beings, cannot live ignoring the development of civilization and also cannot help using it. There are so many problems where nature and civilization meet. Whether it is intellectual or materialistic, if we do not try to balance civilization with sounds, shapes and movement of nature, both nature and human being will go ill. Then, how can I express the civilization in order to make it look like and feel like nature. This is my current important assignment which will combine my artistic ideas. At the same time, however, I firmly believe that painting itself should reflect the contemporary worldwide tendency. It is not best to paint only truly on one's own, ignoring the surroundings. Painting should be creative enough to lead, and reflect the twenty first century's art through its contemporary composition, space, colors, lines, and overall image."

The quotation above is somewhat long but shows clearly the inner world and core intention of the artist. Choi focuses on nature, and the natural appearance is the basis of the artistic world he pursues. Nevertheless, Choi does not ignore the surrounding world and also includes fundamental factors of the fine arts into his creation. Primitiveness still exists in the mind of people who live the highly civilized world, as if a sound of the soul. From the recent work of Choi, we can hear the sound of freedom. From his recent work, we can also hear a primitive sound. The sound might be the primitive sound heard in the middle of a civilized city. From this primitive sound, we can find freedom and primitive purity. Choi will be accepted even if he was clumsily spoken. Choi will be welcome even if he hesitated and stuttered in the middle of a busy city street, because the sound of his clumsy pronunciation might reflect the other side of the face of the people who live in the busy civilized world.

Lover
oil on canvas, 32x41cm
1984

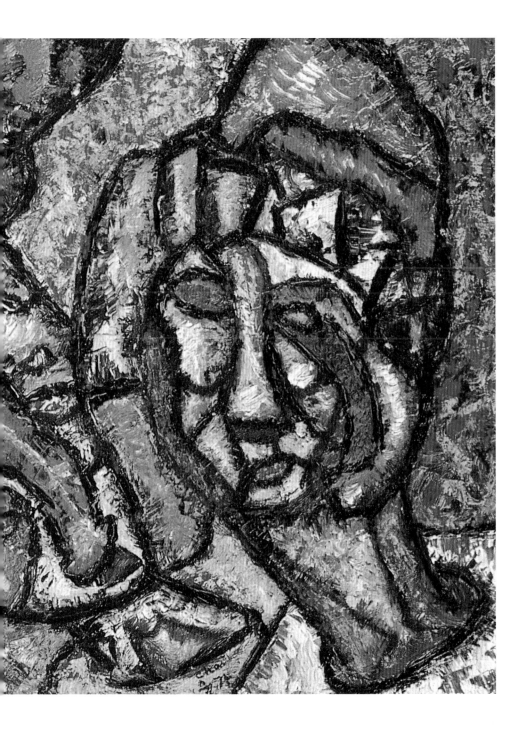

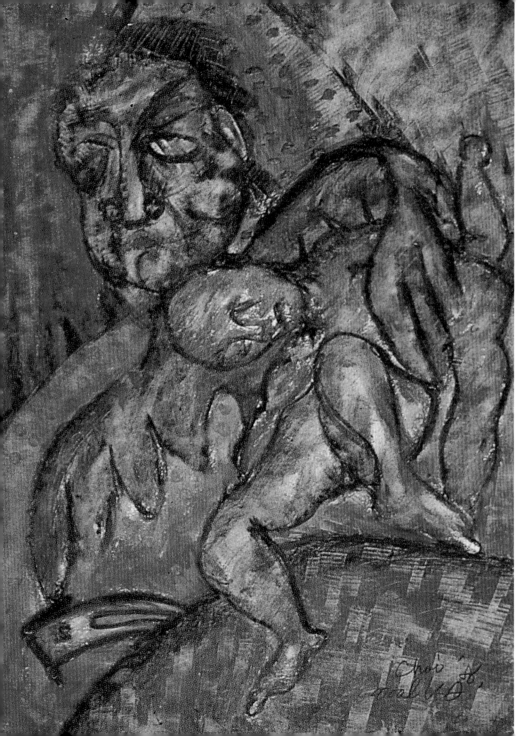

Father and Son

paper on crayon, 41x32cm

1985

Dreaming People
oil on canvas, 162x130cm
1985

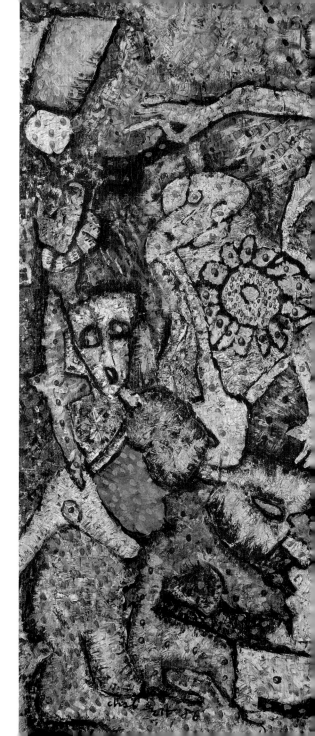

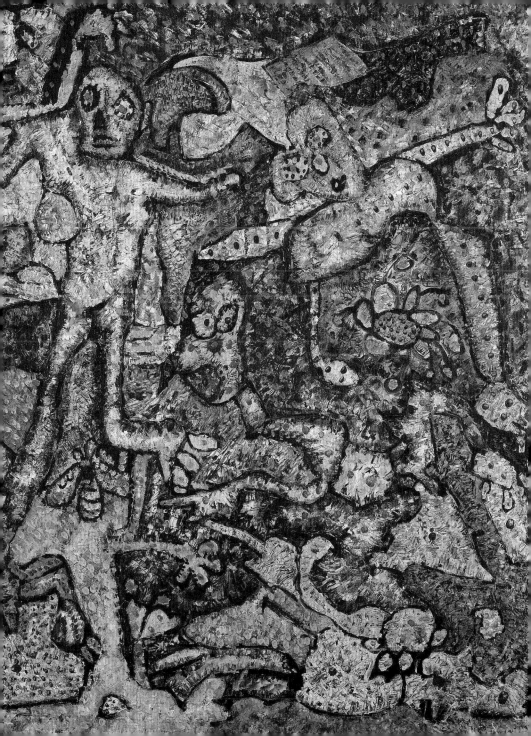

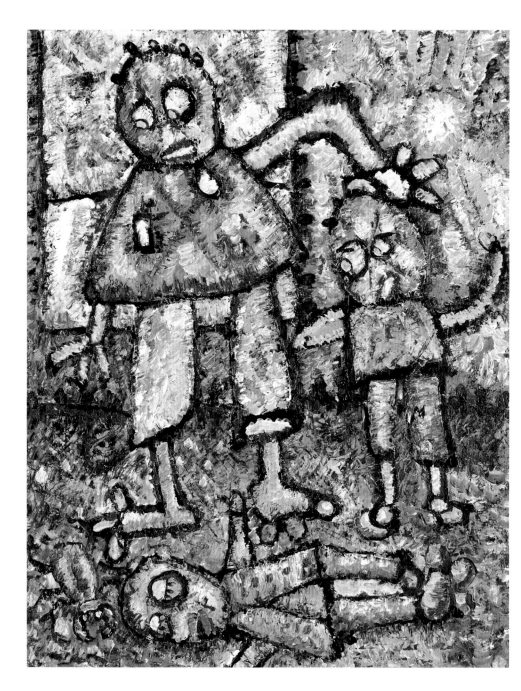

Puppet Play
oil on canvas, 72x54cm
1986

Night and Wine
oil on canvas, 38x45cm
1986

A Secret Hidden in the Play

The value system Choi Woolga pursues in his works seems to be rediscovery of a primitive moralism. It belonged to a genre of unconsciousness anybody could pursue, but in our modern times, it is expressed rather as logical thought, while being theorized in a more complicated way, and as a result, it seems to be more difficult to understand than any other genre. However, I believe that the emotional consciousness of seeing and feeling is not much different from the primitive one. The power of his consciousness of eulogizing the freedom may lie in a kind of autistic nostalgia naturally evoked when he tries to reflect on his works earnestly his intention or a mental by-product after a career of some length during which he raised questions incessantly through plays.

Alain P. Donald
[art critic]

To Choi Woolga, the consciousness of the past will not follow some realistic value criteria but recollect the past memories fantastically and thereby, create his own space to settle there comfortably; any artist may well have such a consciousness when he or she is distanced far from present or future. Anyway, we may feel an infant innocence or a mental freedom dreamt by us for the images of his consciousness recalled, which I cannot deny makes our instinct happy regardless of our educational background in the society.

To Choi Woolga, painting belongs to the genre called play, but some realistic expressions are hidden inside his paintings.
It is not that only the painting like a photo is realistic.
It is nothing but a technical element.
Jean Dubuffet's paintings express some internal facts.
Pablo Picasso, Francis Bacon and Jean-Mitchel Basquiat may have reinterpreted the realistic expressions in some ways.
As a more plausible example, when children are painting their moms or younger

brothers, they try to paint them realistically. And even if they feel that their paintings mirror their moms or brothers, they would think what is visible in their paintings are not all about their moms or brothers.

To children, painting is nothing but a kind of unconscious play, and through such activities, they would be happy and pleased. They do not mind others' views, drawing their paintings according to what they feel. Thus, the viewers would feel free for their paintings like a clean brook.

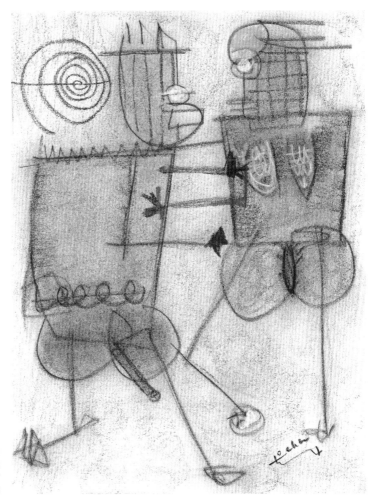

**Base Painting
in New York**
crayon & pastel on paper
21x29.5cm, 2000

According to Choi Woolga, "human beings are happy with the incessant plays, work for the plays, and earn money for a happy play." After all, "human beings' ultimate goal lies in pleasant plays and their enjoyment." The artist who argues that everything in the world consists of play culture expresses his consciousness of pleasant play as paintings, refusing the serious, philosophical and conservative academics.... So, he does not think any work dictated by knowledge conform to his tendency of art.

Then, what is the world of painting desired by Choi Woolga?

First of all, summing up his mentions about his motive of art, his motive derives from the behaviors or the situation in time immemorial when no letters existed and when only some unconscious thoughts and emotions purified only as feeling were enlivened before material civilization and political consciousness began to dominate the society. The primitive men needed a play but did not want their play being watched. They just played for pleasure, not for clothing, means or housing. They were engaged too naturally in their plays for their physical reverberation or mental pleasure. To our human beings, particularly our modern men shackled by the framework of civilization, the primitive art images may well be sources of mental pleasure or surprise, as if they were clean and clear wells found deep in the mountains. It is conceived, therefore, that Choi Woolga himself has come to draw the paintings conforming to his motive partly because he was born to do so and partly because his life course has befitted his inborn nature accidentally.

When he was young, he may have not be satisfied with everything around him. He used to cry frequently, drawing the paintings on the small void ground beside his house. Such paintings have formed a secret passage leading to his present art. In this long and tough passage, the weightless plays might still be processed.

At any rate, the play-like consciousness of life he pursues is never denied by him, and instead, accepted thoroughly as his reality. I believe that such a consciousness is a motive great as lonely struggling human spirit under any standards.

However, he still seems to face the challenge how to express the human consciousness of pleasant play into paintings.

Nevertheless, any artist is obliged to face the challenge beautiful and pure.

Amazon, the only primitive part on this planet may call him.

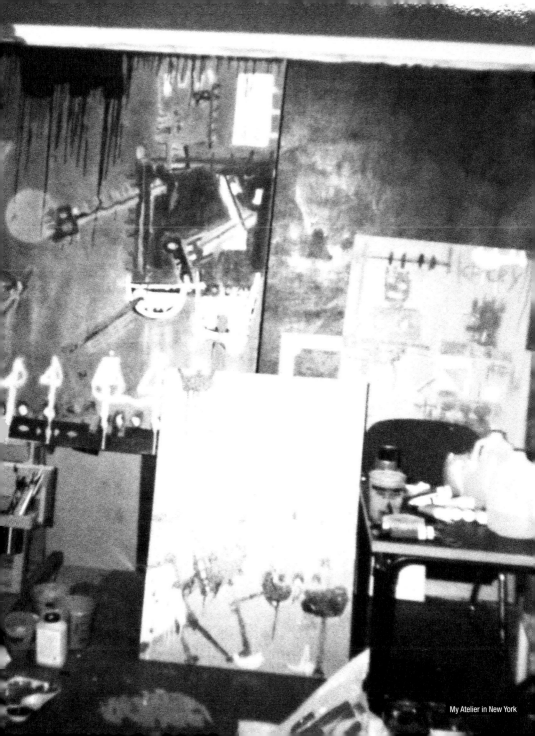

My Atelier in New York

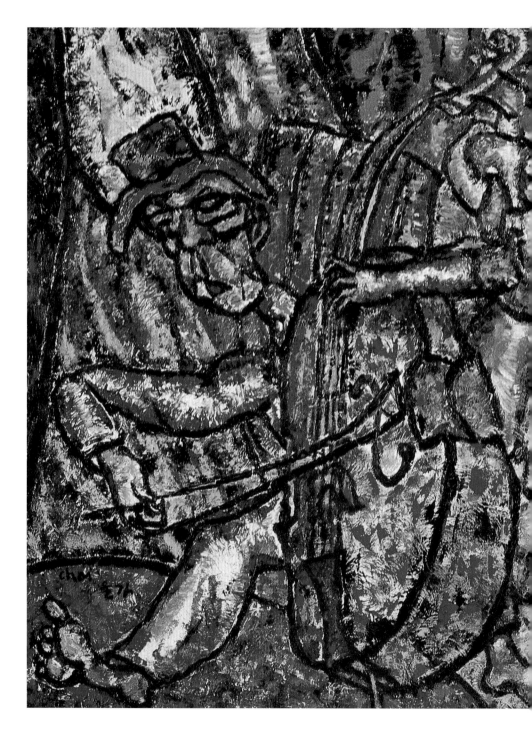

Mr. Lee's Performance
oil on canvas, 54x72cm
1986

Root of Memory
Acrylic on Korean paper, 48x53cm
1990

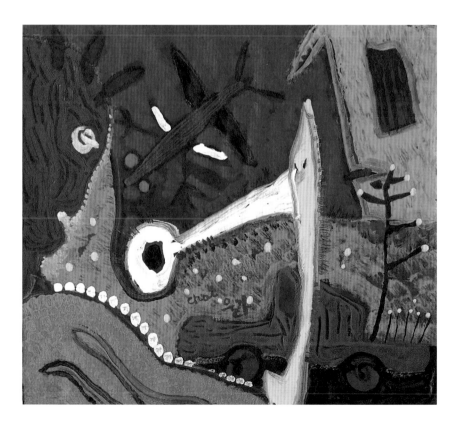

TV Fairy Tale
Acrylic on a Used Record Jacket, 32X27.5cm
1991

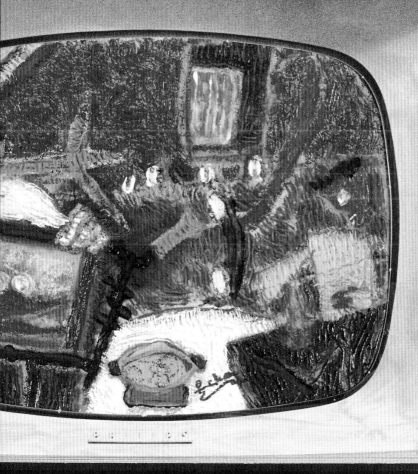

I Don't Like Smoking

pastel & pencil on paper, 21x29.5cm
1991

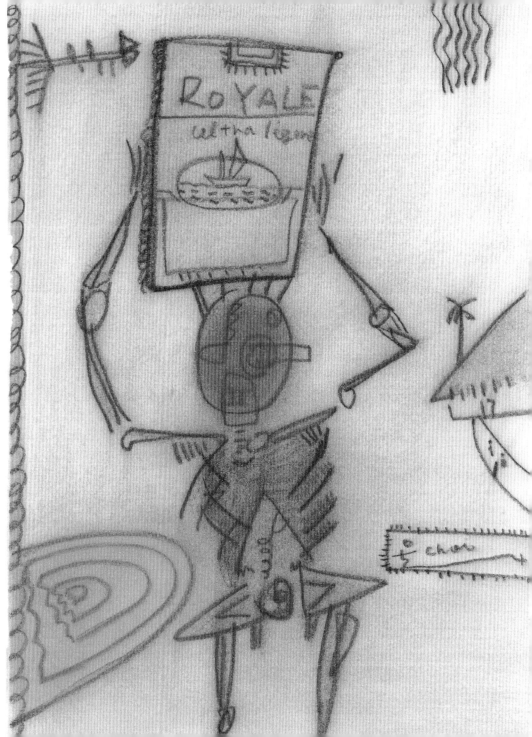

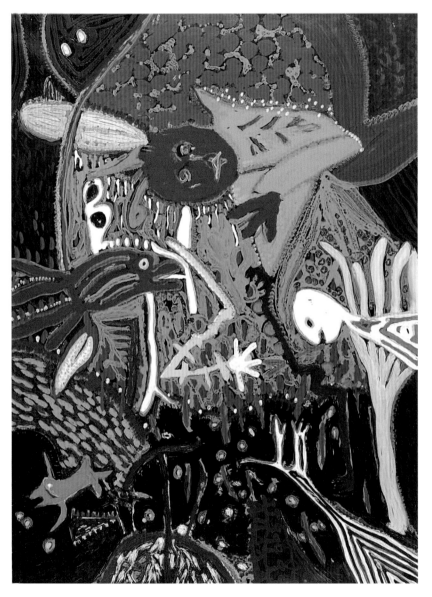

Journey on a Desert
Acrylic on canvas, 95x130cm
1991

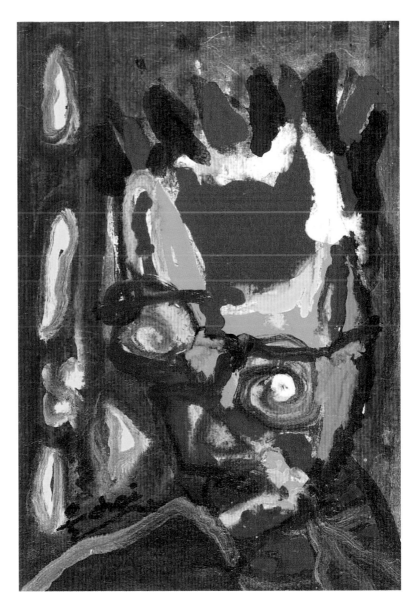

Self-Portrait
Acrylic on wooden plate, 21x28cm
1991

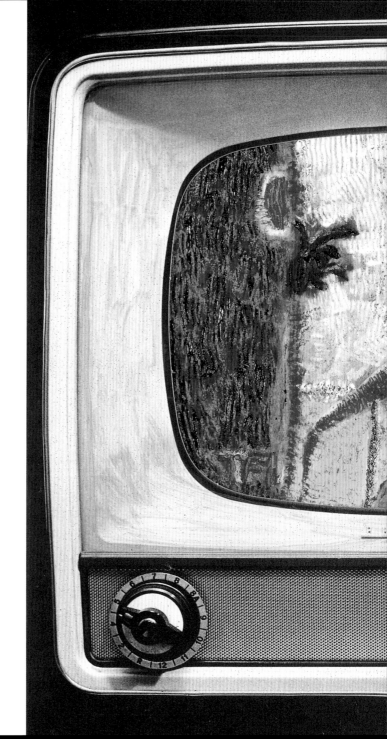

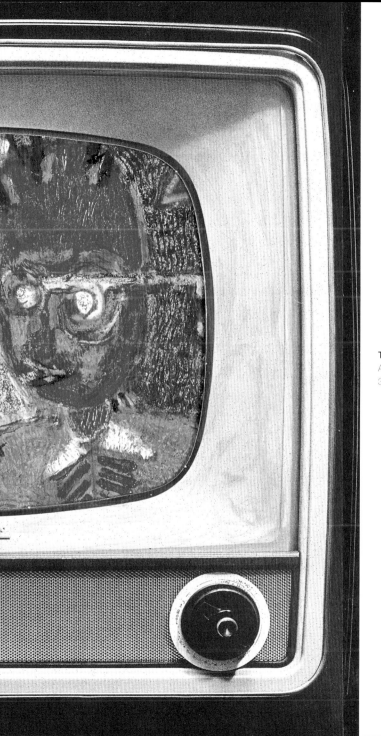

TV Anchor
Acrylic on a Used Record Jacket
32X27.5cm, 1991

Shift from Coloring toward Line Drawing

Choi Woolga's world of art has evolved through several changes over the last 3 decades. His world of art has changed from the seemingly explosive, gorgeous and passionate colors in mid-80's to an intellectual and semiologic world today. Since such changes have been made primarily over some 20 years, they may seldom be apprehended if we should focus on their parts rather than overview them. And we cannot afford to review his works produced for the period from late 70's to early 80's, which is a regret for us, As he has been too a prolific artist, however, we may well be able to analyze his world of fine art easily in overall terms; since mid-80's, hehas been steadily constructing his own unique world of art only to establish an art sect of his own.

A series of works produced by him during mid-80's are interesting, because they show a kind of his autobiographic art world. Their subjects are the artist's family members centered about him. The examples are "Father" (24x33cm,?1986), "Brother" (41x32cm, 1986), "Blood Relative" (41x32cm, 1986) and so on. Another subject is a strongly sentimental impression with the life surrounding him. The examples are "Mr. Lee's Performance" (54x72cm, 1986), "Night and Drinking" (38x45cm, 1986), "Portrait of A Man" (36.5x23.5cm, 1986), and the like.

The works during this period feature in common a black contour line accompanied by contrast between cool and warm colors and rough touches, and the overall atmosphere is very dark and gloomy. As the artist wrote in one of his essays, such atmosphere may have been attributable to his financial difficulty during this period. However, when compared with his airy and bright primary-colored works during late 80's and early 90's, his earlier works contrast dark color tones, which interests me. As I implied above, such a slack world of art hints artist's sharp sense of compassion for human beings at that time. Considering the attributes characterizing his works at large, such atmosphere must be very peculiar. His paintings during this period suggest a strong sense of

Yoon JinSup
[art critic]

affection for their characters. A cry for life in "Brother", a street bandsman's hard life in "Mr. Lee's Performance," a sense of escapism in "Night and Drinking".... All these senses represent artist's warm affection for human beings.

Inferring from the biography about Choi Woolga's works featured in his pictorial, it is presumed that he underwent a great change during late 80's. It was a seemingly explosive contrast among gorgeous primary colors. It is also conceived that the direct factor for such a change might have been a changed living environment; he resided in France during early 90's. For a new living environment would be likely to lead to a new painting style. According to artist's confession, he experienced a great psychic change after his exhibition in 1988. The psychic change may have been attributable to his experience at an atelier in Paris. He would be keen about the nature as mother's womb of civilization, and after all, he would be awakened of the fact that any artistic achievement should have an aesthetic value acceptable universally throughout the world. His artistic itineraries thereafter have been nothing other than incessant migrations and pilgrimages. His artistic itinerary from Paris to New York reminds us of a vagabond's life struggling for an universal aesthetics.

Choi Woolga's works produced in 90's feature a pleasant and animated sense, a characteristic of the Mediterranean culture. Although they belong to the same category as our traditional 5 colors (red, yellow, blue, black and white), his primary colors used during this period give us a different sense or aesthetic taste or color value. The dizzy and explosive images reminiscent of kids' paintings must have resulted from a 'Kunstwollen' (art will) attempting to antagonize the civilization, while praising a sense of freedom deep inside ourselves to be emancipated from the shackles. Choi Woolga's works which may be referred to as to 'modern cave wall paintings' are living diaries written by a civilized man and at the same time, represent a fascinating color festival longing for regression to the cave life of the pre-historic age. Choi Woolga's works characterized by such a strong sense of primitivism may be his own records about today's human life, just as the cave wall paintings during the pre-historic age were records about the primitive life. Such a characteristic is in line with his long and steady use of black line drawings. Choi Woolga as recorder of the daily life or collector of daily images attaches his own unique value and meaning to his drawings by vividly expressing the fragments of our daily life.

After he arranged an atelier in New York, Choi Woolga would undergo another change

in his world of art. The change occurred on the threshold of the new millenium. It was a fundamental change, departing far from the gorgeous primary colors and the unique sense of texture of brush touches, characteristics of his works during late 80's and early 90's. In a nutshell, it was a shift from coloring toward line drawing. If his preceding works featured the lines subject to colors, his new works in the new millenium feature the colors subject to lines. Isn't it that the reason why his new works are reminiscent of graffiti is because the colors are subject to lines?

Another characteristic of these new works may be conspicuous use of the white color. His recent works on the thick-box-like canvas tend to be darker. The neutral base colors or the whitish gray, the reddish brown or the flesh color prevailing in his works during early 2000's would represent an interim tendency in the way toward the dominant white color in late 2000's. Anyway, such chromatic colors would appear, although partially, as rectangles on the white canvas later. The rectangular color planes located on the edges of the canvas are expressed as if they were worked with threads. According to one of his essays the source of which I cannot recall, he was concerned much about the expression implying a fence protecting the kids.

Choi Woolga's works produced in 2000's, which remind us of children's paintings, would be more and more reminiscent of machine design drawings or chemical lab over time. These works combining a variety of signs, letters and images on the canvas like a complicated circuit look like the cryptographies which could be deciphered only by the artist himself. In order to decipher them, we need a help from him. However, the artist is not kinder than suggesting the canvas with his unique lines complicatedly combined with such objects as fish bowl, fish, clock, helicopter, plant, number, star, animal, man, building and room. His paintings do not show any ladder that is required for the audience to apprehend the objects. Thus, the audience would feel like being the forlorn sailors who have to sail their vessel without any nautical.

Here, the cross-encounter between the artist and the audience is realized in an imaginary space inducing such 'an interactivity.' Choi Woolga's works speak to the audience rather than answer them. Not that "here is an apple," but that "it may be an apple or otherwise simply a small circle." Whether the circle can be perceived as an apple or not is wholly up to the audience. So, it requires not only imagination but some patience to read his paintings. Sometimes, reading them may be compared with puzzle game or lime cave exploration, which means we need to be very careful to

My Atelier at SoHo in New York

read them. However, we may as well enjoy his paintings for that reason. It involves an empathy of making his experiences our own as well as a sympathy derived from the empathy.

Choi Woolga's theme or idea is expressed on a plane in a multi-dimensional way. Just as innumerable cells exist in a cyber, so the dimensions of different tenses (past, present and future) exist in his paintings. Criss-crossed time and mobile space are symbolized by such media as clock or helicopter. Accordingly, Choi Woolga's works are the model analogue works, but in terms of semantics, they may well contain the digital contents. The images appearing in his paintings are the objects existing in audience's imagination. We can meet and enjoy them in a cyber world expandable limitlessly. They are the signifier like the buoys floating on the boundary between reality and virtuality.

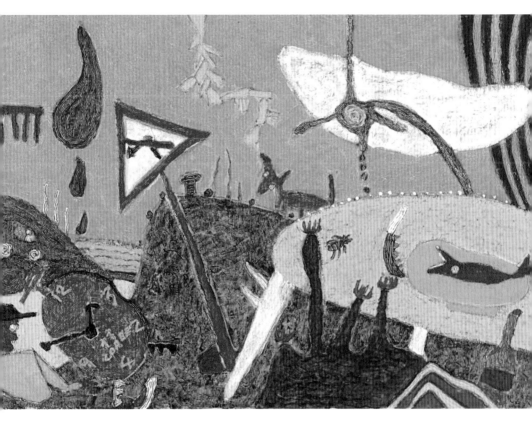

A View with a Traffic Signal Board
Acrylic on Korean paper, 97x65cm
1992

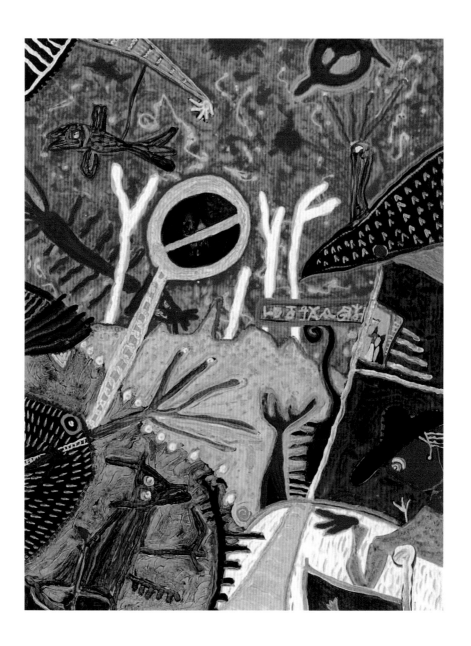

A Night on Desert

Acrylic on canvas, 96x130cm
1992

A Cafe Looking up the Stars
Acrylic on Korean paper, 95×130cm
1996

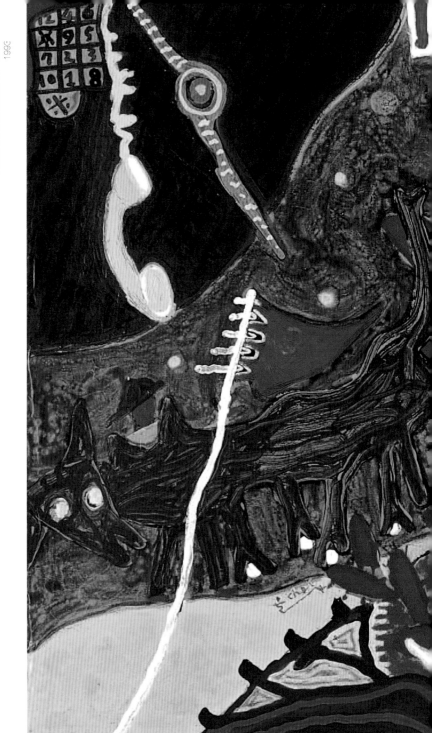

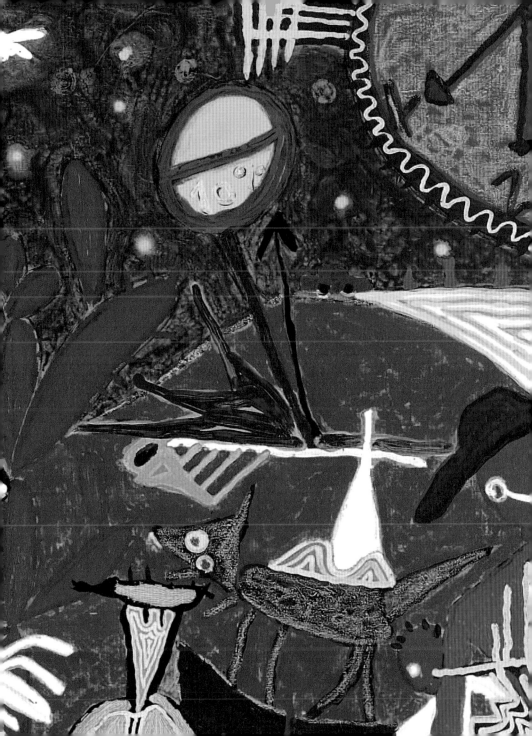

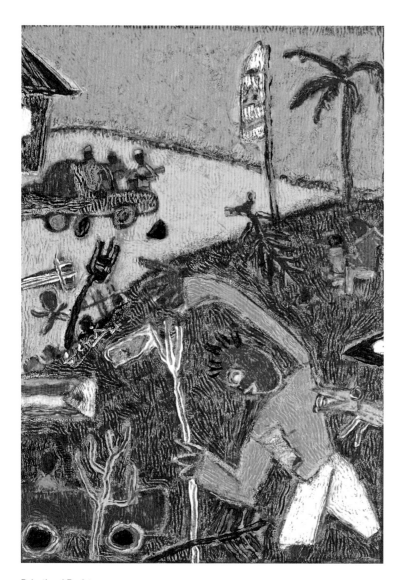

Palestines' Resistance
Acrylic on Korean paper, 25x36cm
1993

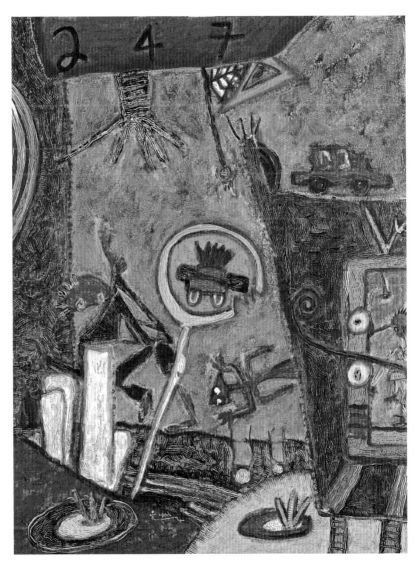

A Fancy Free Play
of the Instinctive Emotion

M, chunder

His narrow atelier in an artists' camp or Spring Street is always messy. The colors used not all but dumped, the canvas of his own invention, paper coffee cups scattered here and there, the vessels of various types used for works... I push open through them to sit down on an smudged Pakistan futon (folding bed). Upon reviewing his works to be submitted to 2004 KIAF, I could feel how he had poured his energy into his new paintings at this atelier for the last several years. The paintings drawn on the small boxes he says picked up from the SOHO street. And the works with the colors seemingly pushed into the thick white color.

Upon reviewing his preceding drawings, we know that he drew on a monochrome primarily using the color planes with chalk or oil painting materials or mashed the colors or used the flowing-down colors to express the US-style wild nature intensely. I crouched for a while amid the works which urged me to doubt that they might betray his own image as such.

For the last 5 years, he has attempted frequently to escape from his past world, probably in an effort to participate in the post-modernism dictating the US fine art. He may have wanted to enjoy a sense of liberation from the French atmosphere or the anticipation for tradition and something orthodox. However, he says he was shocked to hear from a commissioner of a gallery (Chelsea) on the 10th Street that he should present them with the works of his own style. Anyway, his paintings now feature numerous trials and errors he has experienced and experimented.

For his forms or images in 80's and 90's still remain amid configurative or abstract lines. As we can feel from his past paintings, we can find his apparent struggle to graft those various forms exquisitely drawn in his past paintings onto the fancy free scribbles. Where does the 21st century head for?

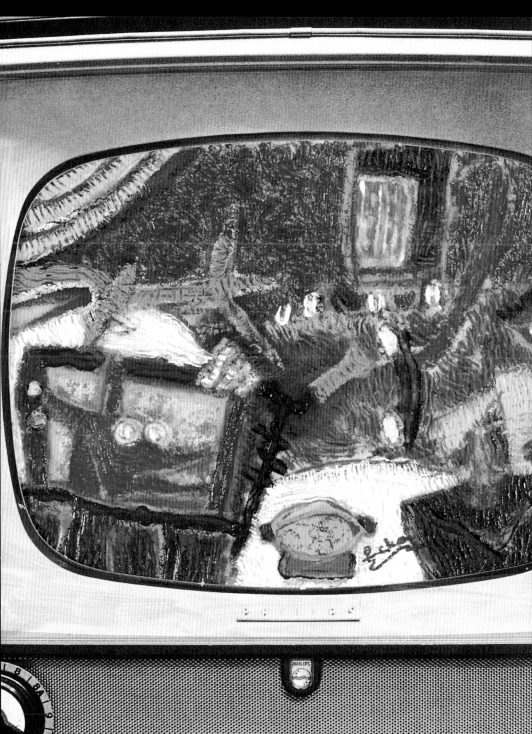

"Me" at My Atelier

And what culture do people want to share? Now, most of the nations throughout the world have escaped from the dark tunnel of the 20th century.

Now, we live in an ultra-informatization age when the news about every accident or event can be heralded just in a few seconds. People do not want to return to the past dark tunnel painful to them. So, now we cannot but think about where our paintings head for. The abstract images fashionable since Tapies have been followed by numerous artists as if they were decent and elegant, and many artists expressing them have been introduced to us. Maybe, the European fine art drives numerous artists into a bedroom decorated colorful at a dead end of lane.

However, the result has been found reversed. Every fine art market has moved to the United States, and European nations, particularly France struggled in vain to recover their fine art markets, and their markets have fallen into a deep quagmire due to the ills of socialism policies. Fashion. It is a harmony of an age inviting participations beautifully. Artists participate in the fashion to arrange a ground to share the social culture of their time and at the same time, deliver to the audience their own high mental values and perceptions.

Even today's paintings cannot afford to escape from the fashion or probably a harmful genre of culture. However, how about Choi Woolga's paintings? In a sense, paintings

like his could be found long time ago.

Too far from something new or a fashion. In a sense, he loses consciousness to walk alone, murmuring. His paintings are far from being refined. Even a single modern painting technique cannot be found. They look like the scribbles drawn randomly. The lines drawn with crayon or oil painting stick flow randomly, and the crude lines seem to be drawn with a stick like wooden chopstick. They are never something new. We feel that we have ever seen them somewhere.

Then, why do we pay attention to such paintings? As mentioned above, his paintings are the ones that we can find in any age. But they are never relevant to a fashion, while containing a fragrance which everybody may have smelt. Innumerable tens of thousand images derived from an area which we have forgotten, namely, the origin of our human spirit, may attract him so much that he may be indulged in his works forgetting about shortage of subjects.

Dangerously Playful Paintings

However, although the images of his world will not be depleted eternally, he must face a danger because he himself is one of the artists using the images. He must fear where his spirit heads for. Since his works are produced depending on temporary conditions and moods, he may fall into a more dangerous quagmire if he should not watch out for himself. And if he should continue to be too deeply indulged in the limited materials, he would probably experience a mannerism like many other artists I know. Time exists in every human material. So, I would like him to use his sense of materials more widely. A higher barrier of the world paintings stands before him. If he should give vent to his own primitive freedom as long as possible, he would be obliged to drive himself in a world of farther and freer spirit. Just as the soil cannot be dug only with a shovel, so such a long and hard journey to better working conditions can only be driven by the artist himself.

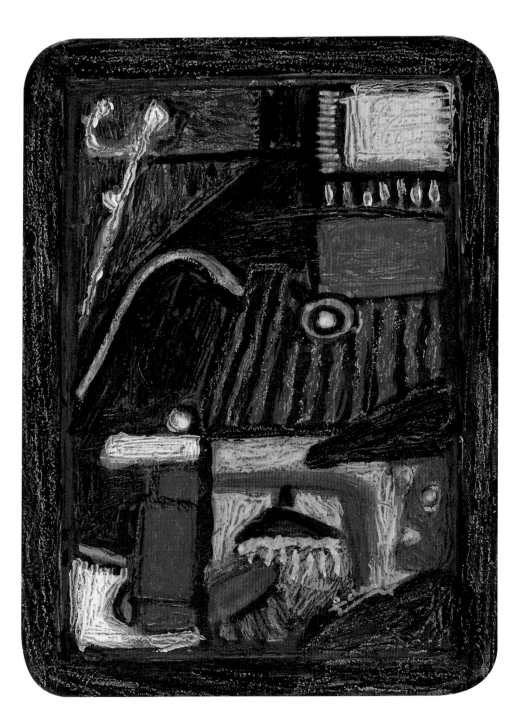

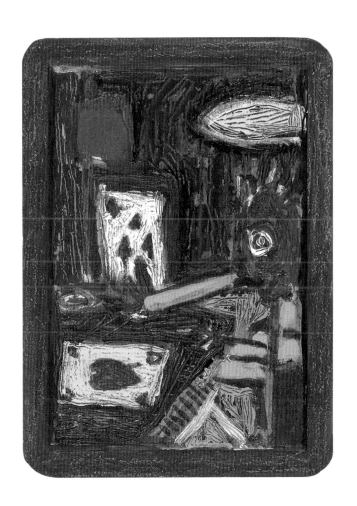

Civilization and Primitivism Series
Acrylic on stone plate, 20x27.5cm
1993

Playing card
Acrylic on stone plate, 20X27.5cm
1993

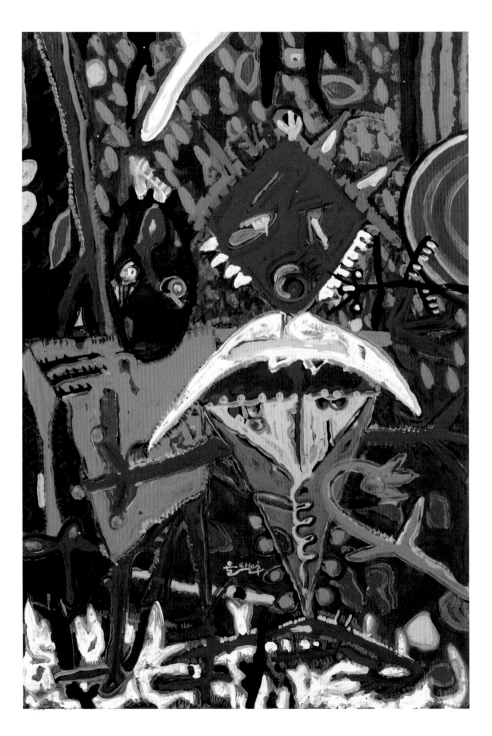

Two Brothers in Africa(1)
Acrylic on Korean paper, 65x98cm
1993

Memory Series 4
Acrylic on Korean paper, 20x25cm
1993

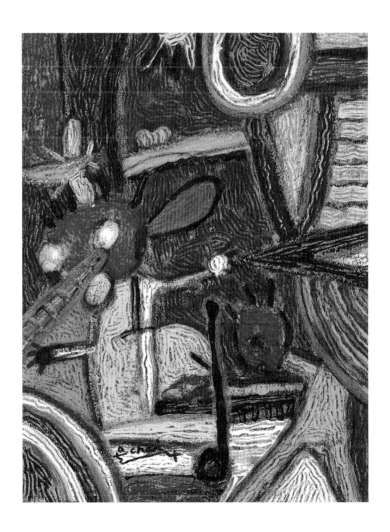

A Game at Night
Acrylic on Korean paper, 65x81cm
1993

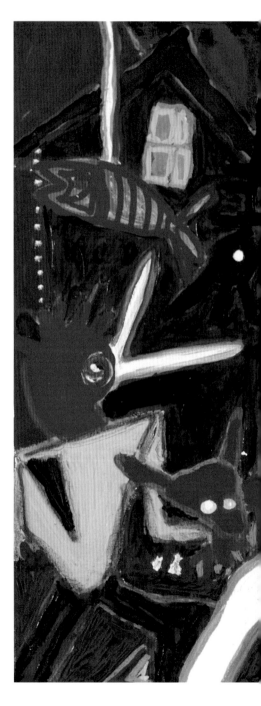

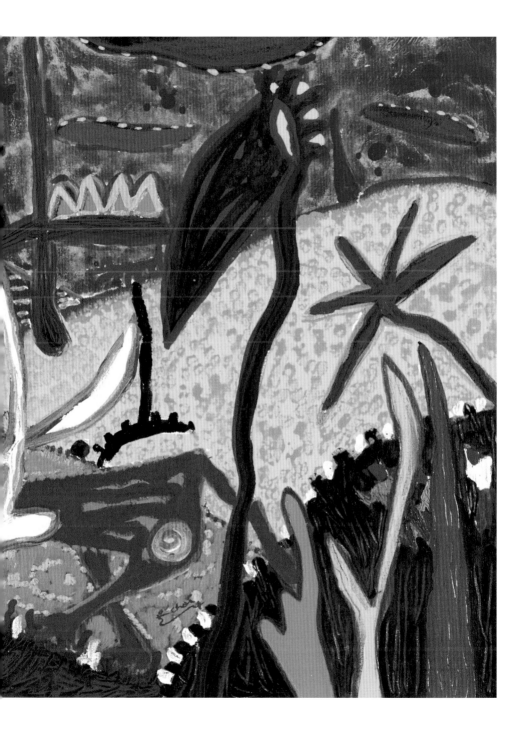

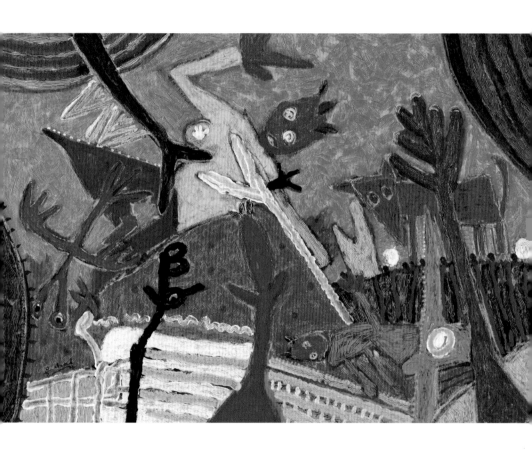

Deep Sleep
Acrylic on Korean paper, 97x65cm
1993

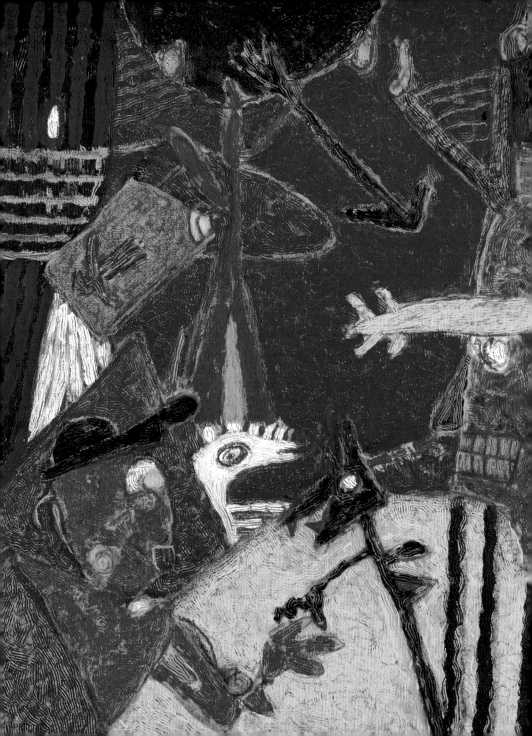

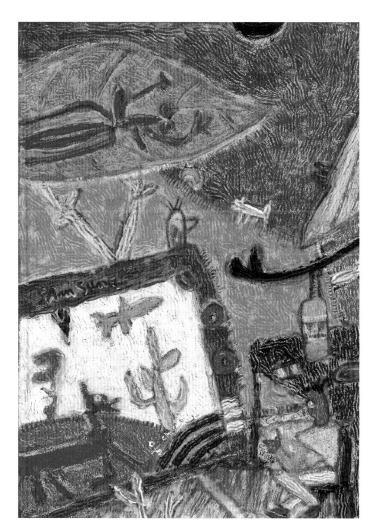

A View of the 21st Century
Acrylic on Korean paper, 25x36cm
1994

Their Everything
Acrylic on Korean paper, 51x69cm
1993

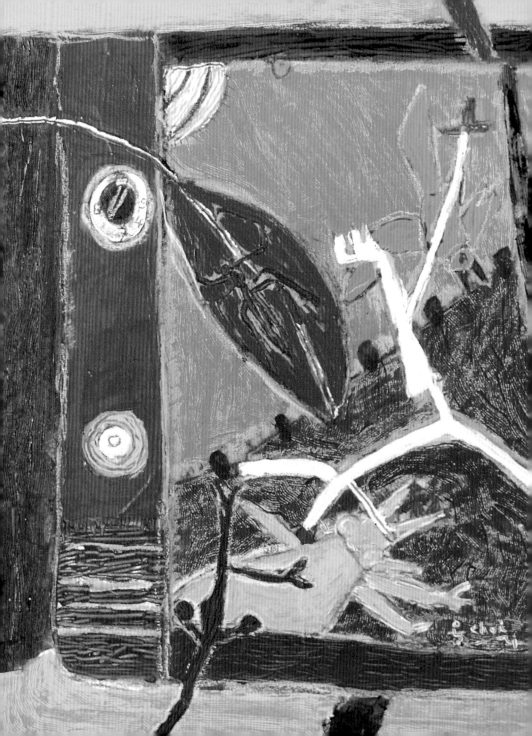

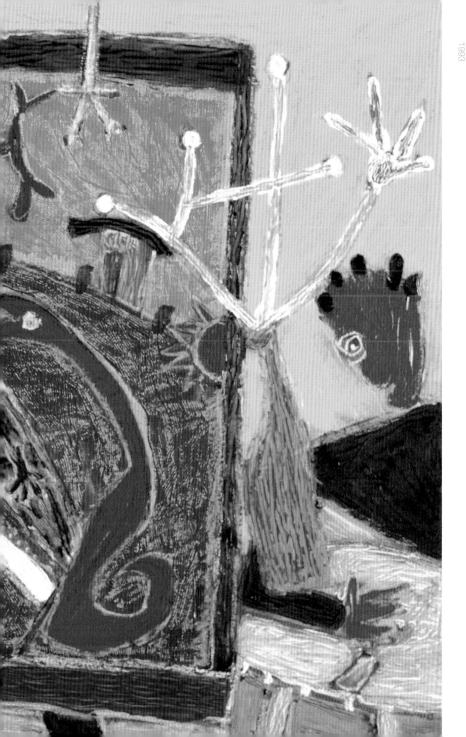

Primitive Men's TV Watching
Acrylic on Korean paper, 65X97cm
1993

Reversible Time and
the Remains of Daily Life

Yoo GeunOh
[art critic]

While Korea and China were using sundials, the world powers of Europe began using mechanical clocks, which is the predecessor of today's clocks since the 14th century. Although there were differences in time divisions, there was not a great difference in the concept of time between the East and West. Though all civilizations may have had their own unique method for measuring the concept of time as well as their own standard or way of use, there is no mistake that there was a universality of time within their civilization. However, the different time divisions between different regions and nations created numerous problems. Therefore, the need for a worldwide time standard became obvious. A standard time was first applied in 1912. However much this system was practical, not everyone was satisfied with it. There were still various issues to be dealt with. Newton's absolute and objective measure of time was being questioned. Durkheim claimed that time was begotten from social relativity and attacked the concept of time concentrated in Europe and also opposed Einstein's theory of irreversibility of time. Moreover, debates of whether time is physically homogenous or heterogeneous continue and furthermore, the conflicts between the inconsistency of public and private time are yet to be resolved. In result, in modern practicality, time's social, physical and psychological relativity has been negated. The reason why time is mentioned in so many different perspectives is because I have found that there were many relations between time and the paintings of Choi Wool-ga.

Belock is a Russian anarchist that appears in Joseph Conrad's 1907 novel, 'The Secret Agent'. His mission in England is to explode the Greenwich Astronomical Observatory, which is the prime meridian. The prime meridian signifies the authoritarian element of official time and therefore there is no better target for anarchism to Belock. Through this, Conrad expresses in extreme the conflict between official and private time. Ironically however, the art critic Nakahara Yusuke has compared Choi Wool-ga's paintings as that of an 'anarchist world'. What Nakahara means by the anarchist

world is that the various images on the canvas totally ignores the importance of thedifferences in size and the standards of comparison, as if they were espoused in total disorder. However, it can be interpreted in another way. Though Choi Wool-ga had no relationship with political anarchy, he seems to bring the issue of time artistically.

Then what does time mean to Choi Wool-ga? To jump straight to the answer, time is heterogeneous and reversible. His paintings show that time is tangled up between the past, present and future. Hence, the past sometimes passes ahead the present, while dreams and anticipations of the future sometimes infiltrate into the past. For example, the painful past is transferred into the present and is vividly expressed as if it was currently happening. Meanwhile, the current day is broken into fragments as if it is vaguely remembered; creating a sense as if it was something that has yet to have occurred. Becoming free from the strict order of time represents that one becomes oblivious to all senses even it is only for a brief period. In this case, when the daily occurrences are observed, its main essence quickly disappears leaving behind only the skeleton, and though much effort is made to grasp the essence, it is of no avail. Therefore, the canvas of Choi leaves only the gaunt skeleton, which is absolutely normal. This is the method of existence for Choi's paintings. Most paintings

occur in a flat space and therefore it is difficult to draw the delight and dishonor of past experiences, emptiness of lost time and feelings with other objects or animals. However, as if Choi sympathized with Marcel Pourst's words of 'the existence of man which takes up a spot, or in other words, a larger place than the limited spot allotted within space, to draw an existence that takes up the dimension of time'. Therefore, attempting to recover the spatial matters of what is drawn is a wasted effort. Only expression methods using lines can defeat the desire to occupy space and only sectors such as alarm clocks, stars, flower vases, fruits, cats and dogs, tables, televisions, old radios, etc. can occupy irreversible time. The reason why he uses rough drawing methods is his effort so that those things are not kept at its mere physical form.

Dials of a clock appears regularly in his paintings. This shows that it takes up an important role. It is clearly expressed that existence and time meets. However, there is the need to take a closer look at the clock face of the alarm clock. It is somehow different from the common clock face. It not only ignores the order of time that follows a chronological order, but it also ends at 13 and 14 o'clock. In its surroundings, lines which tick as if to be an image of the sound of a clock are rampant. These images are not mere mistakes or images that coincidentally appear as a method of free expression. In reality, nobody can become free from the rules of time. It is the fate and trap befallen upon mankind. Furthermore, it is a flow that cannot be controlled and it is a sad desire. However, images oblivious of this type of official time makes traditional time such as continuance and divisions disappear as well as getting rid of the spatial boundaries. This is not the absurd thinking of creating non-reality through reality, but instead is the apparition of Einstein's reversible space in time. Consequently, his painting is fixed within a unique criture in spatial time. His drawing of petty daily life ventilates us from our languid routines in life, but also brings out the audience's artistic senses in hidden objects and occurrences that we! always live with but never see or feel. We can presume that this type of thinking that Choi has was acquired while working in Seoul, then Paris and finally in New York. We are able to detect the relevance between time and space here. When flying from Seoul to Paris, we are able to experience two days in one. This is where official and private time collides in conflict. As seen here, the face of a watch can show a definite time and a calendar records each and every day accurately, making it without a reason for doubt of the universal time. However, the psychological private and personal time can exist in a wide array of ways.

Various elements coexist in two different characteristics within the paintings of Choi Wool-ga. This is represented by the innocence of children and the perceived world of adults. It is represented by primitivism and modern compositions. It is represented by heterogeneous drawings and a homogenous color of the canvas. It is the range of completion and incompletion. These are contrasting elements that is presumed to be unable to mix. However, as if everything was to be valued, these harmonize in the canvas of Choi's. In short, this can be said to be temperance and freedom. Furthermore, not only is there visual aspects, but audio aspects are included as well. This stubborn relationship has a strange implication between the author's passionate fervor and unusual sense for formative arts with that of daily life. When tracing back on his work, we can find that the floor of his paintings are evenly layered with carefully selected colors such as white, black, blue, red and gray. It is then followed with objects and animals that are drawn freely as if it is out of his instinct or as if he just did not care how it was painted. These pictures seem like magnified images of dessins of once-too-many told stories drawn by children in their notebooks. At times it seems ridiculous and sometimes it seems to be that of disturbingly exaggerated graffiti. This vivid and gleeful, sometimes loyal to the primitive act of drawing, sometimes simple or at time unique, sometimes as if its writing in a journal, but always inconsiderate of gentlemanly art is where we can find the few basic values of Choi's paintings. These are characterized by a clean spirit, freedom, vast creativity, transcendent technique, purity and artistic energy.

However, these alone do not explain in full his paintings. If it did, his works would be recognized merely as art brut, primate art, graffiti or figuration libre. By thinking outside of the box or scrutinizing his perspectives particularly in his latest works, we can see the difference. The color planes that seem to be tightly knitted together intrude the screen everywhere and reverse the feelings of old. These color planes can be understood in two different ways. The first is that the colors are free-wheeling and restricts the somewhat disorderly drawings in order to act as a constituent of tension and relaxation. The other is that these color planes resemble a sketch book and acts therefore as a drawing on a canvas or pre-figuration. In other words it takes on the role of restoring the work to its preparatory phase before it was complete. In more accurate terms,! it is not something that is incomplete or non-finito, but creates a feeling of something that lacks completion. This is not an insufficient expression but is an extreme vibration that can only be boldly expressed with incompletion. In other words, the most basic will of the creativeness in his works are directly indicated to

us. In actuality, this is not entirely unrelated to the fact that Choi Wool-ga's works are compared to 'anarchist worlds', 'basic genuineness' and 'primitivism'. In addition, his screen continues all the way to the sides of the thick canvas, and expands his world to allow interpretation of a 2.5 dimensional world. It cannot be restricted with a frame and therefore glorifies the freedom of his painting which cannot be suppressed or subdued by anything.

The author says that 'people forget the fact that they live only a day'. The intention of this is to dispossess the mythical privilege of time which contradicts reality and it attempts to make its audience think in retrospect about daily life which has become mystified. Quoting from Roland Barthes modern myth is 'everyone expects it and forgets about it'! . He states that it is seen as something natural and obvious, so that nobody thinks twice about it. The paintings of Choi Wool-ga do not directly bring up social issues, but it may be more introspective than reality. Petty objects and pets in daily life such as fish tanks, fish, cats and dogs, cacti, liquor bottles, cars, watches, watermelons etc are not normal in his perspective. In his perspective, daily life falls out of our view as soon as it stars, and attempting to speak on behalf of it is just too commonplace. Therefore, it is not important to try to construe the world of objects and people on a small space as that of a canvas to him, but instead existence at the moment within an object of the world is what is imperative. The forms which have been almost disintegrated into but a sign that strips daily mysticisms actually reflect the rejuvenation of the forgotten history of daily life. Each of Choi' s works epitomizes his daily life. In addition, we think about our daily lives through that of the painter's. The real value of Choi's paintings is that it is released from the unanimated restrictions of daily life and confronts it with a living, breathing life. Passing that of a representation of an object, we can come to know that his lines and colors are not restricted by formalities and we can feel the great artistic energy in his paintings. Choi Wool-ga's paintings, which extract our ubiquity for human life to breathe life into it, are actual traces of his own energy.

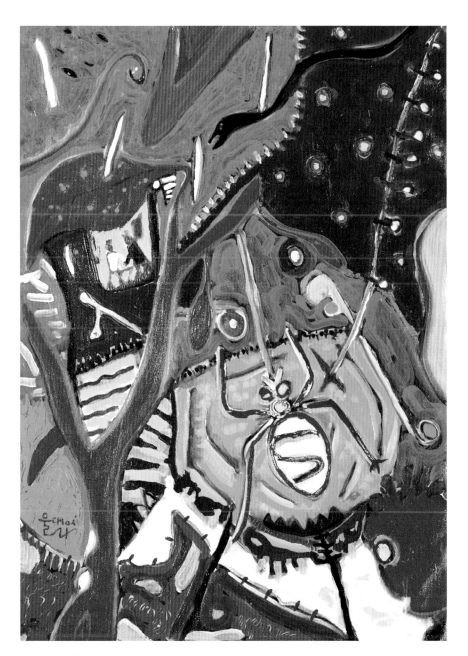

A Story about Home
Acrylic on canvas, 45x60cm
1994

Childhood Remembered in the Flowing Thoughts

Kimura Sigenobu
[art critic]

"In the Korean Fine Art in 1990's - Story about Mannequins" has been held at National International Museum until January 26, and since January 24, Choi Woolga Exhibition will be held at ABC Gallery. It is not a simple coincidence, and the nature of exhibition is quite different from each other. Choi Woolga resides in France, not much associated with the trend of the Korean contemporary fine art.

Nevertheless, Choi Woolga's works (painting style) is not of a French style. In the French fine art community respecting the refined senses, his works are very heterogeneous, their forms are rough and colors are intense. To be more specific, he may belong to the 'primitive' sect similar to 'art brut' (art natural) championed by Dubuffet.

Choi Woolga sings, "Those who were all kids long ago. Why are they not willing to recollect his childhood?" To him, painting must be equated with recollection of his childhood to which his memory flows. Accordingly, in his paintings, every object is encoded like children's scribbles. Like fragment of bone, tree and shrub, fish and animals... Although they are encoded, they are never revealed as objects themselves but float after the process of metamorphosis. Namely, such signs are not readable because they are accompanied double or triple by other images. Upon observing such cipher-like signs, the audience must feel a secret of life.

'Not the phenomenon of the nature but its fundamental life.' This is the secret of the fairy tale-like poetry sung by Choi Woolga alone.

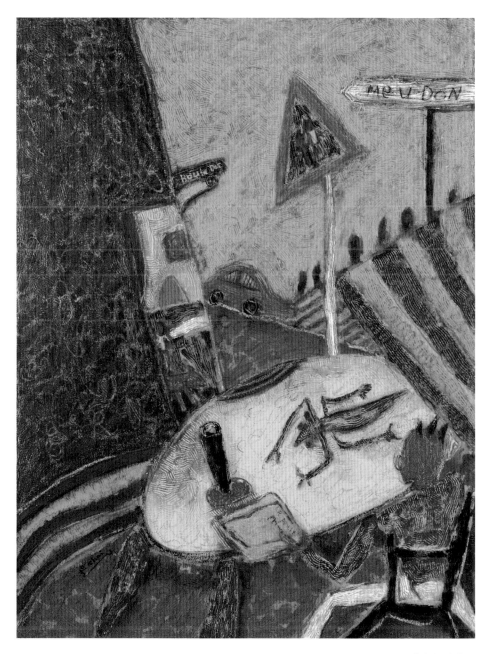

Cafe boule D,or
Acrylic on Korean paper, 51x69cm
1994

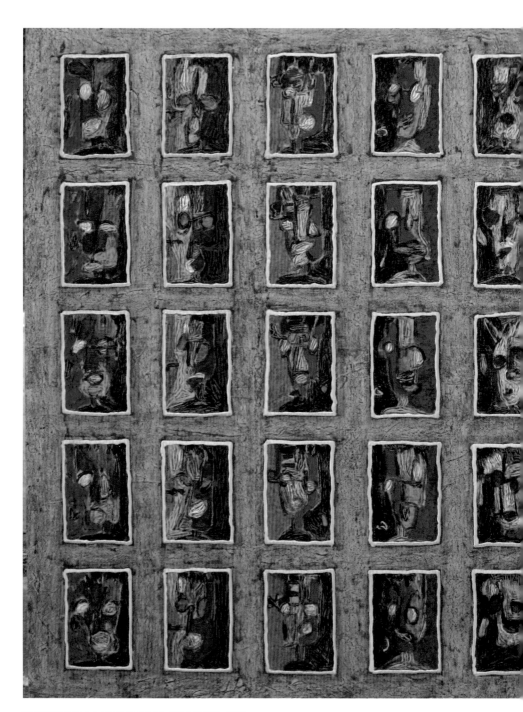

50 Peoples' Faces, Acrylic on canvas, 181.8x259cm, 1996

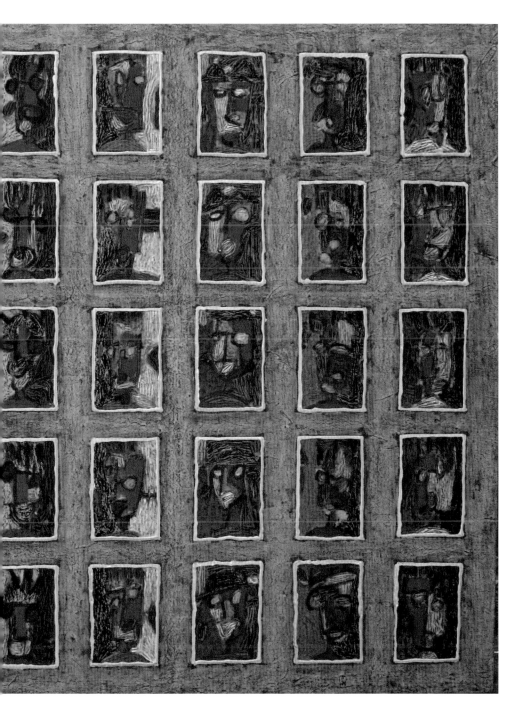

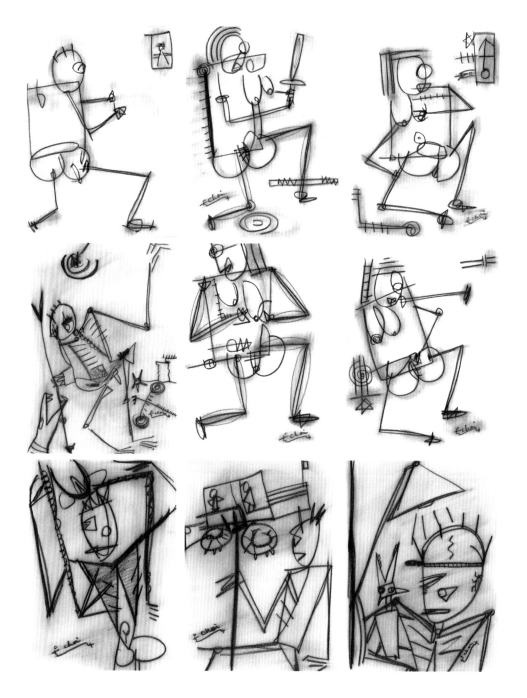

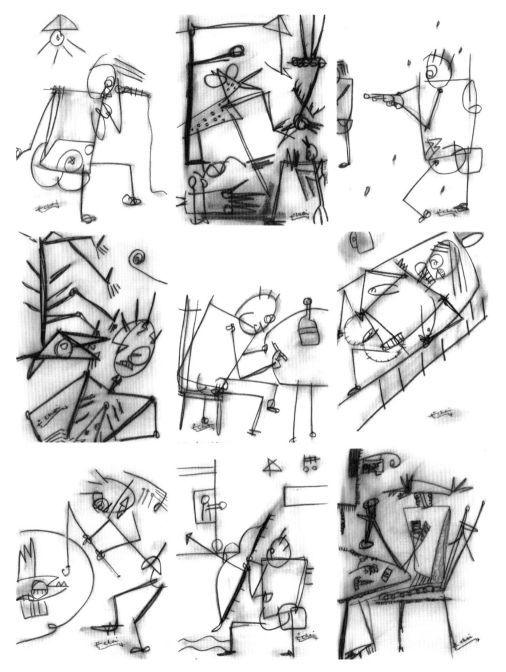

Dessin Series
conte on paper

A Rural Yard
Acrylic on Korean paper, 97x65cm
1994

Memory Series
Acrylic on Korean paper, 20x25cm
1994

A Journey on Desert
Acrylic on Korean paper, 95x130cm
1994

Choi Woolga's Paintings
- Infant and Epic Painting Diary -

Kho ChungHwan
[art critic]

In his book titled "A Theory on Aesthetic Education," the German aesthete Schiller divides the human nature into reasonable and emotional impulses, and he argues that a third impulse or play impulse mediates these two impulses to lead men to perfect personalities. While reasonable and emotional impulses aim at certain goals, play impulse is oriented toward the purest and most innocent forms. Thus, the author finds in such a play impulse the power of engine of art as well as the ground for aesthetics. According to his argument, play impulse is a moment of life or existence enabling a perfect personality as well as a moment of art.

In a pure sense of the word, play and pastime have no decisive rules unlike the games. Although there seem to be some rules, they are arbitrary and voluntary, not controlling the pure enjoyment and pleasure through play and pastime. Like the forms of art, the rules are pushed up to the outside by players' some internal need for a better play. So, they may well be nothing more than the moment which can be modified, complemented, abolished or corrected anytime. Play and purity go hand in hand in such a way. And superficially at least, the logic, namely the equality of play and purity is nearest children's scribbles. Usually, the scribbles expressing what they see or imagine as minimal lines simply contain the essence of objects (for example, structures) and even subject's instant and sometimes, continual emotion therein. The rock-inscribing paintings or the cave wall paintings at the dawn of human civilization or during the Paleolithic age were the prototypes of such scribbled

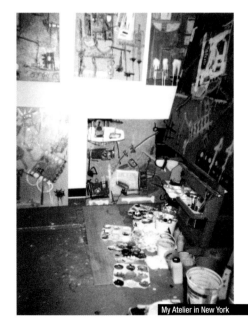

My Atelier in New York

paintings (those produced at the dawn of one's life), which would lead to the paintings featuring a strong drawing tendency in our contemporary fine art.

At a glance, we can see that Choi Woolga' paintings are on the same line as extended from with such Paleolithic rock-inscribed paintings, children's scribbles and those paintings showing a strong drawing tendency. And his paintings are more or less affected by or akin to various tendencies of fine art: such French free configurative artists as Jean Dubuffet, Pierre Alechinsky and such American graffiti artists as Keith Haring and Jean Mitchell Basquiat. Within the scope of such influence and affinity, Choi Woolga seems to pursue his own unique painting style.

Choi Woolga pastes his canvas thick with the colors, mostly the white color. And no sooner the pasted layer or color has dried up than he performs drawing using a pointed tool on the canvas. Although the layer is not much thick, the resultant painting would resemble rock-inscribing painting or low relief. And he also uses other pigments, crayon or pastel for painting. In most cases, he demonstrates footloose and fancy free drawings or lines not reigned by any form. From these series of paintings, we can confirm that although they are in certain forms, they have various characteristics of children's scribbling paintings. For example, such grammars required of the descriptive paintings as perspective or value are broken up, and as a result, we can find in his paintings a tendency of planar painting at a glance. Various painting elements, such daily objects as clock, flower vase and piano, such animals as dog, such traffic vehicles as train, and so on. All these objects seemingly not related with each other co-exist on his canvas imperturbably. The boundary between daily and common-sense contexts has collapsed, and in addition, even a daydreamy vision derived from imagination does not hesitate to intervene. The fancy dreams rising up before the canvas (for example, recollection about the past journeys) and the objects visible are mixed into one. Further, various elements emerging in the painting are not distinguished from each other in terms of order, superiority or weight. The objects neither related with each other nor distinguished or different from each other in terms of their intensity or weight seem to float over the plane as if they were swimming in a non-gravity space of vacuum state.

The artist seems to make us envision Laotzu's statement that as the human misery is attributable to knowledge which in turn is attributable to distinction, we could recover our happiness only if we could withdraw from (overcome) the distinction, or Foucault's

insight that every distinction is arbitrary and out of one's volition, or Lacan's conception about infant's self-sufficing stage of non-distinction before his development from the imaginary to the symbolic (a stage of discernment and distinction by agency of symbols and language). Of course, it may be more or less unreasonable to interpret Choi Woolga's paintings as a logical conclusion from a serious self-introspection in line with such humanity science theories. Anyway, it is apparent that the artist sympathizes with such theories in an unconscious stratum, and furthermore, that such a sympathy is supported by his innocent vision like children's (or desire for destruction of forms?).

The numerous lines crossing the canvas and the objects hinted by the lines combined serve to highlight the two-dimensionality of his paintings, while extending even outside of the plane. Namely, his canvas is felt like being cut out rather than completed, or it is felt like a part rather than a whole. His paintings expanding even outside infinitely or the impression of having torn off a part of reality reminds us of Baroque paintings. (While Renaissance fine art was self-sufficing and completed, Baroque fine art was based on expanded forms.) On top of all these, the artist's paintings expand even to the frame of the canvas. The canvas itself is self-sufficing for itself rather than a background for an image. (For example, the canvas itself is seen as a form of object.) He realizes an ambiguous meaning by demolishing the boundary for the conventional frame (expanding it outside the painting unreservedly) to emphasize it (admitting the unique properties of canvas or the limited frame).

Sometimes, the artist arranges a certain formative mechanism to control the canvas hinting the unreserved expansion outside the painting. The example is the color plane embracing the whole edges of the canvas or parts of them in his recent works. He tunes his canvas by contrasting the color plane (static mechanism or element) introduced partially with the drawings penetrating the paintings or the fancy free lines (dynamic mechanism or element).

Choi Woolga's paintings have the themes dictating or hinting play and daydream in many cases. And the themes are the core concepts supporting his paintings. Play avoids either artificial form or canvas composition as much as possible, and instead, reflects artist's will to pursue a painting detonated spontaneously by an internal moment or inevitability. And the resultant paintings are footloose and fancy free drawings rather than children's paintings per se. The objects emerging on the canvas are not related with each other in the context of daily life uses or common sense, but

they get along well by agency of artist's imagination, revealing a innocent world of no distinction. Another core concept or daydream which supports artist's paintings implies a vision that the boundary between daily life and ideal has been demolished for cross-trespass between logic and its leap.

Through such a leap or vision, the artist unfolds a sort of infant and epic painting diary, hinting a fairy tale for adults, namely an unending story not interrupted. And through the story, he urges us to retrospect on what we have been deprived of, what we have lost and what we could not recover, inducing us to be immersed in the nostalgia for the innocent and naive days.

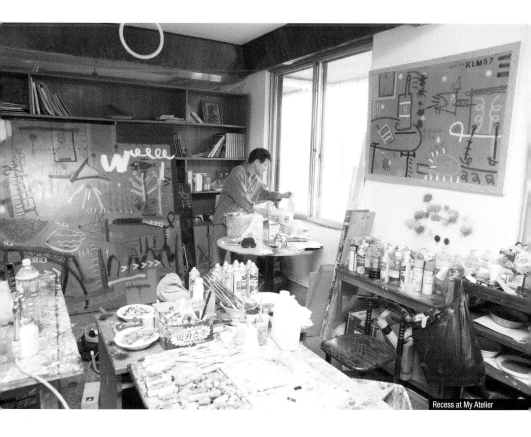

Recess at My Atelier

Reading Le monde
Acrylic on Korean paper, 100x82cm
1994

African's Meal
Acrylic on Korean paper, 21x29.5cm
2000

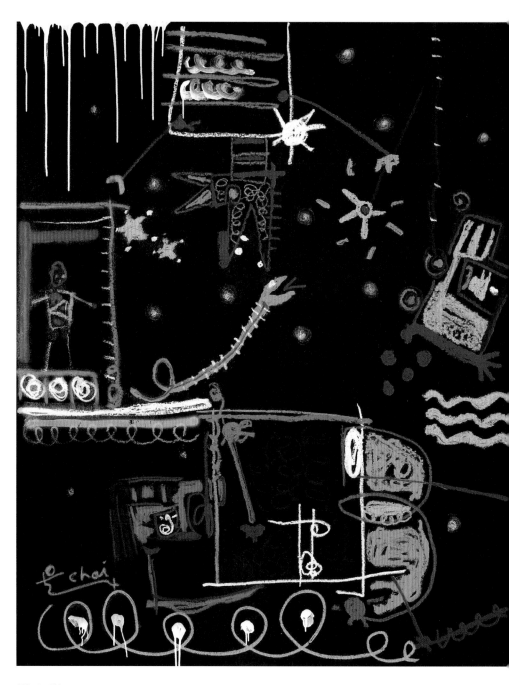

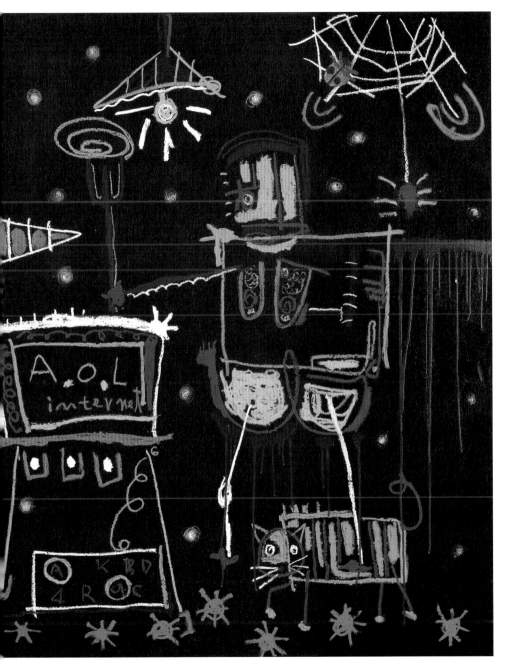

Everything of New York
oil on canvas, 259x193cm, 2001

Base Painting in New York
crayon & pastel on paper, 21x29.5cm
2000

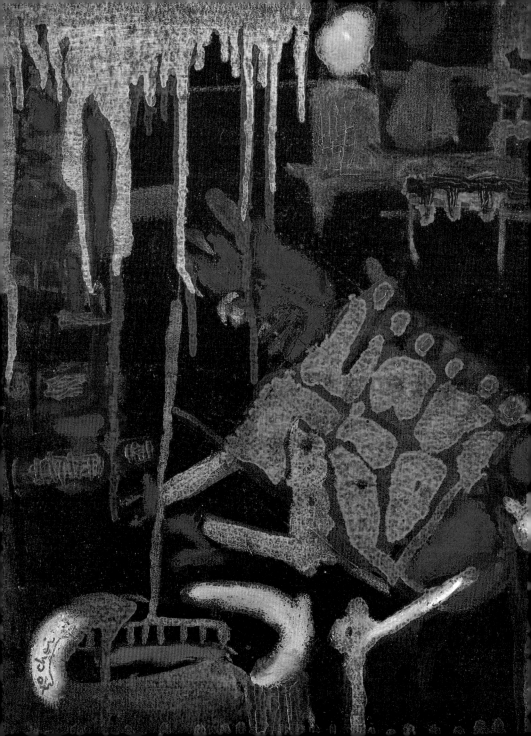

Cleaning
oil on canvas, 45x37cm
2001

Anarchistic Choi Woolga

Lately, Europe has undergone many changes. As the Soviet Union disintegrated, various new nations were born. The Eastern European nations who had been trapped in the darkness would begin to fall in the sweet capitals, being reigned by them, only with the slogan 'Toward the Future.' In contrast, such Western European nations as France, Germany, Spain and Italy began to adopt various socialist policies, focusing on the social welfare policies rather than individuals' comfortable life. The dark-faced messengers were collecting the tax from every businessman and worker without even an error of one EURO. Thus, both newly and conventionally rich people were losing their wealth gradually. As a result, the cultural contents would be worse as 10 or 100 times as before. On the other hand, the Asian nations including China were overflowing with indifferential capitals and labor force, and their cultural contents were appalling. Among them, paintings or picture industry was attracting more capitals than any other genre of culture.

Such Asian nations as Korea and Japan might be influenced by the huge China. Meanwhile, I could have many opportunities to meet the Asian artists. The paintings championing the realistic realitism popular recently in China were pouring out as if the water contained in a reservoir were pouring out as the dam collapsed. I have no idea how long such a boom would sustain. In any age, good artists or those entitled to be recorded in the art history were only two or three, but now in China, the artists whose works are priced between tens and hundreds of thousand dollars exceed a thousand, and thus, a variety of collectors are buying Chinese paintings as if they were diamonds of the future.

While observing the Asian fine art communities with some skeptical view, I happened to see a Korean painter's works. I even doubted my eyes for his fresh works. Quite

Jean Piere Taldare
[art critic]

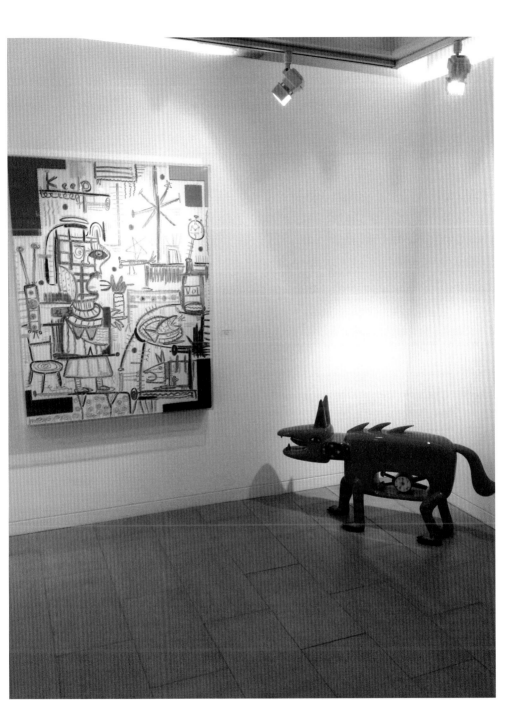

My Atelier in New York

unexplainably, his paintings were very joyful and humorous.

When the Korean fine art was dominated by abstract images in fashion, I met Choi Woolga's paintings. Honestly speaking, the contents of his paintings were not about unprecedented issues or subjects. Nevertheless, what fascinated me was freedom of forms.

The freedom was being evoked within the framework of modernization by some primitive way of thinking that could not be easily conceived by our modern men who are dominated by the modern knowledge. What is visible is apparently of the contemporary fragrance.

However, what is hidden in the contents is more fragrant. If interpreted mistakenly, his paintings may be misunderstood as children's ones, but his painting behaviors themselves are never near children's behaviors. Even if his painting are not processed actually, they may be produced according to some sophisticated calculations.

However, such calculations can never be perceived, and recently, his works seem to be more refined.

He literally freely creates the forms of thick colored texture within an enclosure as if

he were freely walking on the clay ground. Probably, his consciousness is not modern but primitive; the Paleolithic or primitive people who lacked the linguistic ability unconsciously created art as required by their society or as dictated by their senses. Such unconscious art may well be a basic human genre which would not disappear eternally.

We can find in his paintings a modern technique or abstract element, namely a seemingly slanted sculpture plane like cloth wrapper on the edge or outside of the canvas. I once asked him about it, and he quite unexpectedly answered, "When the kids are playing freely beside a creek, they would be dispersed or dangerous if they should not be watched. In order to allow them to enjoy their free play, some watcher should be near them. Then, the by-standers would not worry about their play. Likewise, such an abstract element in my paintings is essential to keep other elements of painting from being astray. It is essential for a sense of stability."
He added, however, that it was too hard and difficult to insert the rectangle or the sophisticated plane there.

Choi Woolga may have been dreaming of a perfection since his life in Paris. However, he could not realize such a perfection even in New York. According to him, he could enjoy a pleasure of perfection when he was sojourning in Japan for a month, working for Kita Gallery. His paintings would change quite due to such seemingly trifle rectangular plane to join the contemporary sense.

Anyway, he has established his own milestone among numerous genres, which is unprecedented in either China or Japan. As long as his daily images existing in the past, at present and in the future are not degenerated into ideas, we will continue to, I wish, find in his paintings a fresh sense of unconsciousness which can always be shared and perceived.

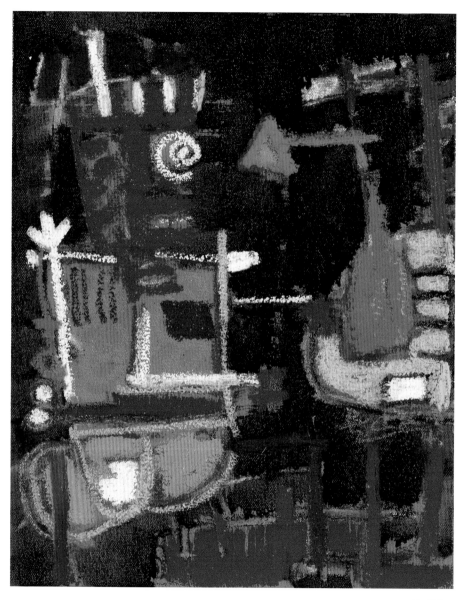

Meal Time
oil on canvas, 45x37cm
2001

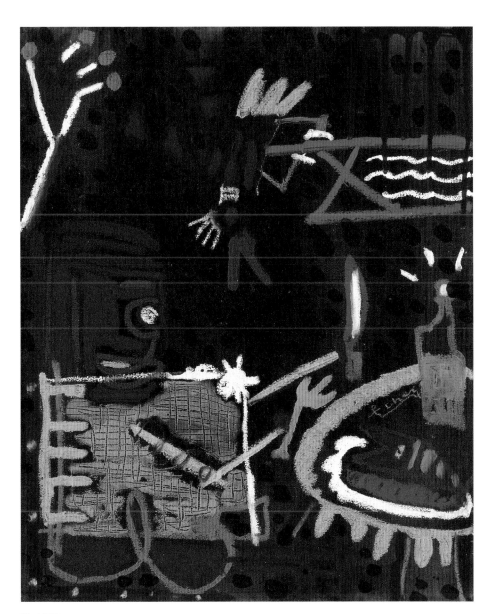

Meal Taking
oil on canvas, 55x46cm
2002

Base Painting for Line Work
Pastel & conte on paper, 21x29.5cm
2003 (each)

Time for Meditation
oil on canvas, 130x97cm
2003

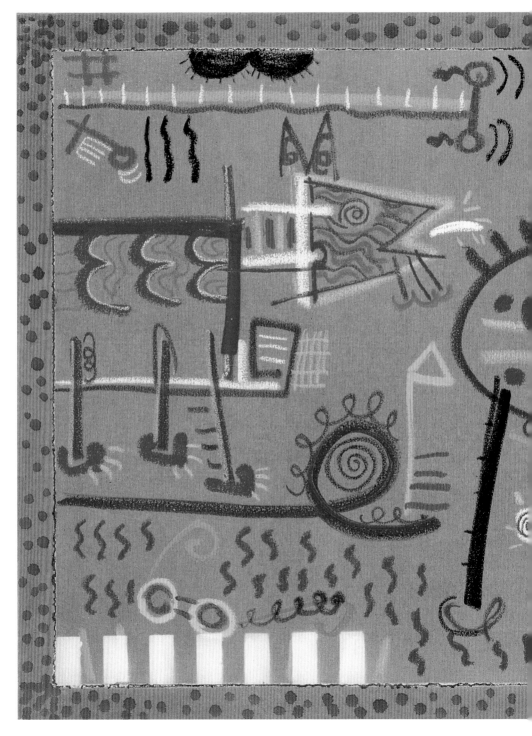

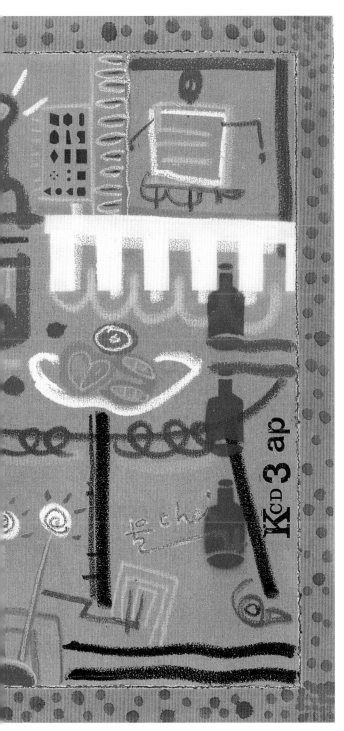

N, line Play Series(6) a snack
oil on canvas, 110x80cm
2003

A Footpath Leading to Choi Woolga's Primitive World

Choi Wooga's works feature intense colors, rich matiere and meaning, all of which cannot but attract our eyes. He shows his own unique path different from most of the Korean painters. However, I do not mean that he has allowed himself to be influenced by the European paintings eager to surmount the barrier of the contemporary art movement.

An art not processed... He draws his hierarchical imaginary world based on a deeper understanding of some paintings with their objects recovered or roughly drawn and thereby, shows us that he himself lives in the context of our contemporary life. A figure, half child and half adult, walks on a footpath, brushing between canvases.

While decoding the images and signs mingled among his canvases, the audience fall deeper into his works. Although themes and scenes accuse our civilization of its rigidity, his intensive color paintings dominated by red and yellow colors echo our possible future pleasantly rather than our explosive present.

In his diary, he tells us the imaginary stories written about his fear of the suppressed violent world. The scenes unfold like a film. Road, cafeteria, atelier, moments afar, imaginary memories like postcards... The scenes are characterized by poetic magic, lyrical places, period of vortex, footprints of fear, and so on. The artist hints some rest in his diary. The time-honored paintings dispersed here and there in a corner. The shabby and humble forms who do not seem to find their own ways. Where are they headed for now?

F.SIEFFERT
[art critic]

What we should not overlook is that his paintings reflect his childhood, and therefore, that he wish to return to his childhood or another footpath of hope dominated by primitive instinct and ancestral fear. There, he finds the weapons forgotten and a way leading to nature, future and eternity.

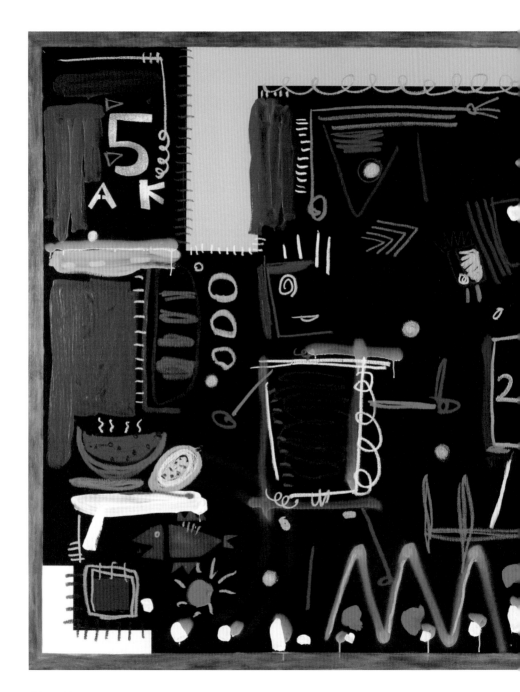

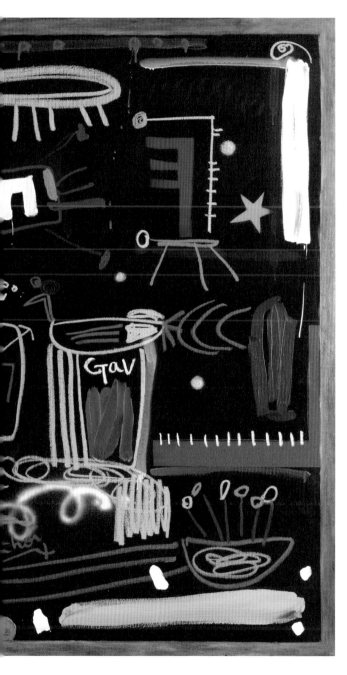

Searching for Mom in New York
oil on canvas, 259x193.9cm
2006

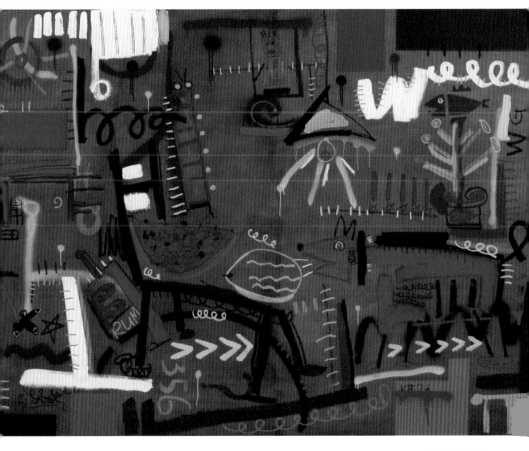

K, Black Series
oil on canvas, 259x193.9cm
2006

K, Black Series
oil on canvas, 259x190.9cm
2006

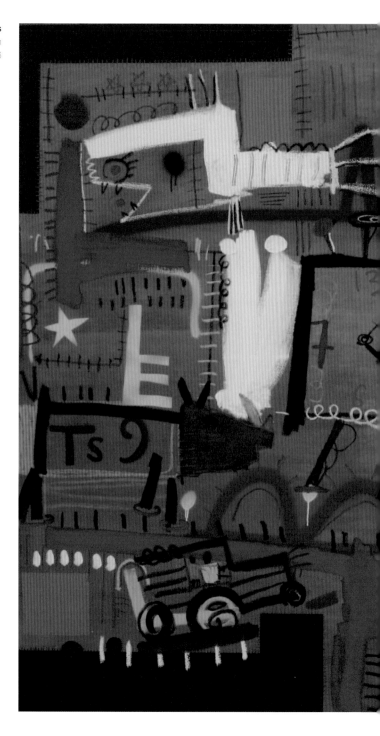

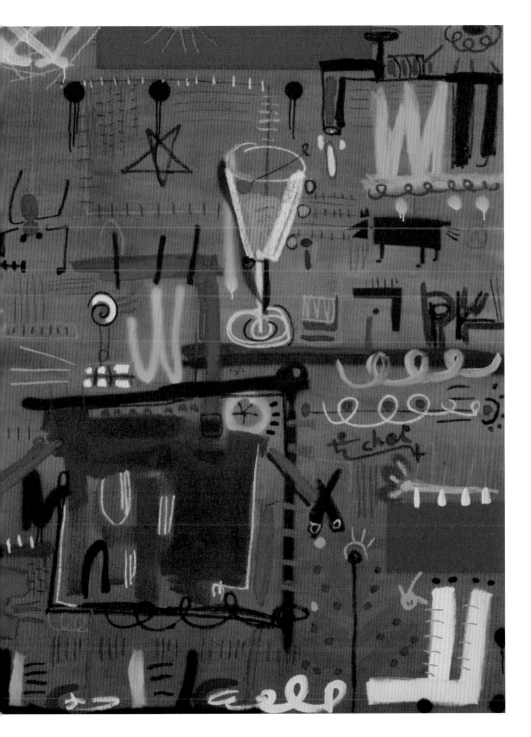

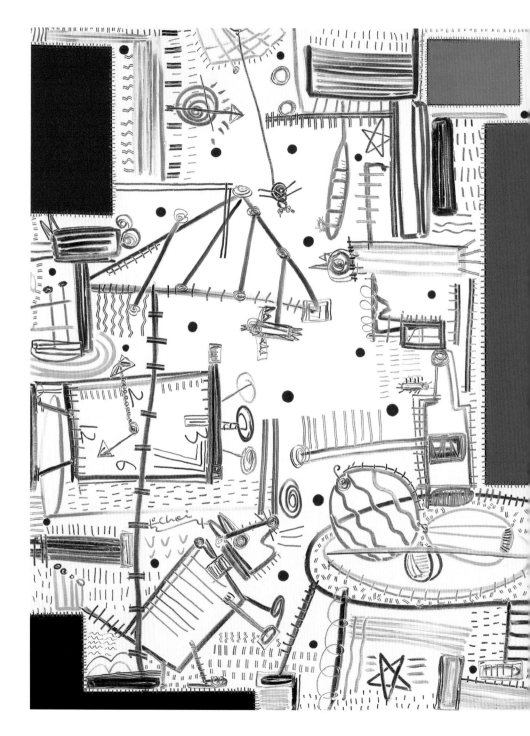

My Atelier on A Summer Day
oil on canvas, 160.2x130cm
2005

Choi Woolga's Colors and Spirit

M, GALERNEAU

Until recently, Korea had been a land of virgin as far as the contemporary art was concerned. Now, Korea is no longer a land of virgin. Since several years ago, many artists enviable in terms of talent or imagination have been born beside the river of art or in Europe. Choi Woolga who is still young as artist has a long background of his own for his creative art.

First, he implemented some realistic fine art. His works in mid-80's hint that he was an Expressionist. The characters deformed and colorful represented his inner pain. However, his grammar of colors testifies to the artist's will to transcend his own expressions.

It is believed that he will approach such a stage at a very rapid speed. In 1989, we could see the endpoint of his desire or transcendence. He would use a new technique with wide and heavy lines and hard matiere, while choosing the blue color tone highlighting the color of fire as well as the palette dominated by the color tone in an effort to create a true form of Fauvism, Pointillism and Expressionism combined.

At the moment, a Neo-Fauvism movement was exploding in Europe. He would not fall into a taste given free out of his challenge but reach the same results as theirs by using his intuition into the modern spirit. However, such violent and unstable period would not last long.

It is expected that Choi Woolga will continue to develop his technique steadily by using more pleasant themes, loving the nature and focusing on the human will in the nature. The colors he uses are more pleasant, changing into purer ones.

He has changed from oil paintings to acryl and crayon paintings on the canvas, and

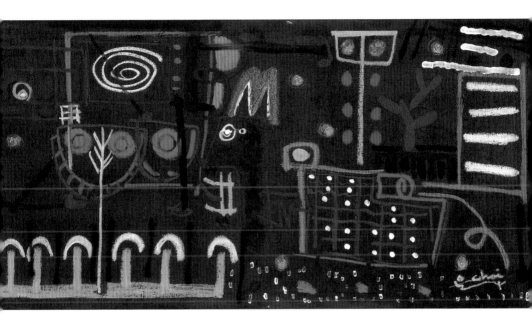

such a technique is his favorite one to unfold the vision of objects more favorably. Choi Woolga reflects his own cognition on the fragile world of his works. First of all, he pastes paper on his canvas and thereby, uses it as a scribbling board like playful children's ground. Representation of children's world is both recreation and play for him.

Through such plays, he learns about children's life.

Colors which seem to sing, negation of communicative signs, concern about reality, and the works attached to the scribbling board (nostalgic media), or the works surrounded by such symbolic TV screen (modern media)... Choi Woolga depicts his own age with them.

The themes and aesthetics of his works prove such attempt of his. Since his works are already there, they are immersed enough in themselves to talk about the contemporariness.

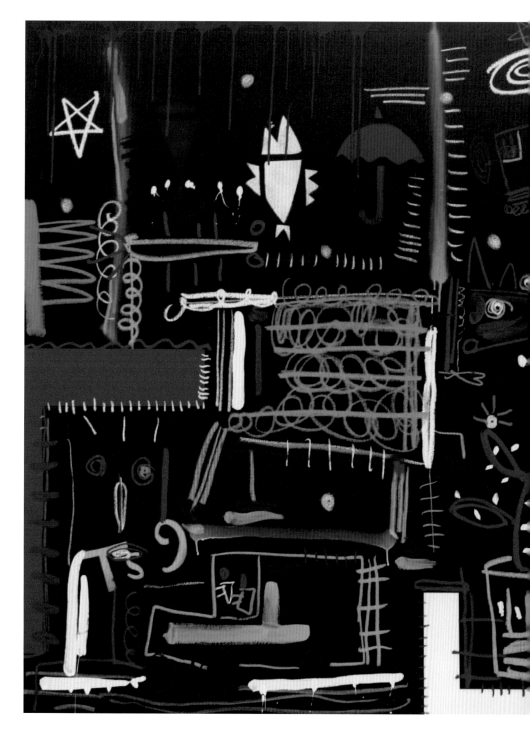

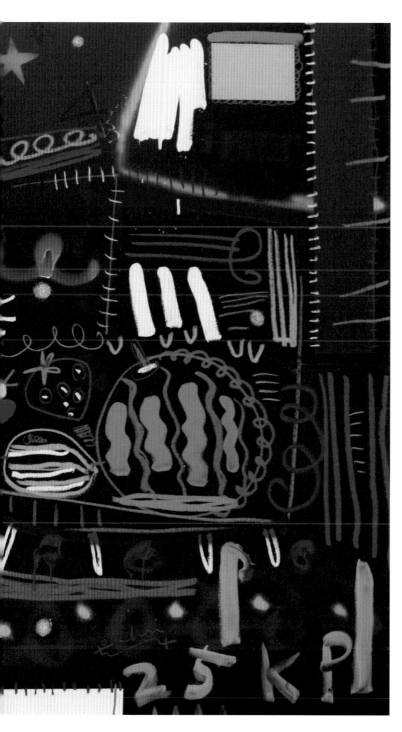

K, Black Series
oil on canvas, 259x193.9cm
2006

K, Black Series
oil on canvas, 259x193.9cm
2005

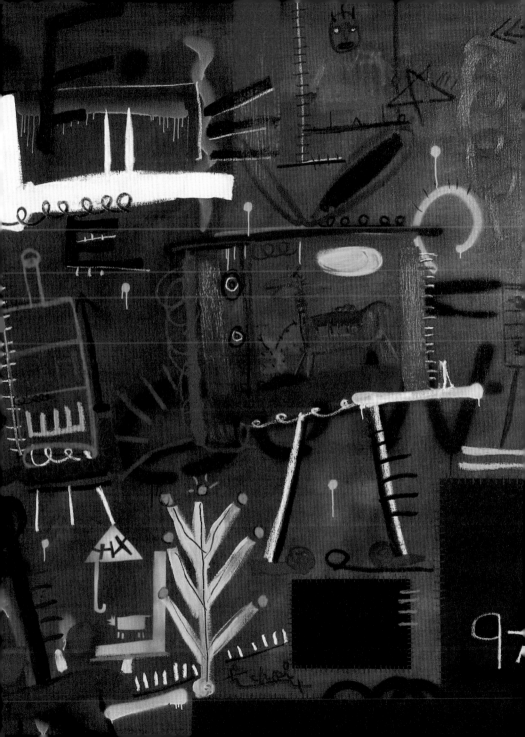

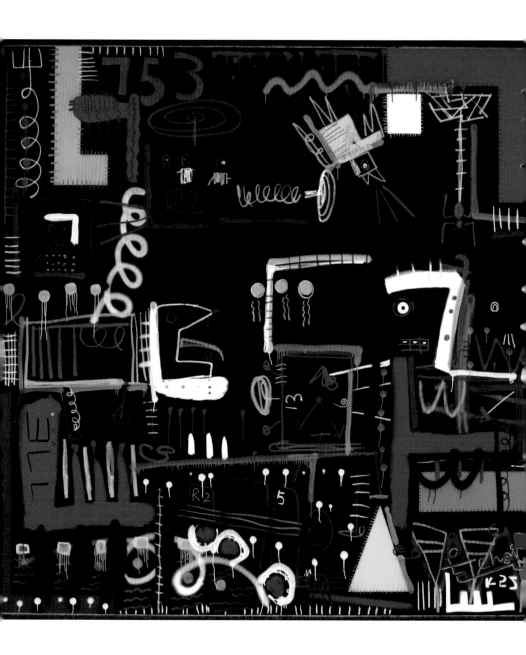

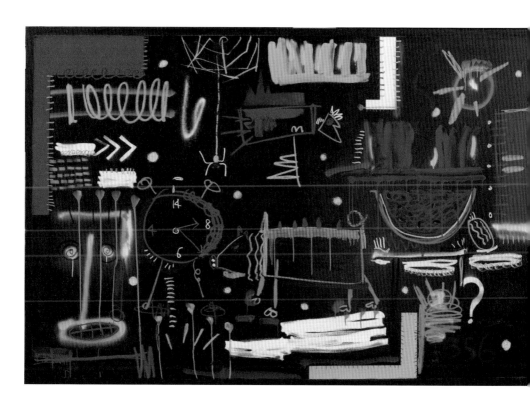

K, Black Date
oil on canvas, 380x380cm
2007

K, Black Series
oil on canvas, 259x193.9cm
2007

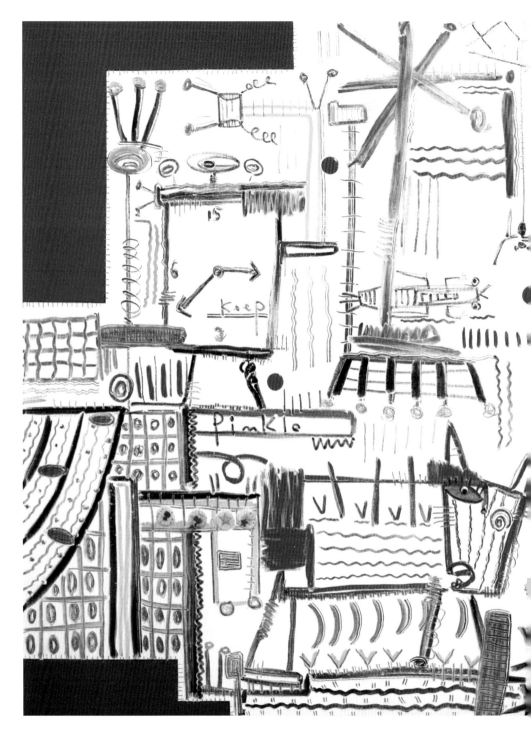

[White Play Series] Be on your guard!
oil on canvas, 112x163cm(seoul)
2008

The play of Perfect Black
oil on canvas, 100x40cm
2008

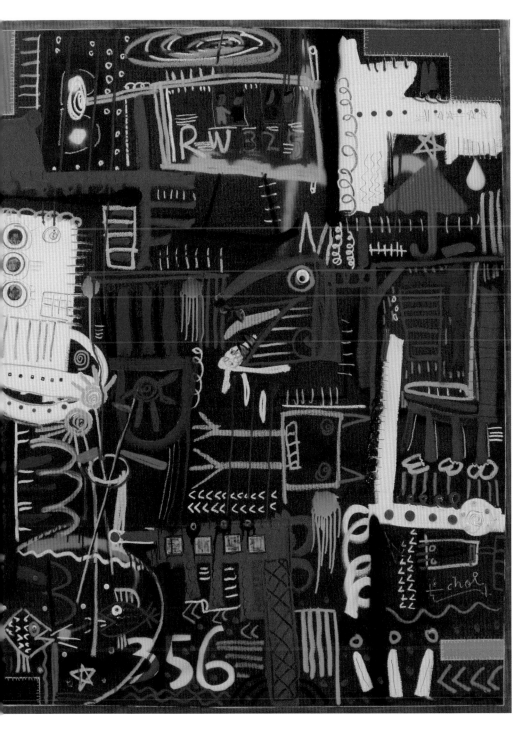

An Ultimate Sense of Aesthetics Suggested by Weightlessness

Lee JaeEon
[art critic]

It is only a decade since Choi Woolga's (real name: Choi Youngdae)?paintings were introduced to our fine art community. Still, his name is not so familiar in our fine art markets. Since he had lived overseas for some two decades, he participated a little belatedly in our domestic fine art community, and moreover, his painting style has not much appealed to our emotion, indeed. In addition, even his pen name seems to play a role in having him distanced from our fine art community. Woolga sounds a name of a man far from Eastern Europe or Central Asia, although it sounds like our native word 'Woolbo', too, meaning crybaby.

Anyway, such a sense of distance has not so positively acted for appreciation of his paintings. Today, unique and individualistic forms are much common, but even during late 90's when he showed up in our fine art community after a long overseas life, such forms looked unfamiliar. Footloose brush touches and line drawings like kid's scribbles, unpredictable primitive energy, weightless sense of space, dreamy fancy canvas..... Such unique features were strange but they have helped him to outstand in our fine art community.

The artist's activities before his entrance into our fine art community are veiled much. He had sojourned long in France and would happened to come to Japan, and his successful activities in Japan were bridged to our domestic fine art community in a natural way. One day in 1997 when I happened to meet him at Insa-dong, Seoul, he had just come to Seoul after his exhibition in Osaka, Japan. Since I had heard a news that his paintings had been sold out at his tour exhibitions in Osaka and Kyoto, I was very pleased to see him, wondering what he would say. Then, owing to the successful exhibition tour invited by Asahi TV, a series of exhibitions in Japan were waiting for him. It would be later that I came to be aware that such successful activities had not been easy or accidental.

In fact, his paintings are very sensitive, showing some literary senses, but the prevailing view was that they would appeal more to the Western audience rather than our Koreans. Due to such obsession, he may not have been interested much in our domestic fine art markets. Nevertheless, a series of his exhibitions in Japan hit the markets there. Maybe, the Japanese audience sensitive to a variety of foreign forms were more friendly with his works than we. I remember that it was his success in Japan that our domestic fine art community began to pay attention to him. Anyway, the artists would find a wider base of his fans later in Japan, and thus, he would expand his activities into Paris, German cities and New York.

When his free and unique paintings were introduced to our fine art community, they were accepted as a fresh shock. Although our fine art community has been like a martial art ring with diverse pluralistic forms appearing and disappearing, there have not much been the forms giving a fresh shock to us. During 90's, our domestic fine art community witnessed the long standoff ended under the name of collective individualism in favor of experimental and individualistic art, but at any rate, it was necessary to conclude a period of fine art. Then, Choi Woolga showed up to introduce to our fine art community the canvases combining creative energy and insight into a Zeitgeist; we could not but be impressed with his footloose and fancy free expressions and genuine power of painting as well as his passion and energy.

At a glance, his canvases are reminiscent of New Painting or Trans Avant Garde represented by Basquiat or Baselitz. The clues are fancy free and awkward forms like scribbles, color tones rough and energetic, dark shadows little unexplicable, gloomy and apocalyptic contents, and the like. However, the artist's paintings seem to be different from those dreamy or schizoid ones. Rather, his paintings explore a therapy for the pathological modern world.

Of course, from a therapeutic viewframe, his paintings still look deconstructive and unstable enough to evoke a sense of uncertainty and chaos. Nevertheless, the artist seems to be somewhat cautious about such attributes as may drive him into a certain sect or category of art. Concerning this bone of issue, it would be reasonable for us only to review characteristics and attributes of his art opposing the attempt to evaluate his paintings with the scale of New Painting.

The artist's canvas reminds us, first of all, of the freedom of expressing his

unconscious desires and imagination as much as he pleases. Since a structure of certain icons and patterns repeated can be found in such a freedom, we may well interpret that his works are obsessed with autistic nostalgia and impulse of play. Such duality is converged onto a painting concept and motto called 'weightlessness.' We human beings who are doomed to experience gravity dream of non-gravity mentally and physically. I once was concerned about the universe on the occasion of an event for selection of would-be astronauts organized by a local broadcasting company I involved. Then, I used to dream of myself floating in the weightless space.

"We never want to feel a sense of weightlessness in a state of non-gravity
We just want to be conscious of weightlessness in the state of gravity.
This world not allowing for such a consciousness.
Not requiring the energy
Everything not spoiled..............
May I be dreaming
A short dream at dawn dreamt of even now
Like the endless orgasm of possession crossing the blue ocean.
I have to show that a weightlessness exists in this world"
- Quoted from artist's note

The concept of 'weightlessness' mentioned by the artist at various points may be read as a polysemous metaphor. I mean the metaphor for physical limitedness of time and space as well as for supernaturalness, mixture of first and later events, ontological resistance to the inborn burdens like the Sin or destiny, epistemological skepticism or criticism about the established order or value immanent inside us. The artist suggests that his creativity is premised clearly on the state of gravity or reality and history. Weightlessness is an important key to understanding of his works. It is a concept differentiated from an equivocal state of chaos or deconstructivism, and therefore, it may well be an important clue to prevent us from dismissing his works hopelessly as a trend of art.

Even as recently as 90's, the ontological weightlessness and the epistemological weightlessness were summed up into a creative order of space. The link between space and object is disturbed, while the spatial hierarchy of common sense is overturned, in favor of a visual weightlessness. When we review closely the secret forms and gestures like child's grumbles on his canvas, we will enjoy some interpretive

Together with Nakahra

spice. The objects appearing on his canvas are mostly of the ordinary landscape. However, they would look humorous due to deformative and weightless composition, while hinting some surrealistic crudeness and existential seriousness. We can confirm that his canvas does neither negate the gravity itself nor abolish such formal elements as minimum modelling or composition.

In case of his paintings using the TV as object which have been frequently drawn, the images shown through the Brown tube are very random, crossing the threshold of its frame freely to float about. The audience who view the scene would be invited to an illusion of weightlessness, because the people slanted with their eyes suffering from the illusion and lingering effects are creatively recomposed to look weightless. At the same time, let's not overlook the delightful canvas; the landscapes of our contemporary age are rough and intense but vital and imaginative as if they were carved on the rocks.

Lately, the sense of weightlessness felt from his canvas has been expressed mainly by the line drawings near deformations. He scratches his canvas of white or dark base to draw lines or signs like scribbles. His canvas is reminiscent of the line drawings on the white paper by infants or kids using the color pencils. It may well be not wide off the mark for us to tell that his degenerative scribble-like images are in the same line with the primitivism characterizing the rock-carved paintings during the pre-historic age. Of course, we can hardly avoid the feeling that such a formative tendency is being

patterned or diagrammed. As the concept of weightlessness is being consolidated, he seems to be contended with the primitivism of his some reductive painting.

Now, we may confirm that such evolution into the two-dimensional painting conduce to acceleration of the weightlessness, dismissing planes or volumes in the genuine sense of the words. The line drawings by means of scratching may be equated with a temporal weightlessness because they look as if they were reproducing the rock-carved paintings during the pre-historic age. Just as the primitive men carved the contents of their common life on the rocks being dictated by their sense of aesthetics, so the artist carves his own diary on his canvas as commanded by his own sense of aesthetics. Yes, he carved his paintings rather than painted them.

Since his concept of non-gravity is premised on its relativity with gravity, the metaphor of weightlessness perceived from his canvas is calm, intricate and logical rather than impulsive, betraying our expectation. Upon reviewing his canvas more analytically, it is not difficult to find the traces of tuning it with a control and manipulation mechanism. As indicated above, his deformation and recomposition are intricate and compact, while his color tone activates some aesthetic code tacitly.

In particular, we can witness much that he treats the color planes not only with brushes but also with the scratches of diverse effects. As a result, the colors of the same category are appropriately tuned for more aesthetic effects. Of course, we know that the distracted color tones are intentionally created. Merely, it cannot but be interpreted that the nuances of diverse tones and effects are combined to reconfirm the premise of gravity. Given such interpretations, it may be difficult to make techniques and senses compatible with free imaginations and conceptual development, but they seem to be relatively well controlled and combined within the artist's capacity and experiences.

There may be numerous critical comments about his recent void canvas. While he attracted audience's eyes to his tacit forms and compositions in the past, he seems to replace them with a sense of void today. Since he weaves several lines loosely, the net called canvas would ensure free cross-encounters among diverse experiences. Our audience's experiences would freely travel between the knots of the loosely woven net only to exchange freely with the artist. We need to appreciate again whether the ultimate value of artist's weightlessness lies in such exchanges or not.

During Work

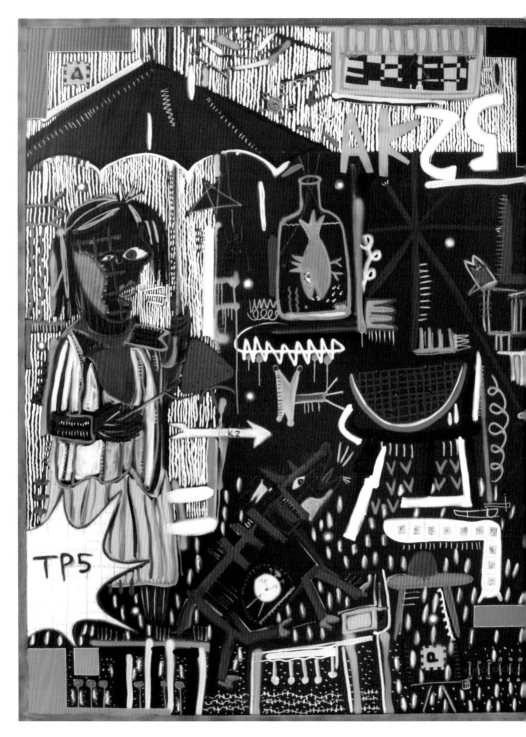

[XP Black Series] are you there
oil on canvas, 181x256cm
2005-2011

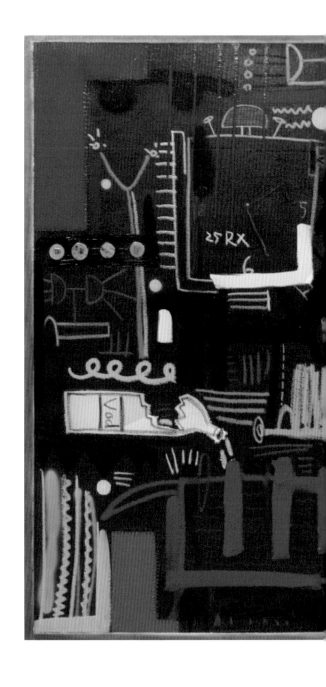

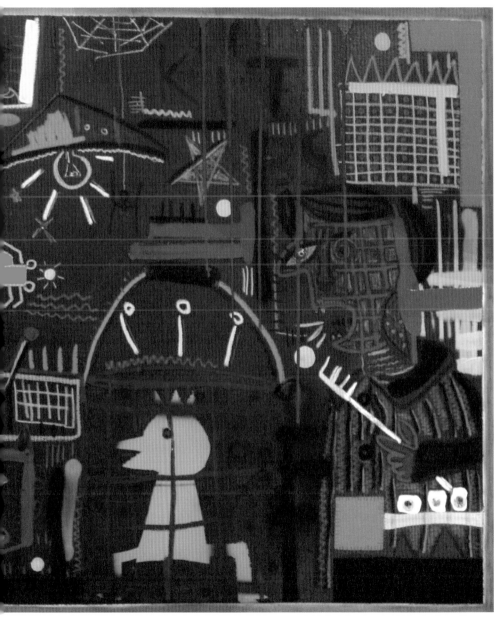

[XP Black Series] the space and space
oil on canvas, 112x163cm
2008

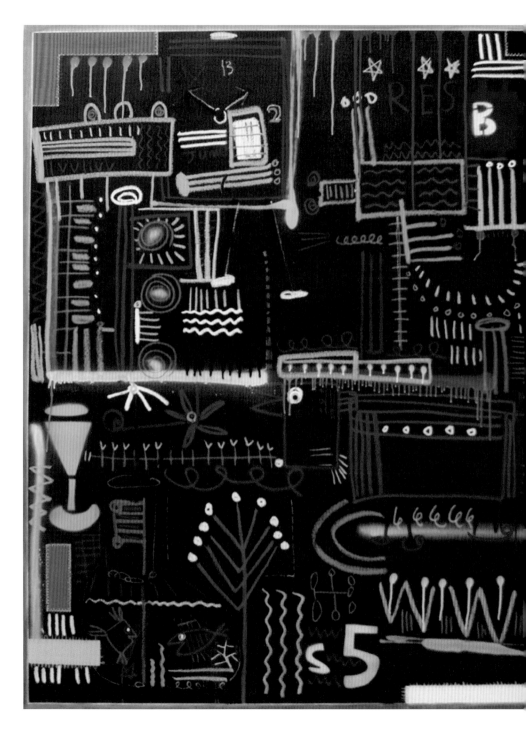

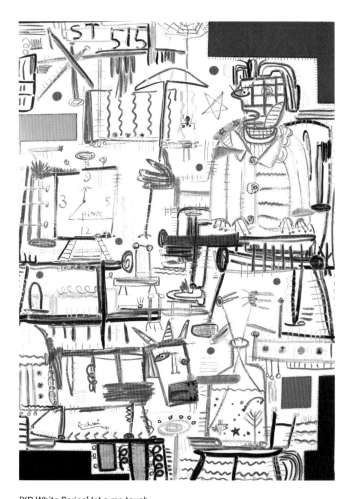

[XP White Series] let,s me touch
oil on canvas, 112x163cm
2008

[Black Play Series] Fish Bowl
oil on canvas, 136x163cm
2007

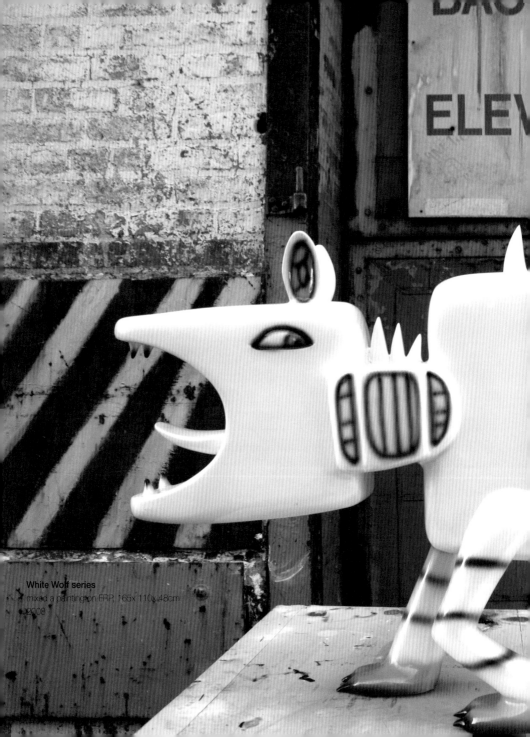

White Wolf series
mixed a painting on FRP, 165x 110x 48cm
2008

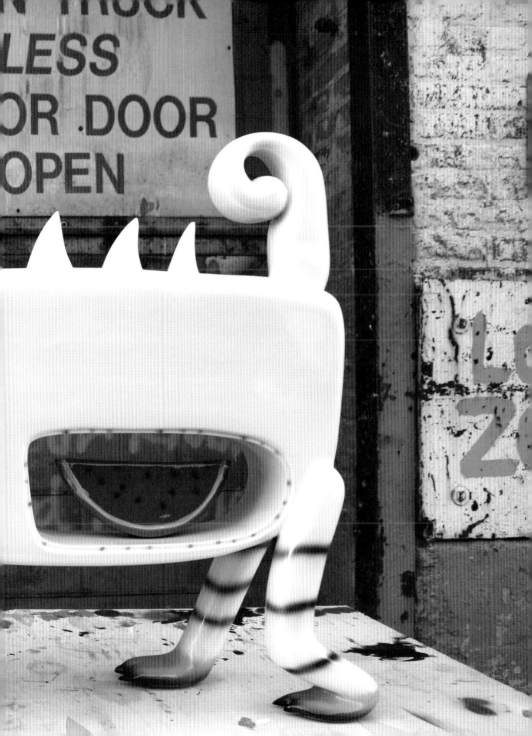

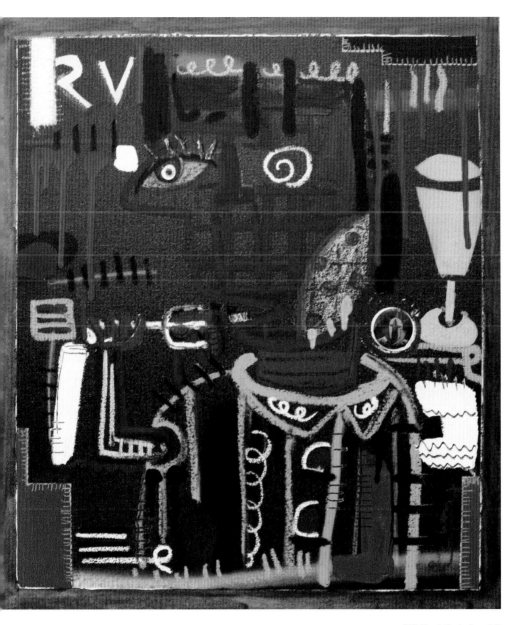

[XP Black Series] portait
oil on canvas, 53.0x45.5cm
2007

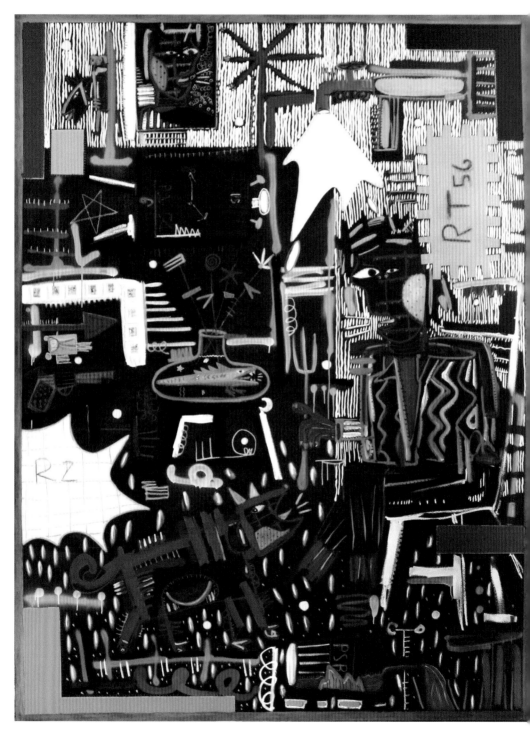

[XP Black Series] I am here
oil on canvas, 181x256cm
2005-2011

Paintings Drawn by Chasms - Choi Woolga's Paintings

Park YoungTaek
[art critic]

It does not sound unfamiliar that paintings are based on plays. Everyone began to draw and enjoy paintings during childhood, having lot of fun drawing something. We painted not only on the white paper but also on ground, wall and every plane accessible. The void planes were the attractive arenas satisfying our sense of curiosity, imagination and instinct for play, and they were felt like playgrounds actually. In fact, the school playground was a ground for both play and drawing. Everybody may well share the memory of having drawn the lines along the contour of the shadow cast on the ground or having made the forms with footsteps or other traces. The play of making or inscribing some images, although obscure, relying on texture and touch of earth,

might have been a primitive and vivid experience of fine art. Large and clear eyes and small hands were wandering amid the voids on wall and ground, which must be a beautiful memory. Most of the childhood is always spent so with wandering or roaming. Since the childhood is temporarily reserved before being controlled by rules, goals and forceful frameworks required by the society, the idle hands may be particularly free. Moreover, the pre-school children are not forced to learn about painting. However, such experiences and time would be lost and nullified when the children go to school, working hard to be admitted to higher education.

In Choi Woolga's paintings, we can feel the memory of free, soft and far-off primitive drawings before such loss. More specifically, his paintings harbor the yearning for such memory and the desire for keeping it. He would like to be a child. He wants to be an adult painter. His desire sounds quite contradictory on one hand, and comic and desperate on the other hand. Painters have to return to the days before they began to learn, if they have passed a certain period of learning. Their eyes should return to their original state when they faced the paintings for the first time, and their hands should also return to their original state grasping brushes and painting the colors for the first time. In a

nutshell, painters should become the men who face the world for the first time. Only if painters should always keep such primitive eyes and mind distanced from conventional or established ones, they would be good painters.

So, many painters would like to be children. However, it is very perplexed, hard and difficult to reach such stage or level. Our fine art community has witnessed various painters of strong personality: Jang Wookjin, Junggwang, Yang Dalseok, Choi Youngrim, etc. Lee Jung-seop's cigarette box silver foil paintings or postcard paintings and Byeon Jonghwa style paintings should not be overlooked, either. All of them succeeded in implementing children's painting elements into their world of painting. Even now, we can see many paintings yearning for such world of painting or reminding us of it. In this sense, it is perceived that the yearning for the paintings heart-beating not being affected by certain trends, fashion or discourses is very time-honored and eternal. Choi Woolga's paintings seem to be positioned in the same category.

In our fine art history, those artists who worked out the paintings like children's would join hands to launch a movement, which has been discussed as the paintings championing the primitivism or stimulating a sense of innocence. I remember that when urbanization, industrialization and progress of civilization were accelerated, such movement was started accordingly. It may have been a desire to return to such states deemed the original fine art as primitivism, simpleness, wildlife or innocence, or a yearning for a culture of anti-civilization and anti-mechanism. Looking back, the fine art history has always been dotted with the repeat marks due to actions and reactions between these two factors. Graffiti or new wall painting modes which emerged in the age of post-modernism may well be interpreted in the same context. The examples are Kaith Haring and Basquiat.

Their paintings negated the conventional fine art or the fine art system centered about the galleries and strived to return the fine art to daily life continuously. Simultaneously, their gestures might aim to make the fine art breathe freely within the net of extreme pedantry and logic or the systems of commercialism or professionalism. Of course, they did not conceive that their paintings were most ordinary and instinctive, not aiming to collapse the boundary between fine art and non-fine-art.

Choi Woolga's paintings keep Haring' or Basquiat's traces tacitly. Or they seem to be influenced by the French Neo-configurative artists. Choi Woolga bring about all such traces and influences into his paintings to draw/write his own unique story paintings. His paintings

are completed simultaneously with drawing and writing, while applying the painterly, scratch, intaglio/relief, letters/signs and images/symbols on an equal footing. Above all, his paintings confirm the base of the canvas which is painted thick to be playfully scratched, and at the same time, create some visual objects shaped by the voids thereof. The result is a contradictory situation that void becomes filled and vice versa. The traces revealed by peeling off the layers of colors would create drawings/lines.

He plays scratching by stick or spit rather than brushing. And he seems to enjoy his own experiences secretly by using a pointed tool to peel off the skin of certain thickness and height. So, his paintings stimulate our tactile sense much. In short, he seems to enjoy a queer pleasure of peeling off the textured canvas sensuously. His pleasure seems to be derived from his memory of such plays during his childhood as drawing, carving and inscribing with small stone, chalk, pencil or other pointed tools.

Choi Woolga finishes the surface of canvas into a monochrome color layer of a certain thickness and then, decorate the surface with line drawings. In most cases, he makes a thin/low base plane/skin with the white color and fills the plane/skin with innumerable forms and lines. Except for some objects recognizable, the forms are full of short lines. The recognizable objects are those objects and animal forms located in the space of the daily life. The examples are fish bowl, puppy, flower, automobile, liquor bottle, clock, fruit, and the like. They form parts of his own residence or have themselves associated with the universal human life. While such forms are depicted and scratched with unreserved drawings, the diverse lines between them are the straight lines or the lines bordered on an aerodynamic or triangular shape.

Some of them are reminiscent of antennas or electric signals. These forms and lines are similar to the cartoon-like images we had pleasure to draw during our childhood. Choi Woolga's paintings repeatedly show such special signs and lines of certain forms invented by himself, and he uses those signs and lines to produce ciphers and texts. Apparently, the images are overlapped with the indoor landscape, and thus, his paintings emerge as still, landscape or some abstract trajectory. Upon closing up, the images are placed somewhere between painting and cartoon as well as painting and scribble.

To reiterate, his paintings are positioned in a buffer zone between painting and low relief, while being tactile pictures and sort of wall paintings. They remind us of the traces or scribbles drawn inadvertently on the void wall or ground, or they are perceived as the

traces of the most instinctive and primitive plays of filling a rectangle compactly.

It is conceived that his desire of resembling child's hands and mind eternally young through plays and games or free imagination may have been melted down into his paintings. One of his challenges may be how to crystallize such thoughts, senses and hands without being obsessed with the fixed and stuffed myth of playfulness and purity of art.

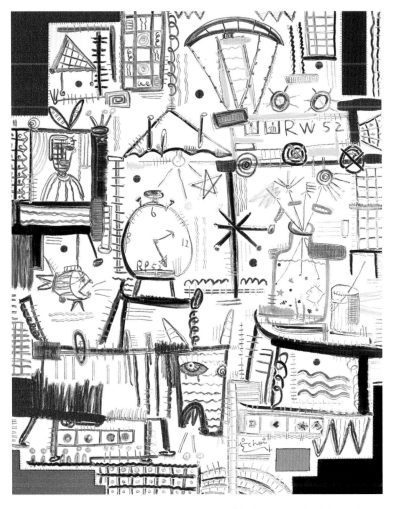

[White Play Series] fly of sky- in ateliere
oil on canvas, 140x100cm
2008

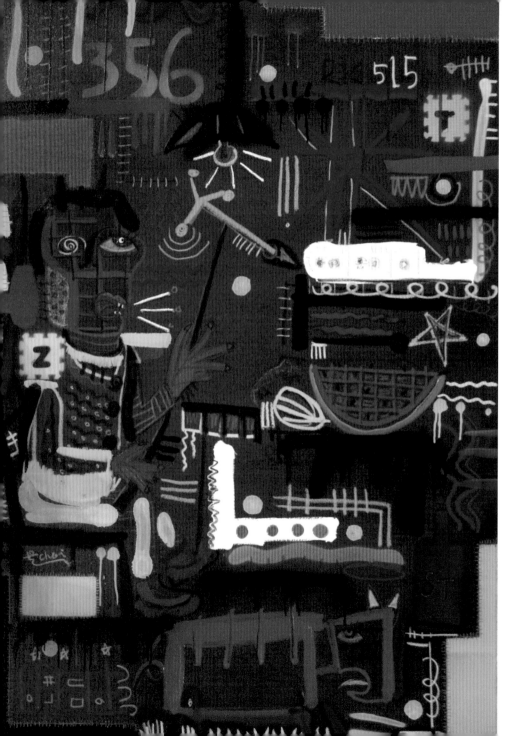

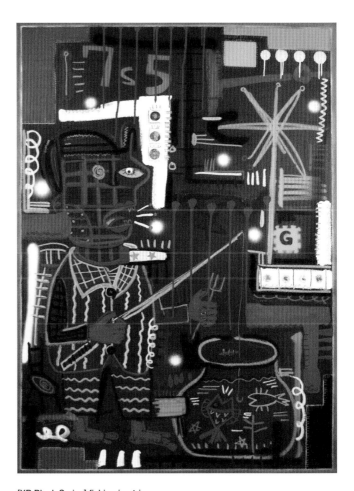

[XP Black Series] fishing in atriere
oil on canvas, 112x163cm
2008

[XP Black Series] What is he like
oil on canvas, 162.1x130.3cm
2008

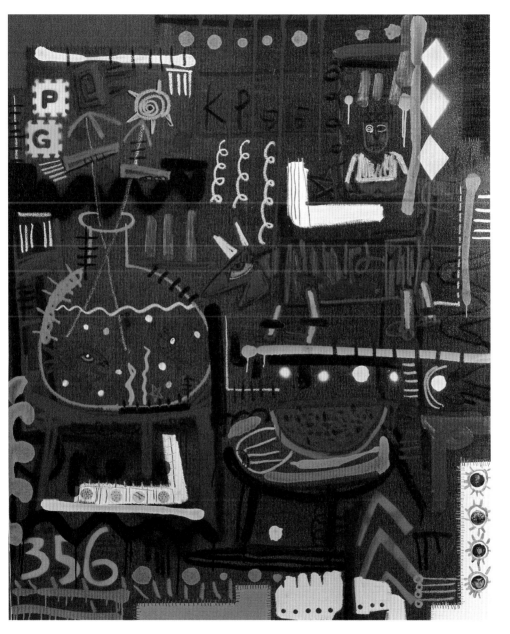

[Black Play Series] shockonsummertime
oil on canvas, 162x132cm
2008

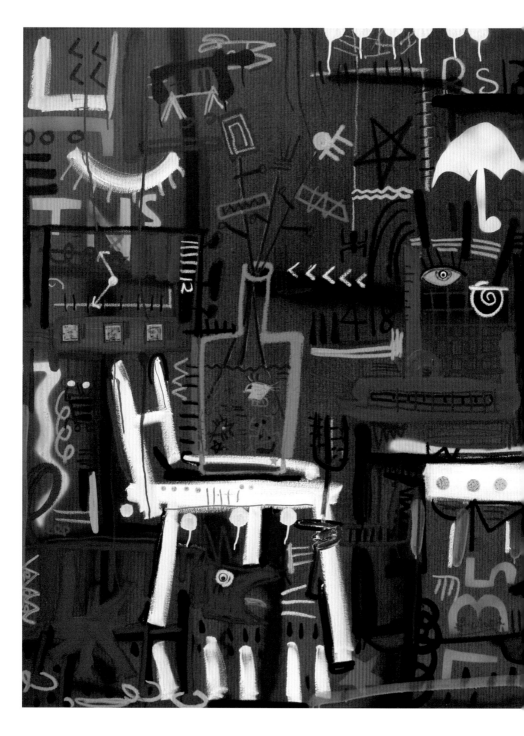

[XP Black Series] the clandestine marriage in summer
oil pn canvas, 131X163cm
2008

[XP Black Series] I need keep
oil on canvas, 131x163cm
2008

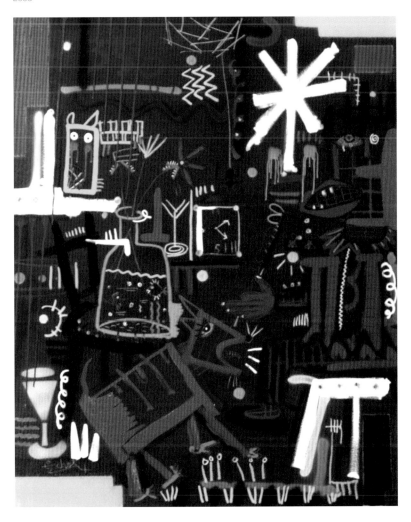

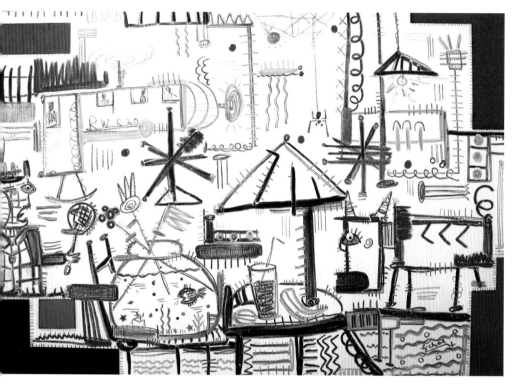

[White Play Series] Atliere in silent
oil on canvas, 112x163cm
2008

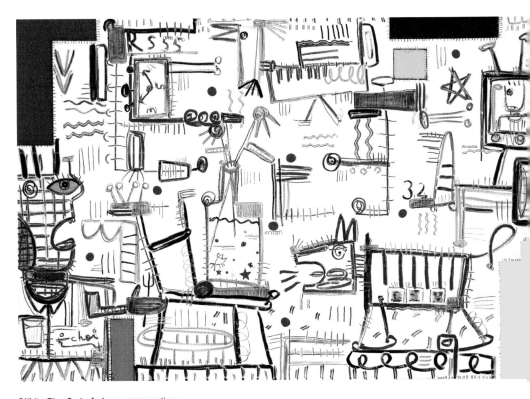

[White Play Series] play on summertime
oil on canvas, 112.2x163cm
2008

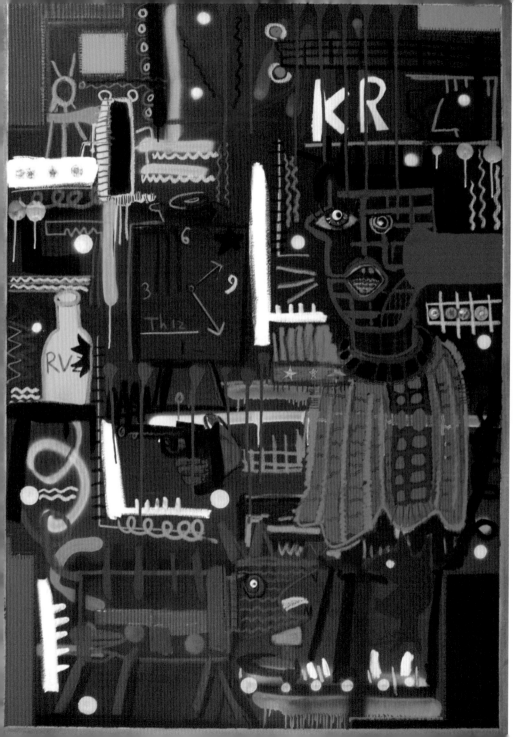

[XP Black Series] My immage in newyork
oil on canvas, 112x163cm
2008

A Yearning for the Native Home
- Flight of Choi Woolga's Recent Paintings -

Lee HeeYoung
[art critic]

In 1979 just before the "great" '80's, Choi Woolga filled with the surrealistic hints relying on allegories and narrations his first solo exhibition revealing his artistic enterprising as professional artist. It was held in Busan. For a decade or 90's, he produced in Paris the canvases full of vitality with the images adhered to the flat surface and the forms contoured obscurely. In 2000's in New York, he abandoned the two-dimensional figures to enumerate the contracted linear forms like hieroglyphics or signs and highlight the entire specification of the canvas.

Amid those diverse changes witnessed in his 30-year-long art career, his paintings have been read as "fancy free primitive" (Yoon, Bum Mo), "Play for Play's Sake" (Kim, Jong Geun) or "impertinent" (Kim, Hyung Soon). Their remarks seem to reflect their positive expectation of Choi Woolga's paintings. The rapidly changing social experiments such as industrialization, democratization and informatization has involved Choi Woolga and his neighbors. The artist himself has produced his works by throwing himself onto the places where such extreme experimentations of civilization have been made cyclically or every 10 years, in an effort to plan his own art by responding to the changes. From the criticisms made for his paintings, I infer 'what should be'; fine art, particularly painting is obliged to cure the pathological phenomenon immanent fundamentally in the social experimentations and the extreme practices of civilization. Since Choi Woolga's unaffected painting has conformed to such a trend of 'what should be,' critics could well have such expectations of his paintings.

Skepticism

According to him, Choi Woolga produced paintings in 1980's being armed with 'a transparent human sense conforming to the nature.' He would put into practice a spirit of 'war and magma' in 1990's by giving vent to all his life and language of heart onto the canvas 'without filtering them' for a fundamental challenge and attempt

for paintings.' Meanwhile, he would move from Paris to New York in 2000's but he could not but 'abandon everything' gained from himself who had poured 'everything' breathlessly into his canvas, and after all, he would experience 'a sense of frustration.' In short, his new life as artist in New York required him to give up his hither-to belief in life of art and start a new life of art again.

When an artist attempts to claim for his or her homogeneity with a new mode or form, he or she would fall into a serious isolation. The neighbors who have recognized him or her would be concerned about him or her or even turn their back to him or her. Choi Woolga did not hesitate to rush toward the canvas leaning against the wall at such a turning point. He left his life and neighbors behind to concentrate on the works. The painterly or the typical attribute of painting starts with covering and filling of the surface. Choi Woolga sums up his long struggle in the following phrase; "Why should I express everything all?"

His insight precisely points out the contradiction immanent in the essential nature of painting. In New York, Choi Woolga would be aware that everything he had struggled and sacrificed himself for should be devoted to the possibility of painting. Such an awareness was a result from his intuition into the contradiction that painting should rely on the physical substance or 'the painterly' and at the same time, should depend

on some unrealistic images beyond expressions. A painting would be completed by 'the painterly.' Nevertheless, Choi Woolga would not abandon his media as the Minimal artists do, or would not give up the labor of the 'painterly' as the conceptual artists do. Rather, he paid attention thoroughly to 'the painterly', canvas and such pictorialities as structure, and thereby, experimented them.

Scale

The canvases worked out in New York in 2000's contrast their entire shape sharply with the relationship between gallery spaces in the real world. The thickness of the canvas edges would be emphasized or painted. Attention to the canvas edges and their thickness would highlight the sharp contact points between the illusory space of painting and the real space where the audience stand, pointing out the obscurity of the boundary. Depending on how to read the painting, the audience would see the shadow of the wall plane falling below the canvas as real or as painting space.

Here, his canvas would be perceived to respond to the scale rather than the size. While his past paintings had been the arenas of struggle like the "magma" giving vent to "a clear consciousness," these works featured a consciousness or struggle limited within the canvas. Upon reviewing his recent paintings contrasting the painting space with the real space, we could see that his past paintings look like the illustrations limited within the images. While his past paintings were limited within the space relying on illusion beyond expressions, his recent paintings are expanded to the points where the illusory space collides with the physical substance of colors surrounding the surface.

Choi Woolga's changed canvas is distinguished from his former one even in terms of the shape drawn on its surface. In his recent series, he suggests as simple lines of rapid speed the various objects derived from the miscellaneous things around him or those harbored in his heart. Such suggestion differed from the past one for setting the contour of objects and covering their insides with colors. Protrusion of the pointed edges shaped like the sawteeth hinting animal' beak, repetition of the parallel lines waving in two or three strands, floating human bodies and animals contracted into skeletons, movement of the hips hinted by 'W'-shaped lines, glittering dotted lines like larva's numerous feet or simple organism's cilia, meandering spiral echo.... All these images rely on the drawings hinting only the characteristics of objects rather than explaining them.

These shapes are not arranged hierarchically centering round a certain part of the canvas but distributed randomly and evenly throughout the canvas, Accordingly, the audience cannot see from his canvas such intentional harmony of composition as introduction-development-turn-conclusion or rhythm but only can see that the entire shape of the canvas proudly occupies the real space. Thus, the audience would be assured of the scale of canvas, and furthermore, experience the media visually and instantly. While his recent paintings rely on direct experiences, his past paintings rely on gradual reading of the images hinting a development of a serious event.

Turn

Now, his paintings are not about the episodes of the images limited to the surface but premised on the direct visuality of the audience present in the real world. Individual forms float, while noises disgorged from a variety of sounds contrast with the structure repeating the four edges of the canvas. Together with the rectangular color planes positioned quite inadvertently, such forms as human body, clock and table rely on combination of horizontal and vertical lines. The grid structure with horizontal and vertical lines repeated looks tidy, striking a contrast with the noises to maximize them. Here, it is confirmed that Choi Woolga's media form a space of opportunity for collision between opposing attributes rather than a harmonious structure delivering a single straightforward message.

Most of the forms relying on drawing in Choi Woolga's recent series conspicuously record the behavior of making a headlong rush toward the canvas. Such composition differs from his past paintings revealing the forms with the painterly relying on brushes in most cases. His paintings produced in 2000's disclose their forms scratched with knife or hard tool on the white surface overlaid on a dark base. The forms are the visual stimulations protruding forwards to counter the base being pushed backwards In order to reveal the forms harbored in mind, Choi Woolga leaves his gestures by carving the surface. They are the gusts of his volition for expression. Strictly speaking, however, his forms are revealed by recovering the original base. In other words, they are created when the shapes which should protrude are pushed back. Here, we can witness a collision between forms and their base.

Choi Woolga's recent flight of painting is characterized by comprehensive homogeneity of the forms relying on the contracted drawing, concern about the scale and introduction of a real space, freedom of revealing diverse cries of the forms admitting

all individual attributes, turnover of the forms revealed by exposing the base which should have been pushed back, and the like. Such characteristics connote the skepticism he suffered first in New York and the practice of art there.

Recovery

The core of such experiments enabling Choi Woolga's flight seems to have been attributable to his recognition of the collision between opposing attributes rather than his attempt to compose the parts in harmony with the integrated whole. It makes his recent works centered about audience differentiated from his past paintings centered about images, while it seems to have been achieved through his consistent painting experiments and setting of a direction long after diverse changes and experiments. The characteristics of his paintings are selection of the materials evoking the memory of infancy and the simple tones and quite inadvertent arrangement of impromptu drawings and painterly, all of which have been consistent over the last 3 decades. The crude contrast among the forms suggested always habitually and all of a sudden by him is quite similar to the collision between the opposing elements enabling his flight.

Such crudeness has been read continuously as humor every period together with the naivety hinted by the materials. Moreover, the primary colors and sloppy painterly applied to his past paintings match the simple visuality and the primitive emotion of touch, even reminding us of the successful primitive art masters. The audience who have viewed his paintings so far have in common indicated a critical allusion to civilization. Considering that Choi Woolga's earlier works were affected by surrealism, the contrast between crude elements seems to have been quite a deep-rooted artistic strategy of his.

Choi Woolga champions the principle of "non-gravity" together with his painterly. According to him, non-gravity existed already, and because it was hidden by gravity, everything came to be defined by order. Thus, he believes that in order to overcome the irregularities, our modern men should recover the original state of non-gravity. Such an argument of his aims to fight the stereotype of reality by paying attention to the pan-universal truth.

In this context, he refers to the case of Paris that letters are delivered through underground paths and the air of Alps is contained into the barrels to be sold at the market, and further, points out the case of New York that shoes and accessories are

sold at cafeterias. Such a belief of his is accompanied by the methodology of facing and admitting what exist already. He attempts to explain as "principle of non-gravity" the aspiration for the original things, places or times.

The humor witnessed in Choi Woolga's paintings does not necessarily consist of comedies. As we can witness in his paintings such manipulations as revealing of the base painterly on the canvas or the existence of the real audience or outcrying of opposing elements, tragedy is allowed in his paintings, too. In the same context, the forms revealed as positive in his past paintings are revealed as negative in his recent works. I can confirm several clues to read his paintings as ontology through his painting humor allowing for tragedy.

[White Play Series] lassitude on afternoon
oil on canvas, 100x100cm
2008

[XP Black Series] noting no more
oil on canvas, 112x163cm
2008

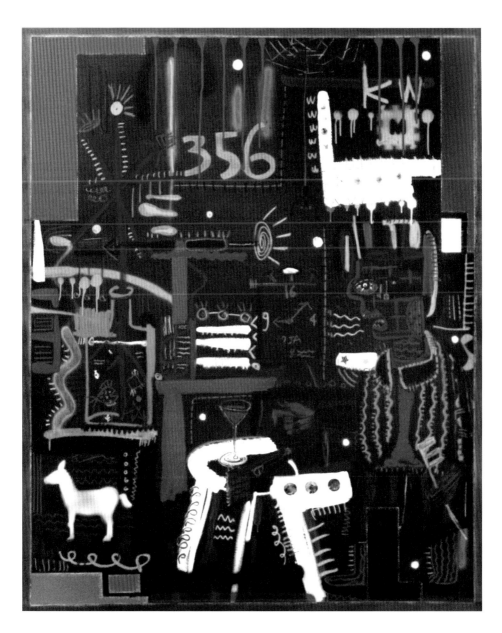

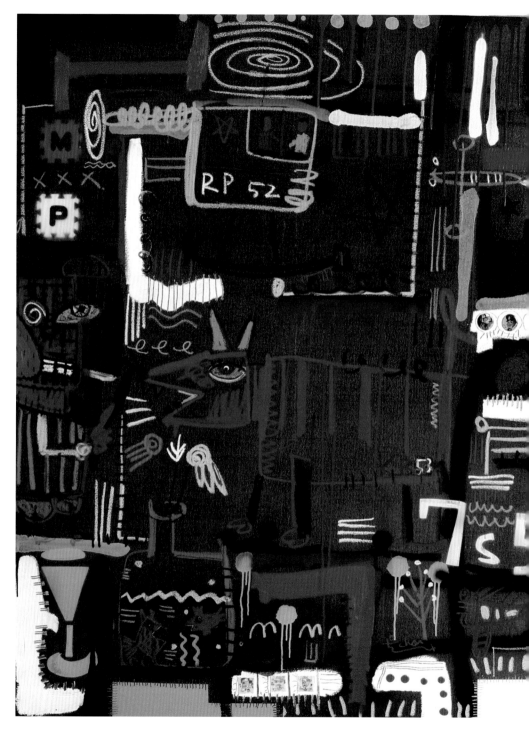

[Black Play Series] play of the mystery

oil on canvas, 132x163cm

2009

[XP White Series] My Love
oil on canvas, 45x45cm
2008

[XP White Series] play a fishbowl
oil on canvas, 100x100cm
2008

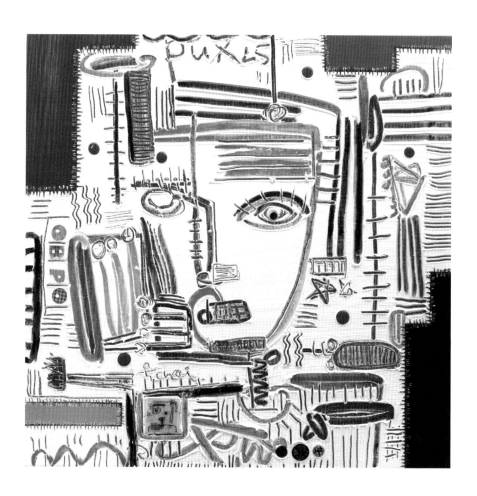

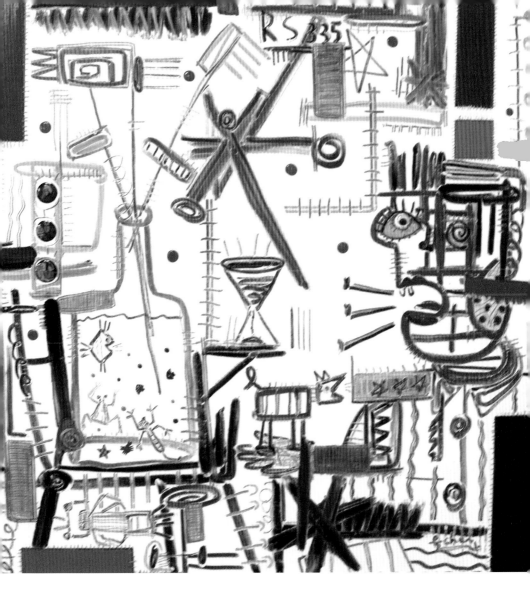

[XP Black Series] Let me see
oil on canvas, 64x51inch
2009

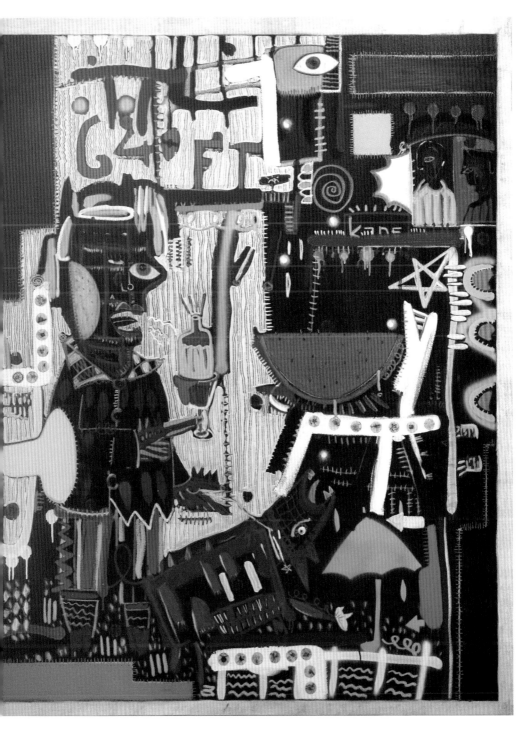

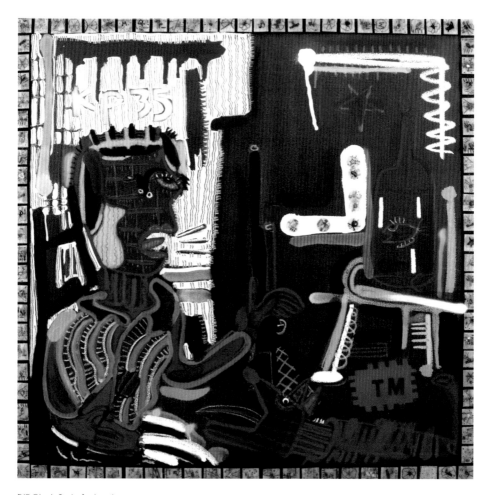

[XP Black Series] a hunting gun
oil on canvas, 100x100cm
2009

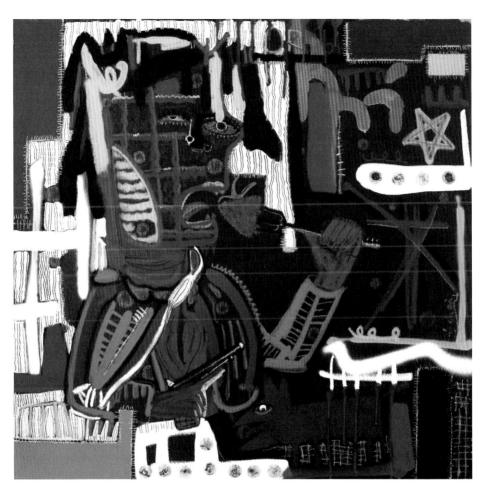

[XP Black Series] It sweeting
oil on canvas, 100x100cm
2009

[XP Black Series] It,s done
oil on canvas, 163x112cm
2009

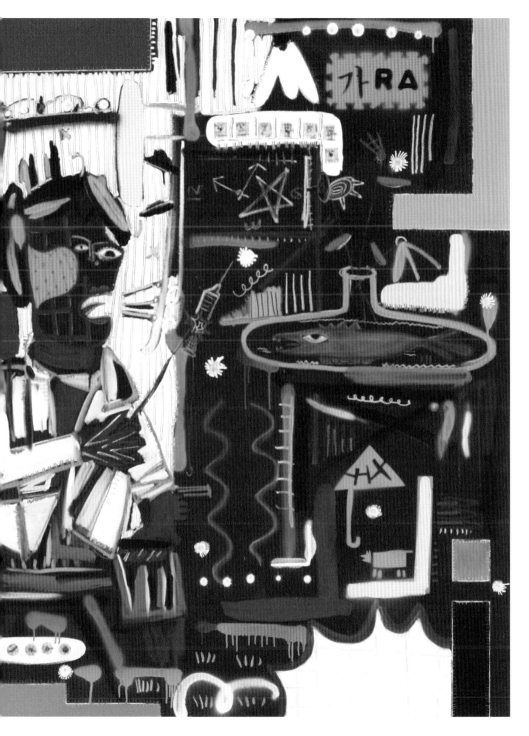

Beauty of Freedom and Origin

Some critics see Choi Woolga's paintings as graffiti drawn on the canvas. It may not be deniable that his works look like the paintings freely drawn by a little kid not minding the formative grammar which should be learned through a regular education, and therefore, that they look like the graffiti found in our ordinary urban space to some degree. On the other hand, however, since his paintings resembling children's scribbles or graffiti are drawn not on the building wall or an urban structure but on the authentic canvas, they can as well be interpreted from a different perspective.

Ha GyueHoon
[art critic]

The paintings of the graffiti form, like Choi Woolga's works, expressed impromptu and freely in the urban space are called city or street paintings. We can be aware of their unique expressions at a glance without their artists' signatures or our impression with their images repeated on the graffiti will probably linger longer. Such attributes may brandize or characterize their artists' styles or may be used as means of indicating the spatial sphere of artists' activities.

If we look at Choi Woolga's works closely, we may witness his attributes repeatedly shown in his images like graffiti. For example, a rectangular color plane is formed by its contour woven compactly with short lines like a needled work, or such a color plane is formed into an animal image with a rectangular body as if it were echoing in a formative way. Otherwise, a curve is repeated to wind up like a vortex or spring. His canvas excludes any painterly illusion. Rather, it shows simple, honest and free expressions at large.

Earlier, critic Yoon, Bum Mo found a free rhythm of straight and curved lines in his works as well as an inner cadence therefrom. Most of the graffiti in cities are critical about the society by nature or decloare something, being ill-tempered and playful, and therefore, images are accompanied by texts in most cases. In certain aspects,

however, Choi Woolga's image-centered canvas may well be different from the graffiti. While the graffiti is drawn on building wall, road or vehicles, his paintings are drawn on the regular media or canvas, being distanced from the city or street paintings, and furthermore,

His paintings are the products of the orthodox art expressions, attempting to explore a new world of art. Merely, in terms of image expressions, namely fancy free or impromptu expressions, there seems to be some typical similarity between his works and graffiti. In 1960's, a group of young black people resisting the racism in Bronx of New York began to express slogans or images with the spray paint on building walls or subway station, and thus, the graffiti called the street painting started. The graffiti in New York was expression of the resistance to racism and discrimination, being critical about the situation that the urban dwellers alienated had lost their identity, but its messages expressed would be expanded gradually to include such themes as opposition to development of nuclear weapons, environmental conservation and human right protection, and more recently, the themes expand to issues of minority groups or miscellaneous private ones.

Graffitos which can be found on the ancient Egyptian or Roman remains and therefore, which may be regarded as etymology of graffiti were crude pictures like kid's ones, but they are similar to today's graffiti because they expressed such key words as political slogans or proclamations or contained the phrases of personal sentiments. Merely, they are different from today's graffiti in New York in that the wall planes were scratched or the natural pigments were used because of underdevelopment of the expression media. Even in the ancient times, the building owners must have been annoyed at their dirty building walls. It is perceived that the history of the hide-and-seek game between building owners and graffito scribblers may be longer than the history of any other human game.

The graffito (graffiti) in the form of fine art is witnessed often on the public facilities today. Its formal freedom and impromptu expression once attracted high attention from the fine art community. If we interpret Choi Woolga's works in association with graffiti or graffito, we may well find that they are similar to and at the same time, different from it. First of all, as mentioned already above, his works seem to be similar to graffiti in terms of formal freedom, impromptu expression, brandizement of artist himself and repetition of images, and simplification of the forms with primary colors

and lines devoid of either perspective or realism. The process of his work covering the base color of the canvas with the white color and then, scratching the surface for making forms is reminiscent of the graffito work process.

On the other hand, Choi Woolga's works are different from graffito primarily in that he uses such authentic materials as canvas, oil paint and acryl, and additionally in that he unifies the atmosphere of the entire canvas although it may seem to be footloose and fancy free, being willing to compose the canvas to look harmonious. Moreover, we can hardly find on

His canvas such texts or slogans witnessed often on the street paintings. Choi Woolga's canvas may be characterized by footloose, fancy free and impromptu expressions, but in overall terms, his canvas must be characterized by balance and harmony as well as contrast of colors in terms of lines, plane or dots of colors. As a result, improvision and composition are properly balanced within his canvas. The diverse forms on his canvas revealed through the lines of such primary colors as red, blue and yellow might look entangled or confused but the entire effect is surprisingly very harmonious and decorative.

During Work

Being a little different from such views, a Japanese art critic Nakahara Yuske indicated that Choi Woolga's paintings might be compared with the cave wall paintings in the primitive times because they are anarchistically chaotic and disorderly, while pointing out an atmosphere similar to COBRA group's

expressionism. Of course, Nakahara finds some order and geometric composition in Choi Woolga's recent works, but what draw his attention primarily is primitivism or the decomposing expression shown on the primitive cave wall paintings. However, Choi Woolga's works show the aspects fundamentally different from the anarchistic cave wall paintings. Above all, images are not overlapped recklessly within the canvas, and the margins of the canvas are balanced to some degree, showing an overall harmony and order.

In terms of themes, as Choi Woolga professes for himself, his exploration of forms and obsession with essence of art in his earlier career would evolve into the focus on existential truth of nature and men. In other words, his struggle to explore his own identity and pursue a global universality during his long stay in Paris, New York and other foreign cities seems to be mirrored metaphorically in his canvas.
He tries to overcome the dichotomic confrontation between spirit and material, being concerned about nature and primitivism. In terms of formality, he is neither too Oriental nor much Occidental. He just tries to express the images perceived universally like children's or primitive men's paintings featuring the human originality; he expresses such images with primary colors, lines and forms.

Indeed, Choi Woolga's works look like drawings rather than paintings in a sense. He expresses the images primarily through line drawings, while revealing some colors on the whitish canvas or overlaying some colors on it. Thus, his canvas is fancy free, being emancipated from the shackles; he shakes off the obsession with the technology producing modern images to open the possibility of approaching nearer the nature of human beings.

Choi Woolga has experienced the fine art communities in New York and Paris or the twin centers of contemporary art, and in the triangular sphere formed by the lines linking these two cities and Seoul, he employs universal and original formative grammar to pursue a painting freedom and essence of men's origin. In his works, we may well experience a visual orchestration harmonizing freedom and beauty of human origin.

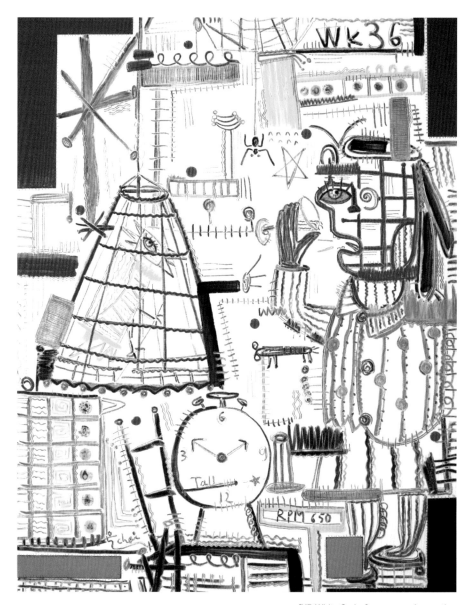

[XP White Series] over more for anyting
oil on canvas, 140x100cm
2008

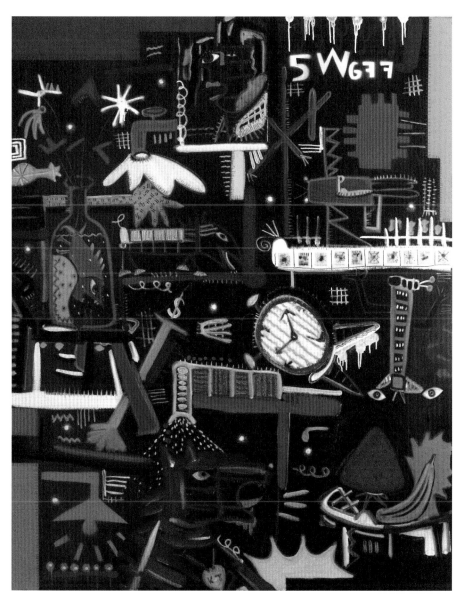

[Black Play Series] Ateliere 51 ; brooklyn
oil on canvas, 64x51inch
2009

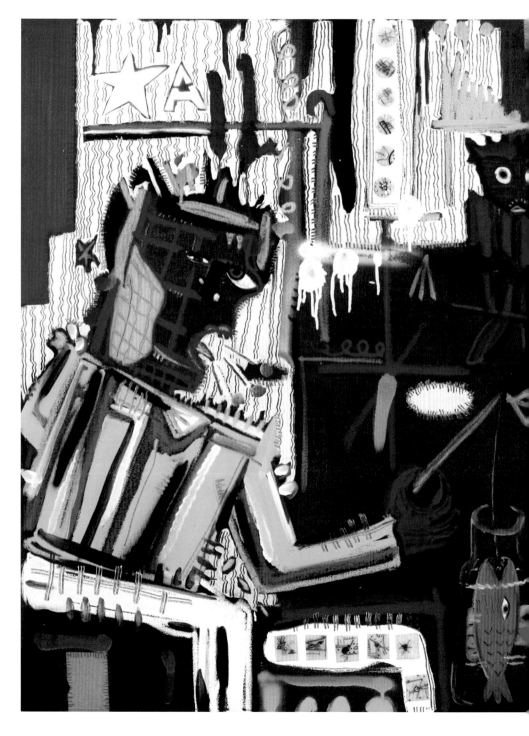

[XP Black Series] fishing in Atliere
oil on canvas, 100x100cm
2009

[XP Black Series] I'm dreaming, aren,t
oil on canvas, 162x130cm
2009

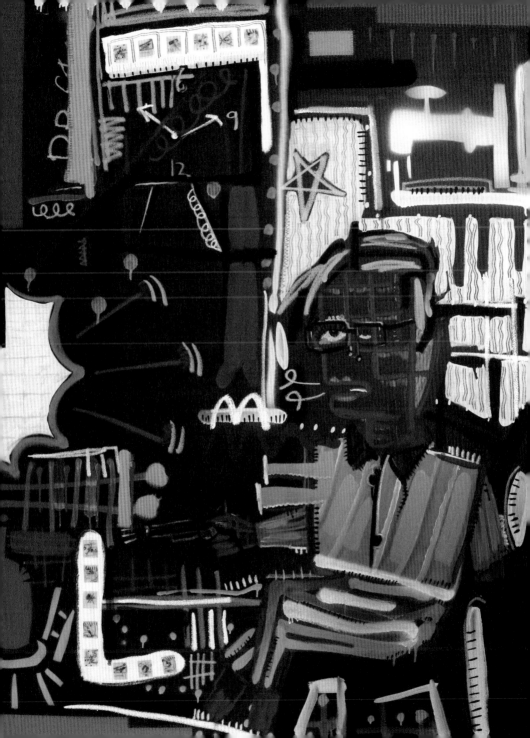

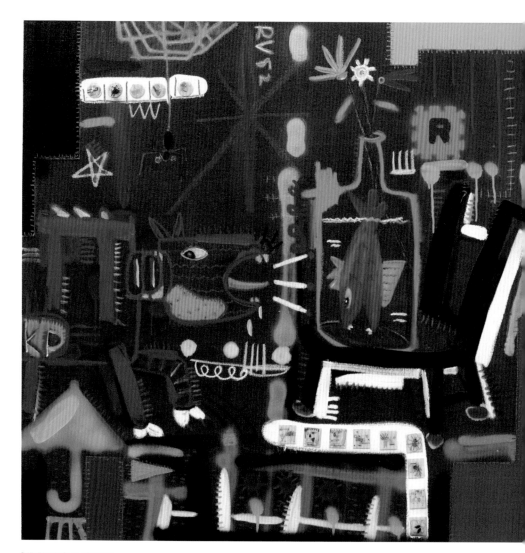

[XP Black Series] like It
oil on canvas, 100x100cm
2009

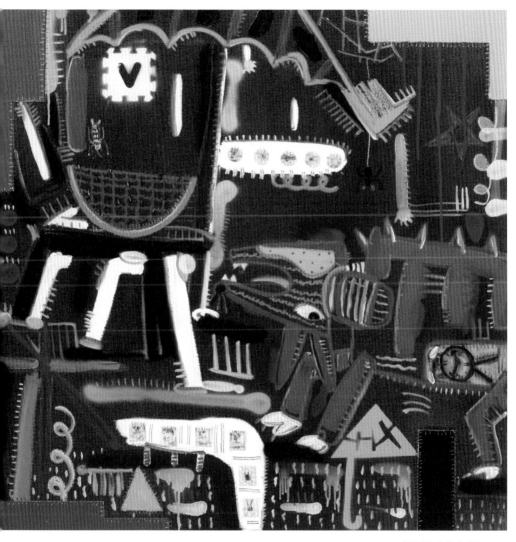

[XP Black Series] It,s over
oil on canvas, 100x100cm
2009

[XP Black Series] It,s rain in my mine
oil on canvas, 130x162cm
2009

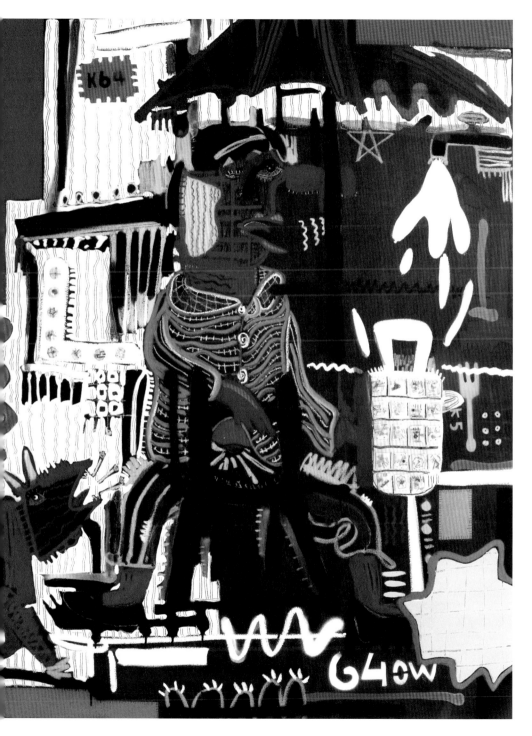

An Ordinary Life Diary through Equivalent Expression of Objects
- Choi Woolga's World of Works -

Lately, such technology fine art works as video installations have decreased at the major exhibitions in Korea, while the painting works have some increased as before, showing diverse expressions. Particularly, the main trends seem to be the pop art featuring the characters from animations or cartoons as well as some hyper-realism tendency. It is not sure yet whether such tendencies in the early new millenium should be important enough to be verified and established in the Korean fine art or they will be parts of the temporary fashion. In the circumstance, we may find around us many artists who show diverse expressions with their own imagination and creativity, not being influenced by the Western art or the contemporary fashion.

Oh SeGwon
[art critic]

Choi Woolga is one of such artists who continue to explore their own world of art not minding the fashion of the time. His world of works may be divided in large into those during 1980's, those during 1990's and those during 2000's. These three categories of his works which seem to be similar to each other, but have evolved, undergoing the changes in different directions. Especially, such daily life records as shown in his works during 2000's have continued to evolve from his works during 1980's.

Although we can seldom see them today, we saw the wide walls made of the cement spread thin on the earthen wall in countrysides frequently as late as 1960's and 1970's. We also saw the wide wall made of rice straws and yellow soil mixed and moulded like mortar frequently. Kids used to write or draw on such walls with chalk, crayon or nail, as if they were scribbling. Here and there on the yards of rural villages, kids were playing such games as pasteboard turnover game, glass bead hitting game, stick flying game, territory seizing game, stone pitching game, and so on. There were solid grounds for such plays or games. Kids drew the game boards on such grounds with nail, stone, chalk or crayon or scribbled or painted on them. Earthen walls or the solid grounds were the good canvases for the rural kids.

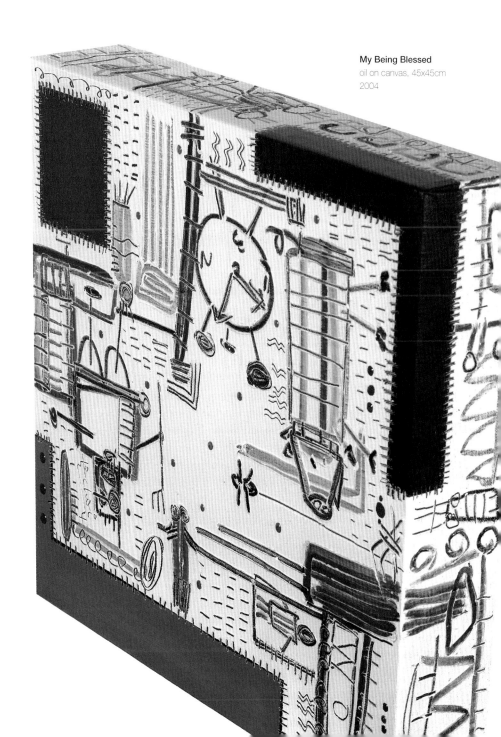

My Being Blessed
oil on canvas, 45x45cm
2004

Upon reviewing Choi Woolga's works, we are reminded of the rural kids' scribbles on earthen wall or ground during 1960's and 1970's. Their scribbles contained their innocence and primitiveness, showing the stories about their daily life like a diary. Choi Woolga's works show such characteristics of children's scribbles. For example, he does not depict the objects clearly, just expressing their characteristics as simple lines, and thus, his paintings are characterized by the front-view expressions witnessed in children's or primitive men's drawings; his paintings are descriptively planar like life diaries.

Daily routine means a continuum of days lived by people, implying people's experiential life within the fence of life. Daily routine within life consists of diverse attributes: repetition, excitement, enjoyment, grief, pleasure.... In this routine, human beings live their own life anonymously. Usually, 'daily routine' is discussed philosophically in ontological or sociological terms, giving weight to human beings' experiential life. However, not in academic terms but in ordinary terms, 'daily routine' means 'the diverse looks of daily life.' In Choi Woolga's works, such looks of daily life are expressed like diaries. The living scenes inside and outside home are expressed as if they were sketched.

Choi Woolga's works may be divided in large into three categories: indoor landscape, outdoor landscape and indoor/outdoor landscape. The first category shows such home items arranged to talk with each other as small clock, fruits, calendar, fish bowl, tea cup, flowers, TV, and the like. The second category features such diverse objects deployed on a plane as bird, chair, tree, helicopter, reservoir, bus, traffic signal lamp, building, etc. The third category expresses, like surrealism works, the indoor objects items juxtaposed with the outdoor ones, while blurring the boundary between indoor and outdoor. The objects are expressed as if they were arranged on a plan for the effect of hypallage.

In his works, people are shown in most cases. One man sits on a chair indoors, and another man stands. Objects and men are set in diverse looks. Outdoors, one man is fishing, while another man is walking on the street, and other man is aboard the helicopter. His people look like being engaged naturally in the daily routine, interacting with the objects.

Choi Woolga's works do not attempt to approach an event or an object to explain about it explicitly. Various objects are deployed on a plane with no sense of perspective, and therefore, the audience can approach them freely to interpret them for themselves. The subject is not expressed centering around a single object. Every object is arranged on an equal footing to be interpreted naturally in terms of daily routine. And there is no perspective. The forms viewed from side and those from above are shown on the same canvas simultaneously. Namely, objects are just arranged or drawn as if they were scribbled.

On the other hand, scratching is a core of his expression. For example, he paints a dark base color first on the canvas and then, paints the white color thereupon. And before the white color has dried up, various images and drawings are revealed in lines or planes of the base color. Next, he adds colors partially to the canvas to vary the expressions. A line is expressed as a stroke just as in calligraphy, and further as in drawing.

If we look closely at Choi Woolga's world of works, we can see to it that he arranges various objects such as men, animals, machines, etc., randomly to unfold the looks of daily routine like diaries. Through such expression, Choi Woolga delivers to us a message that all objects are equal and that life is a careful balance among the objects interrelated with each other.

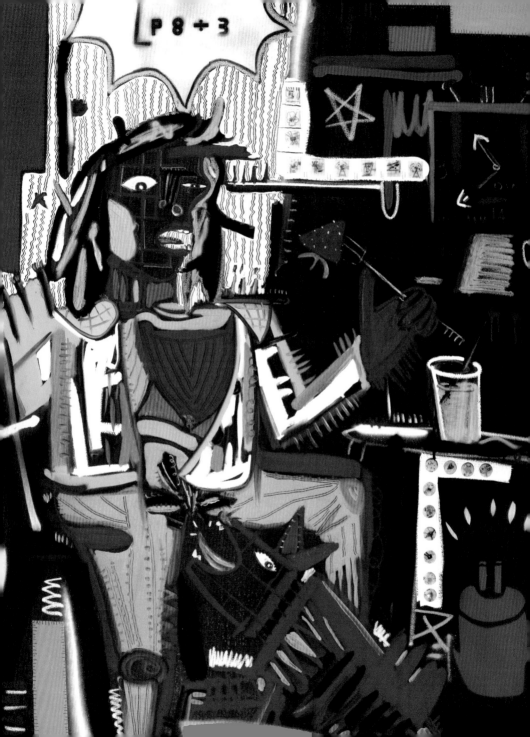

[XP Black Series] Togetherness
oil on canvas, 162x130cm
2009

[XP Black Series] That it
oil on canvas, 163x112cm
2009

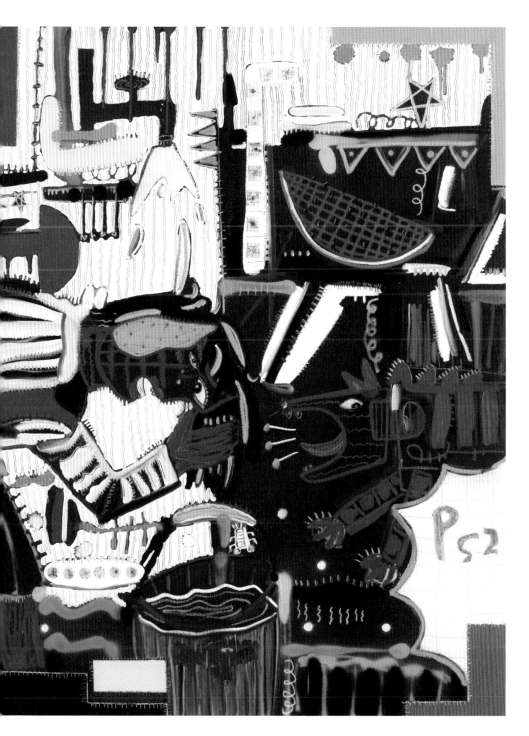

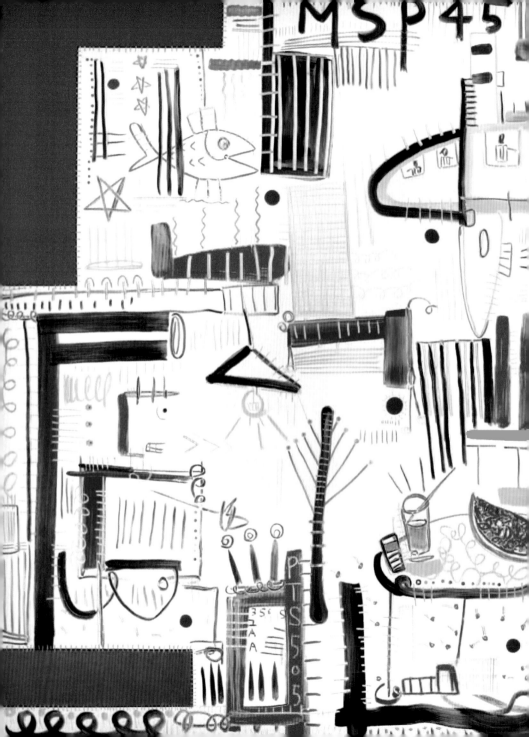

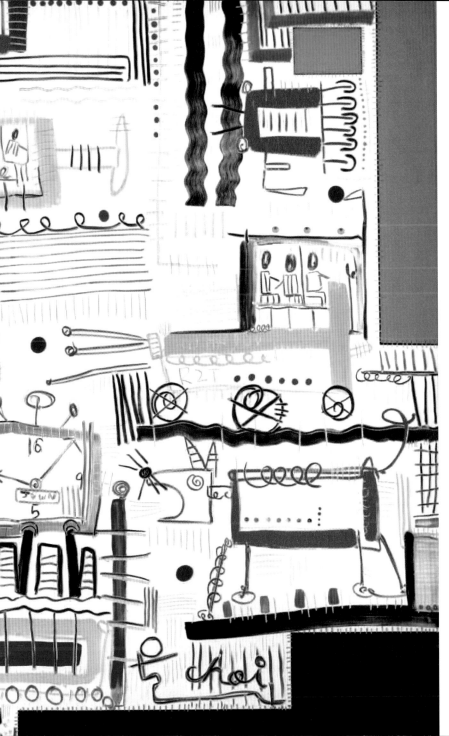

K, white fly
oil on canvas, 570x480cm
2007

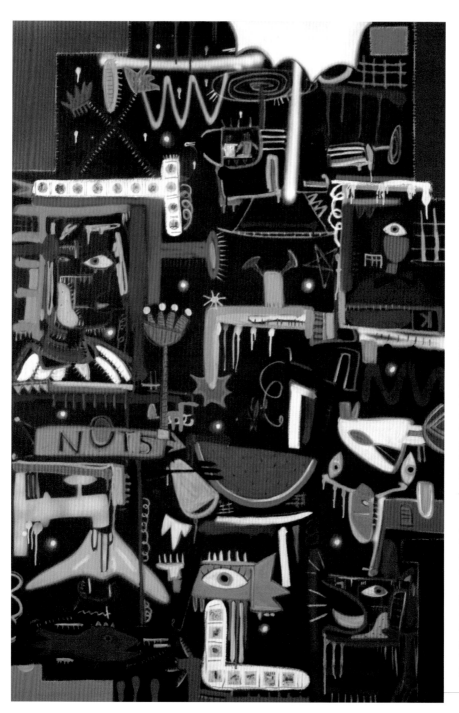

[Black Play Series] I,m not going to home
oil on canvas, 48x72inch
2010

[Black Play Series] Ateliere FT 640
oil on canvas 64x51inch
2010

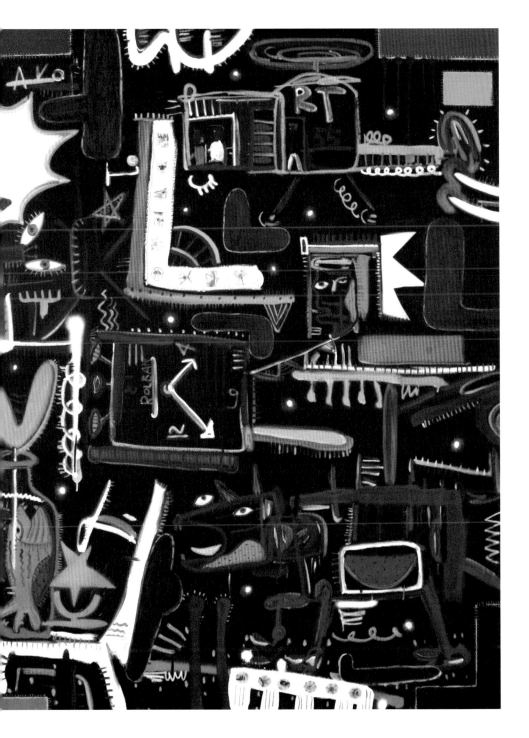

[XP Black Series] Let,s me see
oil on canvas, 100x100cm
2009

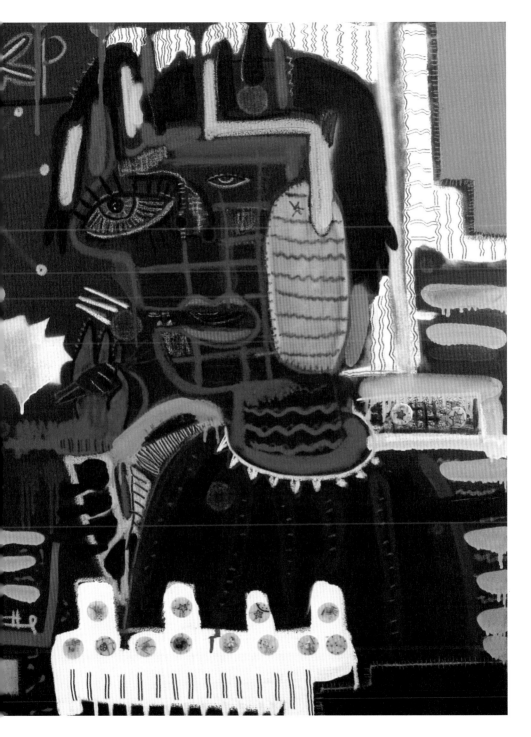

Choi Woolga's Homo Ludens-like Scribbling Diary

Kim JongGeun
[art critic]

My first impression with Choi Woolga

At the opening ceremony for a gallery in Paris in mid-1990's, I met him first. He was explaining to the French audience in French affected by the tough and stiff Busan dialect, smiling brightly. Since then, I would meet him twice more, one at SAGA, a famous salon exhibition in France and the other at Art Fair in Strasburg. There, I could see his many paintings.

Since our life in Seoul and Paris was incongruous with each other, we did not much know about each other. Sometime later, I had an opportunity to visit his wide atelier at Mui-dong, filled full with paintings. There, I came to be aware that he had been more widely known in France or Japan than Korea. Of course, I had ever heard about his paintings, though briefly, from a French art critic, and I had been much anxious to know more about him. Choi Woolga I would know afterwards was very humane unlike his dramatic, vigorous and passionate paintings.

Choi Woolga's unbounded paintings

Long since then, Choi Woolga would conclude his 10-year-long life in Paris to fly to New York, an art city of more vitality. We parted from each other without exchanging any correspondence, but his paintings viewed at the art fair and in his atelier were deeply impressed in my brain. Despite such deep impressions, art lovers rather than art professionals liked his painting more, I heard. There were so-called manias loving his paintings.

If my memory that his first solo exhibition was held at Suro Gallery in Busan in 1979 is correct, he is now a major artist with 25-year-long career. Nevertheless, he flew to France and experienced the orthodox world of art at Versailles Art College and then, continued

his career as artist. His paintings I saw were as much unbounded as his personality. Since his paintings were too footloose and fancy free, I even suspected that he might be an inborn artist. I mean that his paintings were so passionate and hot. The gorgeous and fascinating colors met each other on his canvas with neither chaos nor conflict to create an image, and hence, his paintings reminded me of Picasso's ones. When he used the black lines boldly, he looked like Georges Rouault, and his paintings showing father's and son's candid expressions and pointillism brush touches were reminiscent of Jean Dubuffet's passionate art brut (primitivism) paintings.

In overall terms, Choi Woolga's paintings around 1990 were unreigned and passionate showing neither hesitation nor wavering like Expressionism paintings or Corneille's ones of COBRA Group. His innovative and solecism brush touches confirmed that his was a genuine artist thirsty and desperate for art. He refused to be bound by any painting style or theme. And just as Rousseau appealed "Let's return to the nature," so he hoped that our original human emotion would be recovered to turn civilization into nature. He raised and repeated a question, "I would like to ignore any painting theory. I just paint."

Choi Woolga has yearned for and dreamed of such a non-formal painting drawn with non-theoretical brush strokes. So, his paintings straightforwardly betray our expectation and anticipation of such theories we feel important as perspective, color contrast and composition. And his canvas shows our daily instruments positioned under no conditions. And he depicts the forms so impromptu that they might look infant and crude. Mixture of colors or techniques are alive in his paintings.

Choi Woolga's white paintings viewed at Yonqwon reservoir
Some time ago, I happened to see his most recent paintings at a reservoir near Chungju. They were completed all with oil, pastel, crayon and chalk for oil painting. They had an atmosphere quite different from that of his paintings exhibited at KIAF several months before.

Before then, his atelier of about a hundred square meters was full of the paintings drawn on colors, but this time, his paintings looked like being inside the colors. The paintings drawn as if they were carved on the white color resembled the white porcelains during Chosun dynasty. The matured landscapes carved on the white-

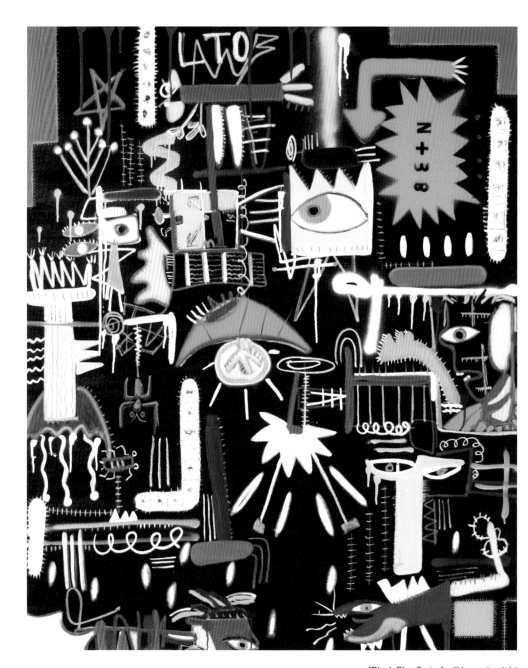

[Black Play Series] will be go to night
oil on canvas, 48x72inch
2012

porcelain-like white color base hallucinated me as if they were the landscapes from Chosun dynasty. However, what attracted me or the audience more were the paintings drawn with a sense of destiny. The artist in a blue jean stained heavily with colors looked like a farmer who wakes up timely in the morning to sow and farm his rice paddy and field.

He says that he produces 6 or 7 works a day but sometimes, he does not produce any work, just walking up and down restlessly. Anyway, he says that he enjoys painting. Yes, Francis Bacon said that art is a gamble, but to Choi Woolga, art is a play itself. What is the unique attribute characterizing our human beings? People say it is a 'thinking.' However, Johan Huizinga (1872-1945) suggested a broader concept including all these. It is a 'play.' He champions that human beings are Homo Ludens. He argues that we have long overlooked importance of play in our culture. He says that significance of human life is derived from 'playing.'

He contends that human beings are not different from other animals in that we struggle to survive. When we spare time for play, we can find our own unique meaning of life. In this sense, our human culture was derived from play, while being 'played.' Huizinga further argues that in a formal aspect, the play is an activity for its sake with no goal, and in the same context, Choi Woolga unfolds daily life, emotion and confessions on the canvas. His canvas shows such floating images as fishing man or golfer. Clocks and people are seen in his paintings and montages.

Every natural landscape and object is contained in his white painting. I absent-mindedly look at his paintings. Looking more closely at them, they look like the graffiti shown on the shabby walls in the subway or downtown buildings. People call them graffiti. Like graffiti, Choi Woolga's paintings are honest and humane

Some regret

Honestly speaking, I have been much sorry for such artists indulged steadily in works like him. For we regret that we have not much been concerned about them. The artist Choi Woolga burns out hundreds of paintings he sees shameful. He must be very rural Parisian and New Yorker. I believe that too humane and too unbounded and fancy free works of his will be reappreciated by us again.

[XP White Series] man portrait in 2001 Year sweet memories
oil on canvas, 100x100cm
2008

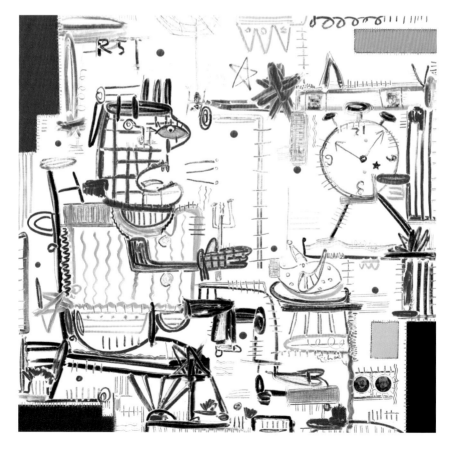

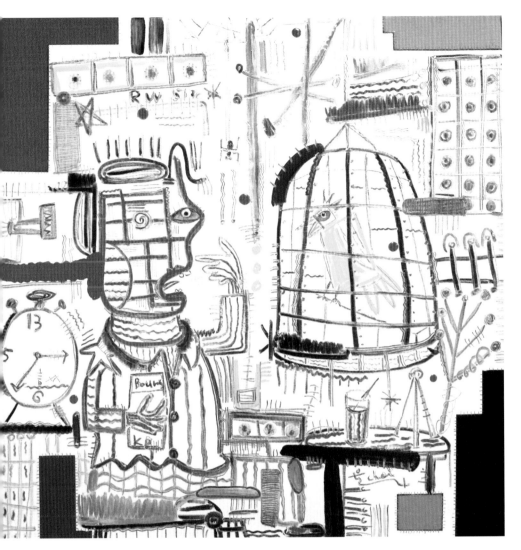

[XP White Series] please, tell me
oil on canvas, 100x100cm
2008

[Black Play Series] dreaming in one day
oil on canvas, 48x48 inch
2010

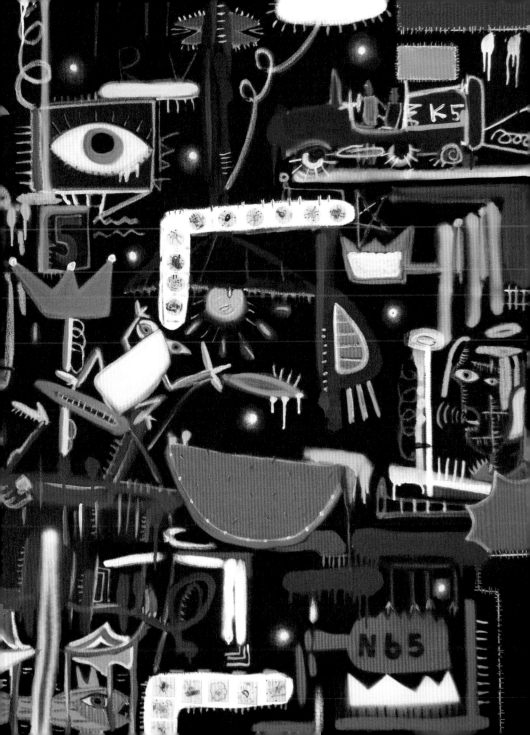

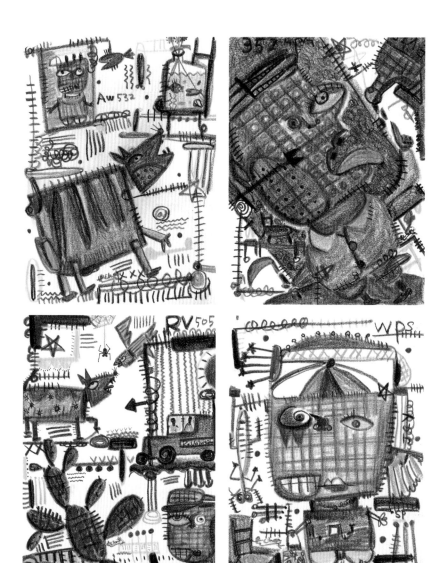

Xtra series
oil pencil on paper, 28x21cm
2009 (each)

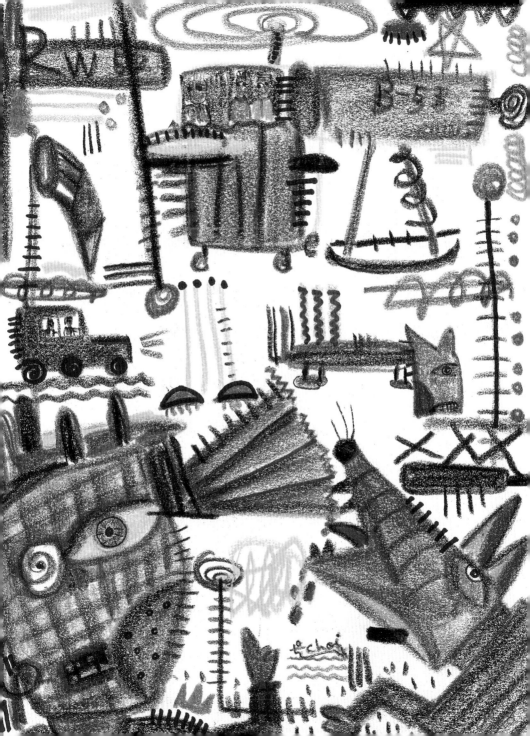

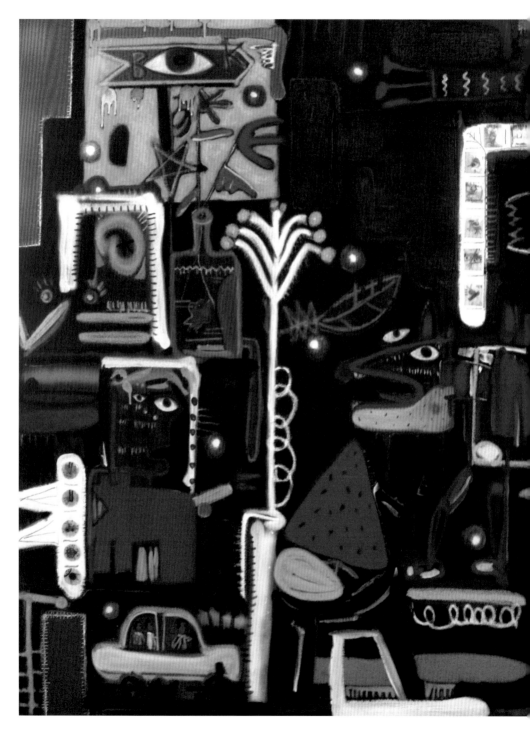

[Black Play Series] the sauvase
oil on canvas, 42x42inch
2010

[Black Play Series] don,t be A stranger
oil on canvas, 48x72inch
2010

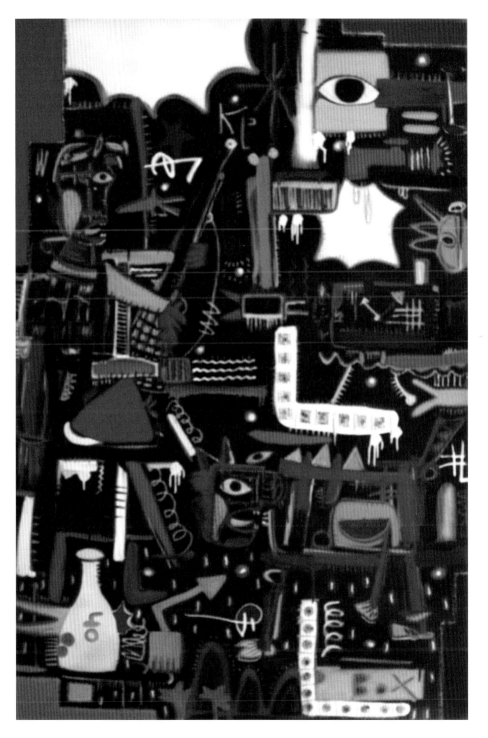

Choi Wool-Ga's New York Studio Inscribing the Images of Image

Shin JiUng
[art critic]

I had already known about the artist Choi Wool-Ga, while having seen some of his works at several small art fairs in New York. With no reason, I firmly believed that he was a Korean artist from Kazakhstan or Uzbekistan. I happened to meet him at the opening of his exhibition and sat with him at a table. As soon as we exchanged civilities, we talked quite unexpectedly about such issues as the Russian history and the former Soviet Union's Asian policies. As our talks progressed, I felt it puzzled that he was commanding a more perfect(?) Kyongsang dialect than I. Hence, I asked him about his personal profile evasively because I could not suppress my curiosity. After all, I could know that he had long been active in Paris, Seoul, Tokyo and New York, and that he had been from not Kazakhstan but Busan, Korea. It was a ridiculous misunderstanding caused by a wrong preconception. He explained that I might have misunderstood his background because 'Wool-Ga' sounded 'Olga' due to his dialect. Although I agreed to his explanation, I was awakened once again how much the wrong preconception would blind us.

For the last two decades, Choi Wool-Ga has worked in Europe. being based in Paris, and in Asia, being based in Tokyo and Seoul, and in the North America, being based in New York. If his nomadic life and work had formed one axis of his art, the liquidity between overlapped images and texts would have formed the other axis of his art. Like the life itself, art is essentially a flowing movement, but in his art works, the liquidity itself is fixed in a uniquely sensuous way to be formed and thus, captured, understood and represented as an image having a specific shape. Flowing and fixing are intertwined and interwoven into a frame called 'a form' to be a more comprehensive and abstract image. And the repetitive expansion of such contents and forms are woven ultimately into huge contents and forms of life and art. Thus, life is art, and art is life after all. Of course, this story may sound ideal and woozy like a dream.

However, such dreamy story is about Choi Wool-Ga's dream of art, desire and journey

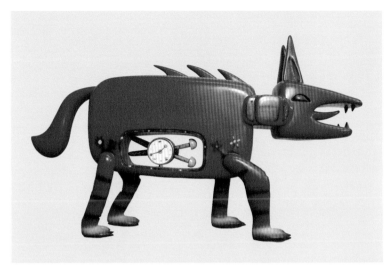

Fox series Red
painting on FRP
120x60x150cm
2009

of art. Because of such dream, he left the space of life he had barely been accustomed to for a decade to live alone in New York, isolating himself from his surroundings. The reason why he has been based in New York where he has had no affinities and where language and drinking water are different and where he should prepare meals for himself distressfully is because he has wanted to separate himself from the world familiar and apparent to him and thereby, input himself into an unfamiliar and heterogeneous space. In other words, he has attempted to meditate on and question the new world to reorganize his ego into an object. Namely, he has wanted to turn himself into 'the other' to make his inside world a heterogeneous world, while homogenizing the external world with himself, and thereby, give some order to the unfamiliar and heterogeneous world to turn it again into a homogeneous space. And such real space would be represented via his body into a painting space. Thus, although his works do not seem to be changed, they are actually changed along with his experiences of the unfamiliar world or the new place.

It was when summer was ending that I visited Choi Wool-Ga's studio. The studio was located on the border between Washington Heights or the northwestern end of the island Manhattan and Inwood region. It is very rare that the Korean artist's living and working space is located in the region where there are not much art activities and where Dominicans and Irishes are concentrated. The street on the northwestern end of Manhattan has been occupied much by Irishes and middle-class Jews. Since the people have immigrated to this region from various countries of the world for the last several decades, English is no longer a common language in its eastern part where the Spanishes live. In

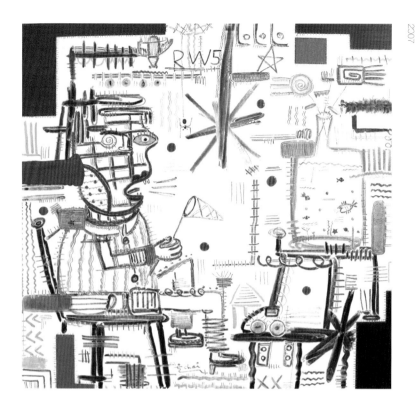

[XP White Series] portrait for fishing man
oil on canvas, 100x100cm
2007

a word, his community is a little clamorous. Even some decades ago, the community was panic-stricken at night because it was dominated by a Dominican heroin cartel. Here, a Korean legend is melted down; some Koreans immigrated to the place like an urban battle-field with little money but they would survive well or even succeed in their businesses such as small stores or vending laundries. But now, it is a by-gone story. As the Manhattan region has been gentrified, the living cost is higher on the entire island, while the public security has been reinforced. So, most parts of the island have been safe. The block where Choi Wool-Ga's studio is located is a peaceful part of Manhattan which seems to have been separated from the wild world before. It is like an isolated island. Solid apartment buildings like the old castles stand in rows on one side of the street with no store. They were built before the World War II. Several blocks away to the north, there is a very beautiful and dense forest called 'Fort Tryon Park.' To the northern end of the park, a metropolitan museum branch named 'Cloister' sprawls. You can appreciate its collection consisting of the medieval European art works and architecture.

Choi Wool-Ga who was settled in such an old community launched his studio in the living room of an one-bedroom apartment house, which seems to be considerably wide in terms of Manhattan standard. Since the apartment building was constructed before the World War II, its wall is thick with high ceiling, compared to the apartment buildings constructed recently. Although the studio is not much wide, it looks wider due to the high ceiling, and it is very tidy. Some art works that had been produced for the last several months stood against the wall. He said that they were Black XP series.

The forms colored luxuriously were depicted closely on the canvas dark-colored like the sky at dawn. They looked like being carved on the rock with a chisel. Because the images seemed to be carved, they looked like cave or rock paintings or African or South American native earthenware patterns which we can see at a natural history museum. So, many people say that Choi Wool-Ga's works seem to be affected by primitivism. However, the images of his painting could be no more refined and matured, to my eyes. They could not have been represented without the skilled hands and the refined eyes both trained rigorously for decades. It seemed to be quite absurd to attempt to confirm the influence of primitivism. Primitivism did not exist for the primitives, so the non-primitive uses the materials deemed primitive for the contemporary expressions. Primitivism is a counter-image created by the fine art itself in the history of the Western fine art, and therefore, it has been a tendency inseparable from the history of the Western fine art. Anyway, the argument that any fine art history like the Western one must not have existed in the non-Western society is too an autistic discourse to be a common sense.

Men with the faces which look like dog or wolf as well as fish and birds seem to have been painted loosely or roughly. Not only such objects but also the colorful background embracing them and the spiral diagrams and their layout do not exist in the real world. They grew up in artist's brain to be represented with his eyes and hands. Accordingly, what are important for him are not the forms to be depicted on the canvas but the images to be printed in his brain. He spends much more time for printing the images in his brain than for the canvas work. The paintings printed in his brain are the ideas about certain images rather than the real images. Such images are equal to the images of image, namely the meta-images rather than those real ones perceived by our senses. Hence, to Choi Wool-Ga, understanding an image as itself is one thing, and forming an idea about the essence of the ordinary image is quite another. Thus, most of the images represented by the artist are the images as ideas or conceptions dualized in his brains from the ordinary images to be constructed reflexively. As in the camera obscura, the objects which can hardly be sensed, thought, perceived or experienced in the real world cast their shadows onto artist's brain. In other words, Choi Wool-Ga has produced sort of 'spiritual paintings' projected in the darkness.

Nevertheless, the paintings inscribed into the spirit with senses and imagination are the passive images reversed optically according to the principle of camera. The images inscribed into the spirit are not automatically represented but reconstructed on the canvas in diverse ways through rubbing and drawing body or the cultural filters which have trained the body. The reversed images like those in the camera obscura are reinterpreted and recoordinated through practice of the body and the historical life course to be created as the works independent from the original ideas. The art works produced as such would be unique enough not to be reduced to their ideas. Due to such irreversibility or irreducibility, Choi Wool-Ga's works have their historic and social meaning, namely "a dimension of the Korean painting" irrelevant to his original intention.

Here, the adjective "Korean" does not imply that a Korean object is used or that the paintings are influenced by the Korean Five Colors or that a Korean material is used. It means that the methods of dualizing the images used by his contemporary artists are used. Namely, his paintings are in line with the pattern of depicting the painting work, imagining the imagination activities and forming the forming practice. He lays out the ideas in his brain neatly and strictly as if he were drawing a building, and thereupon, he fills them closely onto the canvas as if he were constructing a building according to its drawing. Since he paints the canvas laboriously with the highly dense colors, you may well feel choked when you face his works. Although they seem to be drawn roughly and their forms laid out loosely look like kid's scribbling, they are compact enough not to allow for any leakage of water drop. The compact world is a space where we are busy living. Choi Wool-Ga wants to depict such hard life of ours in a naive and loose way in an effort to open our windpipes. His world of art works filled with mischievous and playful acts are serious, depressive and sad enough to represent the world filled with such ironies oppressing us.

I walked around his studio several times, appreciating his warm paintings. We talked with each other over cups of coffee, and then, took a walk to Port Tryon Park. We took lunch belatedly at a restaurant in the park. We could hardly end our talk eating and drinking under a tree at the northen end of Manhattan in the afternoon of late summer before it rained heavily. We were trapped within the park, so we took supper earlier, exchanging gossips about the fine art community or the entertainment community, and waited for the rain to stop. The real world in late summer experienced for half a day with him started with the serious talks about life and art works to end up with gossips and vain jokes.

[XP Black Series] this is not newyork

oil on canvas, 48x72inch

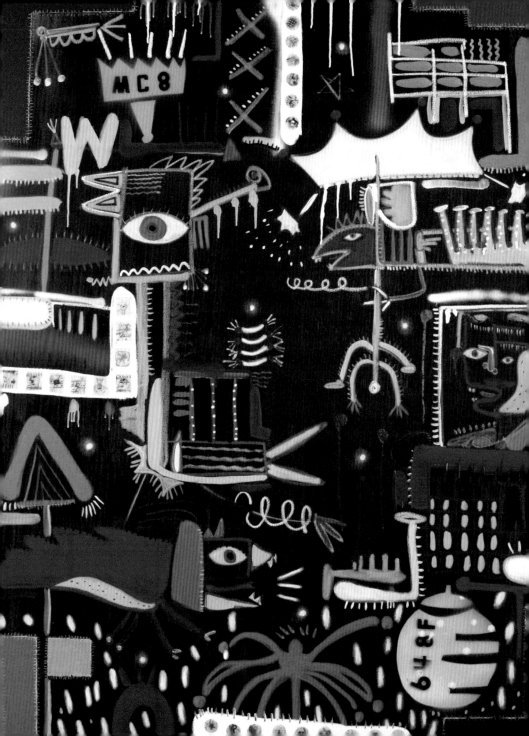

[Black Play Series] Atliere FT640
oil on canvas, 64X51inch
2010

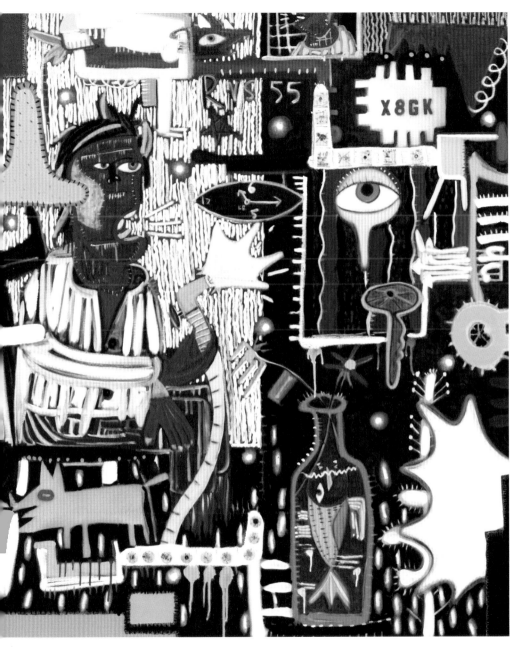

[XP Black Series] Don,t Be A Strange
oil on canvas, 48x60inch
2011

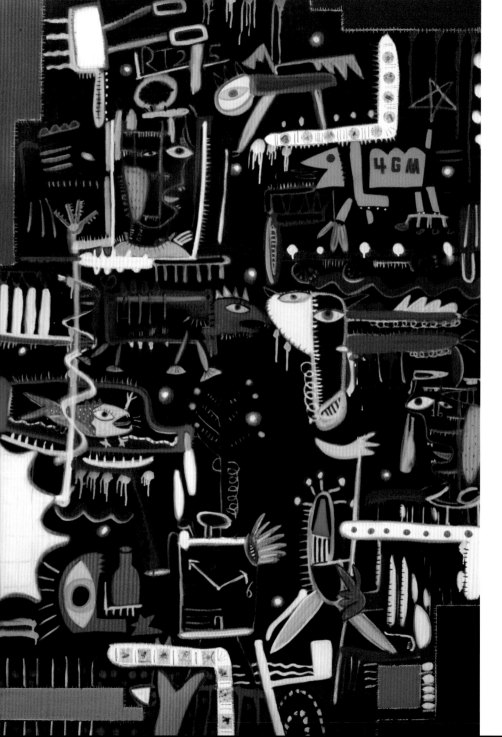

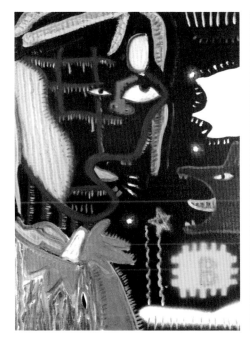 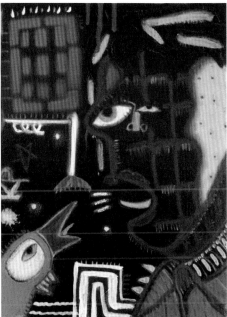

[XP Black Series] portait womon
oil on canvas, 12.5x9.2inch
2010

[XP Black Series] portait man
oil on canvas, 12.5x9.2inch
2010

[Black Play Series] Just, Do not touch me
oil on canvas, 48x72inch
2010

In Search (Again) for a Fundamental Question in Choi Woolga's Works

Lim ChangSeop
[art critic]

What means that we live? There is a moment when I fall all of a sudden into a skepticism about the fact that I am really living. As a phenomenologist mentioned, I may just imagine that I am living, but it is comprehensible that people like to avoid answering the questions requiring tenacious thoughts, feeling limited for their ability.

Like such questions above, cognition for historical or personal understanding of painting behaviors may well be evasive. Expressing elegantly, the behaviors of producing the art works, more easily speaking, the labor of painting need to be questioned seriously in terms of how it should be defined, and such a question should be answered. However, despite such a stubborn request for the answer, it seems to be more and more avoided today.

The evidence for such avoidance of the answer may well be found in the works which dismiss the fundamental question about life and art but only pursue superficial and ordinary senses. Today, only the works seemingly suitable to well-decorated living rooms or those eligible for the lobbies of tidy new buildings are produced, and only such works are sought for. Today, I have no idea or standard of how to accept our reality that the expectation of the works shocking my brain or shuddering my heart is dismissed as refusal of our modern modus vivendi.

Choi Woolga's works interest me first not because of the forms composed by the lines filling the canvas but because of the method of revealing them. He over-paints the white base color on the canvas painted in diverse colors. Then, he draws the forms with lines on the canvas to reveal the gorgeous base colors hidden below the white base color. Such a technique as reveals hidden or past events into the present behaviors seems to be the most fundamental production method for Choi Woolga's works. However, I cannot but raise a question about the fundamental method or revelation of the past.

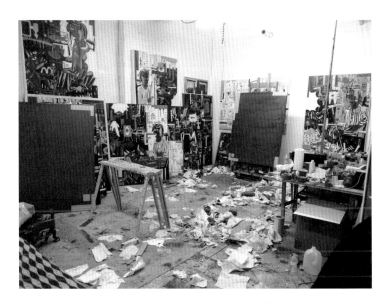

Frequently, we believe that since the flow of time is linear, future is uncertain but the past is certain. Future has still to come, while the past has gone by. Such a belief may be a basic faith or common sense. We perceive that we know all about the past because we have experienced it. However, we need to change such perception because our knowledge may be defined differently. If knowledge or cognition about the past is same all among us, this common sense is correct.

If everybody recognizes the past in the same way, the record about our human past must be the same one, being not different. 'History of Chosun dynasty' must be one, and 'history of Koryo kingdom' must be one. 'History of Korea,' 'history of China' or 'history of the United States' is sufficient of itself as a single history. However, in reality, there are various books of history for a nation. And the past unknown will continue to be reproduced from new perspectives or in new dimensions.

A man's behaviors or a nation's behaviors are intermingled with numerous people's or nations' behaviors and interests. Depending on how such behaviors and interests are understood, the past or the history would be described anew. Accordingly, it can be said that our past still remains unknown as much as our future.

Upon reviewing Choi Woolga's method of art production taking out the base color onto the surface, we may feel that such a method is a fundamental question about

our modus vivendi and flow of the past. One of the effects of Choi Woolga's works is awakening us to reconsider about our cognition that we know all about our past or the time passed by. Probably, he does not draw the time of the past but may produce his own unique 'double meaning-images' for the fundamental question about our behavior of understanding the past.

The traces of the time passed by protruding out of the base canvas are not stereotyped forms or objects. These weakened medicinal forms float in the space of canvas comfortably like children's scribbles. He floats the lines because he feels neither obliged nor a sense of mission to depict the objects as real as possible. After all, a painting cannot but be a plane represented. As long as paintings are drawn on a plane, they cannot but be representations regardless whether they depict reality or non-reality.

Accordingly, 'realism' of painting or the realism defined as real depiction of reality according to our common sense or interpretation of our fine art history cannot but have the contradiction containing distortions fundamentally. It is an irony caused by the relationship between two-dimensionality of paintings and three-dimensionality of reality. At least in the history of the Western fine art.

However, in case of the Oriental paintings (in terms of the geographic scope), there has been no brutal attempt to turn the paradoxical contradiction into an orthodox theory, however hard the Oriental painters have tried to imitate the reality. The perspective invented by Brunellesco and Alberti is a good example of such brutal attempts. The perspective depicting as larger what is nearer and as smaller what is farther must distort reality or facts. An object farther is not actually smaller than an object nearer, and a road farther is not actually narrower than a road nearer. Rather, it may be larger or wider.

The perspective betrays reality or actuality as such. It is a self-evident fact but for those who do not doubt whether their life itself may be imaginary. Such an approach of depicting reality as perceived would lead to another distortion. However, we cannot find in the Oriental painting any of those various technical or painting techniques ranging from the Greek theory of imitation to the realism in the 19th century.

Then, how can we redefine realism correctly if we should do? The phenomenologist

Husserl argues that what is visible is always only a part. He contends that the whole is not grasped by itself but a phenomenon generated from viewer's mental synthesis. If we do not rely on Husserl, such phenomenon has been confirmed by scientists or biologists. We can take an easier example. A cone looks like a triangle when viewed from its front. It looks like a circle when viewed from above or below.

If we limit our cognition to such directions, we cannot grasp the cone wholly. Accordingly, in order to grasp the cone correctly, we should select not a single but many viewpoints or a proper point allowing us to view its various aspects simultaneously and thereby, recognize it comprehensively in our brain. In this context, the argument that the cubism championed by Picasso or Braque is more correct realism does not much sound stubborn.

Time and cognition, and their forms implemented on the canvas, namely, pursuit of realism about the past is the core of Choi Woolga's painting style. As mentioned above, anybody cannot perfectly understand what is hidden or the time passed by. Our memories are differently recorded depending on the relationships of interests. I am not sure whether Choi Woolga records his own memory or some perfect one, but if we understand that a painting is about painter's story, it would not much be unreasonable for us to understand that he has been creating his own realism.

Today, even if we live a hard life, it may not be that our peripheral senses have been dull. Rather, our decadent and playful nerves seem to be sharper and shaper over time. However, such phenomenon is not true in our life. It is not a fundamental look of our life.

It is just a transient phenomenon. If a painter is affected by such a transient phenomenon, not agonizing over his or her consciousness, his or her paintings would not be called realism. If we should not labor hard to find an answer for ourselves, our behaviors of painting or art activities would lose their meaning.

The labor or behavior of art attempting to show realism about his past days through paintings are never in vain. For there is no life that is so trifle. For there is no past time that may well be insignificant enough to be dismissed.

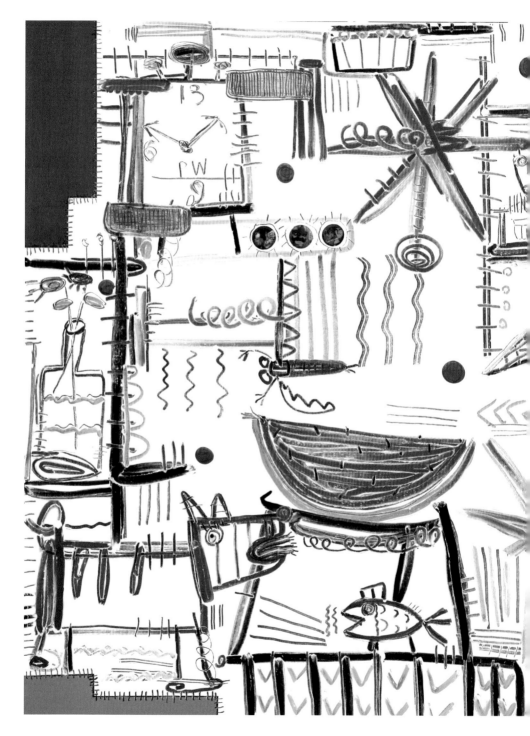

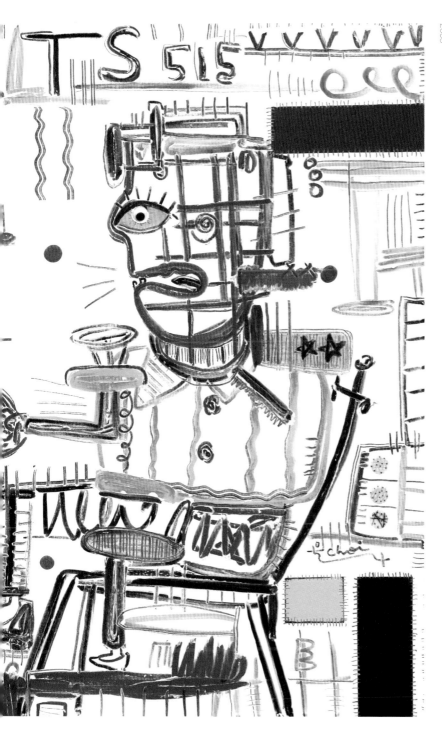

[XP White Series] man portrait in summer
oil on canvas, 112x162cm
2008

[XP White Series] play for womans
oil on canvas, 100x100cm
2008

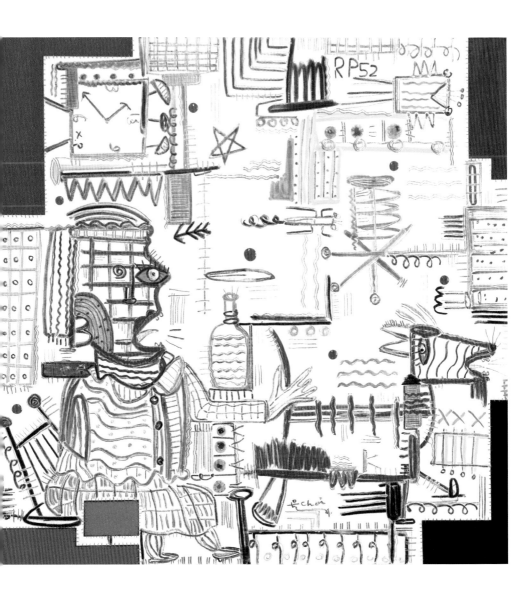

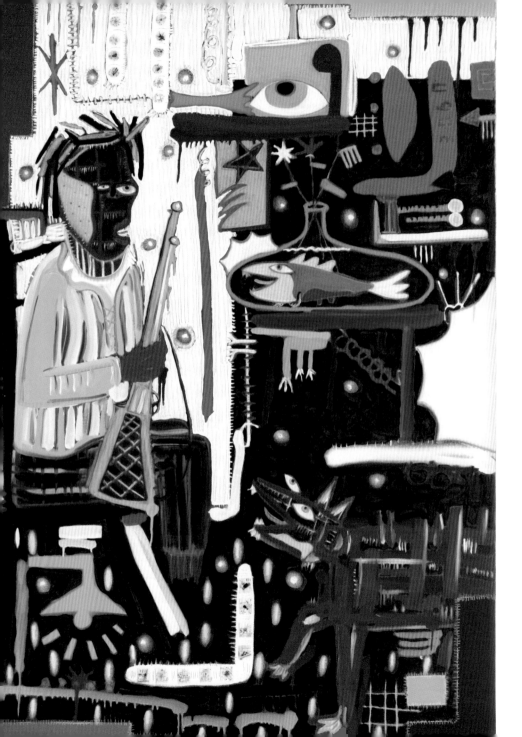

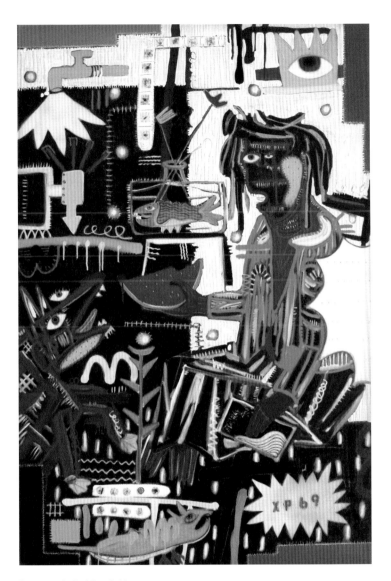

[XP Black Series] Tear in Heaven
oil on canvas, 48x72inch
2010

[XP Black Series] you don,t fool me
oil on canvas, 48x72inch
2010

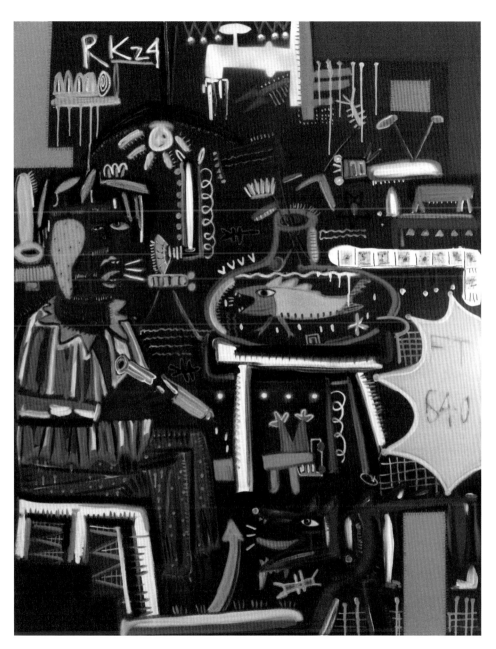

[XP Black Series] you are not believe me
oil on canvas, 64x51inch
2010

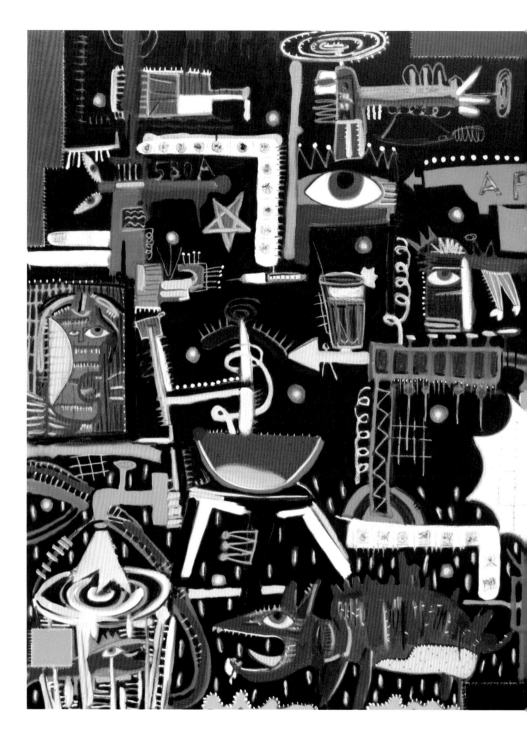

[XP Black Series] painting my daring
oil on canvas, 132x168cm
2012

Choi Woolga's World of Worlds
- Shift from Primitive Natural Aesthetics toward Urban Emotion and Refined Aesthetics -

Shin HangSeop
[art critic]

Can the 21st century civilization led by the electronic science guarantee an eternal happiness for mankind? Of course, many people welcome it because of extended life span and comfortable life, but relatively, not a small number of people are concerned about loss of humanity. In other words, as a considerable part of human life depends on electronic civilization, we may lose the original nature of human being. Maybe, it will be only art that can solve such a problem. Only art may well cure our modern men's barren emotion intoxicated by the electronic civilization driving us into a state of inhumanity.

Earlier through painting, Choi Woolga suggested a way to return our frozen senses and emotion to their original state. He attempted to awaken us of our original nature through the formative languages similar to rock-inscribing paintings or cave wall paintings symbolizing primitive men's life. Didn't his art aim to recover the purity of the primitive paintings harboring the incarnation or desire for a new life, excluding any technique learned? So, he treated the forms as much simple and concise as possible, while employing a method to emphasize visual clarity of colors and purity of materials.

His earlier works centered about human figures were usually rough, featuring thick texture and extremely primitive and minimal images. If the colors should have been removed, they would have revealed a crude and wild sense like primitive paintings. Moreover, the forms drawn with deep and thick lines were epitomic, because details were omitted. In addition, his paintings used to show distorted forms with their certain parts exaggerated or omitted like primitive paintings. Such characteristics of his earlier forms would be a basic frame penetrating his world of works later.

His works during 1980's were more or less difficult to understand in terms of physical images. Although the forms were simplified, they were not kind to the audience because they were distorted and deformed. In some respect, they were extremely concise and

simple like those drawn by the kids who had not learned about fine art. Although children's paintings are simple, it may be difficult to understand them visually. Likewise, his works featured such forms. They were not proportional, and their forms were distorted, and the expressions were straightforward. His canvas was filled with a figure, while the forms were difficult to understand visually because they were drawn with simple and intense contour lines.

On the other hand, because he used a coloring technique like pointillism by employing the knife, the entire image was dominated by the intermediate color tone. Merely, since the contour lines controlling the forms were thick, powerful and simple, the resultant visual impression was intense. However, due to distortion and deformation, it was not easy to recover the figures in details. In addition, he did not suggest certain situation or background but showed only human forms, which makes us difficult to understand his works during this period.

While children's paintings focus on contents rather than forms, Choi Woolga's paintings emphasize the forms. Thus, his paintings may well be differentiated from children's paintings. Such formative characteristics as discussed above determine his sense of formative aesthetics. The formative aesthetics concise like children's paintings and relying on the simple contour lines are very appealing. Of course, since his paintings show only the frames of forms with no hanger-on, they are persuasive visually. Such visual persuasion is very effective in making his messages understood correctly.

By 1990's, his paintings would shift from form-centered to color-centered tendency. In other words, he would depart from such color deployment strategies as pointillism and instead, would use the primary colors so that the color planes could dominate the canvas. Accordingly, the expression of his works at large was bright, colorful, intense and stimulative. He avoided mixed colors as much as possible and tended to accept the primary colors intact. Such a change was equated with his preference of the color plane effects. Thus, the forms would be more conspicuous than before. In a nutshell, the primitive wild nature would be exposed intact by the colors. The images of primary colors tend to respond directly to emotion. Colorful and bright primary colors function to open up the closed consciousness and emotion. In addition, the audience could experience an emotional catharsis. Such a catharsis may be an emotional response similar to our first impression with the nature.

Actually in 1990's, he would change his subject from figures to the daily episodes. As subjects and objects changed, the contents would change accordingly. In case the nature is used as subject, the objects would be diversified enough to enrich the contents. Likewise, the daily episodes would allow for more diverse objects and contents enriching the canvas. The forms of paintings still suggested primitive images or those of children's paintings. As the objects were diversified, the composition would be very gorgeous.

Here, he ignores a realistic concept of space in terms of not only formative interpretations but also arrangement and composition of objects. So, the resultant composition of canvas would be fancy free like a non-gravity world of another universe, being different from the realistic sense of space. So, there is not distinction between front/rear, left/right or upper/below. In other words, the audience could enjoy time and space of absolute freedom with no law of universal gravitation. His forms may well be comparable to primitive rock-inscribing paintings or cave wall paintings. Such a spatial setting suggests a pursuit of an transcendent world quite different from the human society enforcing ethics, moral and order on us. The transcendent world is not irrelevant to the primitive modus vivendi before the social relationships began to be complicated. His view of art confronting the world may have aimed at the primitive modus vivendi following the law of nature only. Didn't he expect that the primitive human emotion would be recovered through purity of the intense primary colors?

On the threshold of 2000's, Choi Woolga would attempt to replace the color planes with a pure drawing expression. He would use oil colors, acryl, pastel crayon or oil stick for his line drawings. Lines determine the forms or at other times, cross the boundary of the plane. By this time, lines were frequently integrated into objects, their forms or color images, not being separated from them. Namely, he applied the concept of drawing, and as a result, lines, planes or forms had their own independent modes of existence. After all, he would follow an integral concept of forms, which makes it insignificant to discern the modes of existence. Extremely concise line drawing, namely the concept of drawing similar to esquisse would dominate his painting images.

Here, he once introduced color planes partially or painted the canvas thick with black or white color, and before the color dried up, he drew the forms thereupon with oil stick or pastel crayon to reveal an intaglio canvas composition reminiscent of the lines drawn or inscribed on gray-blue porcelains. Such a form may be significant as a mechanism

complementing the lightness of drawing. In other words, despite the visual purity and pleasure, the single line stroke may well look light. His line strokes similar to drawing have been supported by a consistent formal logic. Maybe, his line stroke is similar to the singular brush stroke for literati paintings. Anyway, his singular line stroke would be highlighted very conspicuously in his works during 2000's. Before the thick layer of color on the canvas dries up, he draws forms thereupon as if he were working out an intaglio. For the conditions of his canvas allowed only for a single line stroke each time.

Accordingly, the singular line stroke would be enlivened as a fresh image in his works during 2000's. In order to conform to such singular line stroke, every object and form should be contracted into simple line drawings. So, all forms would be compressed into simple and clear images to conform to the concept of signs, signatures or diagrams. Compression of the forms would necessarily result in some independent images interpreted according to such formal logic. Thus, his recent works could have a consistent formative pattern. In other words, they have come to have an independent formative aesthetics. All objects emerging in his paintings have their own compressed images, namely signs, signatures or diagrams. Since his recent paintings have their images as promised, these images would diverge or converge to allow for constructivism works.

The line drawings following the forms of objects are straightforward and audacious. They are neither obscure nor vague but clear, powerful and candid. Such line forms make us feel a visual pleasure. He need not bother to make his paintings look like primitive paintings. That his line drawings are speedy, pleasant and rhythmical proves that he has come to be skilled enough for his works. Now, he seems to have been relieved of painting labor. Some critics may feel that his works are too diagrammatic, but I feel that due to the perfection of the formal aesthetics, the entire impression of his works is bold and refined as well.

Now, he seems to have refined his sense of aesthetics or matured an aesthetic sense different from the natural images, while approaching near an urban emotion. Of course, his paintings still have the primitive attributes. Even in terms of the formal aesthetics, his paintings seem to have a formative order with no hanger-on. Yes, his recent works feature an urban refined taste, not losing the wild nature. Such characteristics can be found in his changed subjects and objects. Such evaluation can be supported by his subjects and contents found in the daily life.

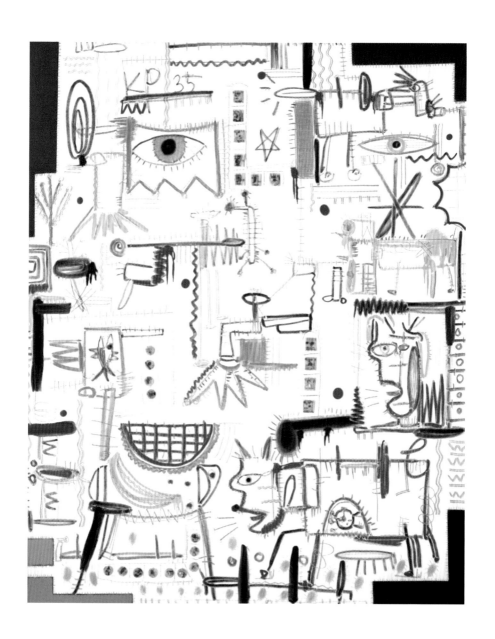

[White Play Series] be parched with thirst
oil on canvas, 48x60cm
2012

Red fox series
mixed a painting on FRP, 165x110x48cm
2008

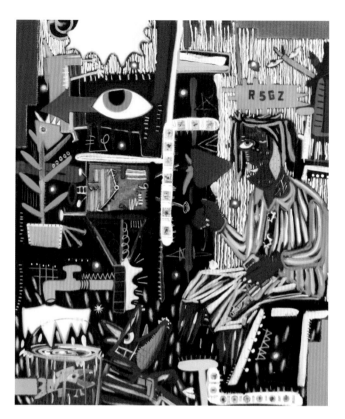

[XP Black Series] still loving you more
oil on canvas, 48x60inch
2011

[XP Black Series] believe me
oil on canvas, 132x168cm
2012

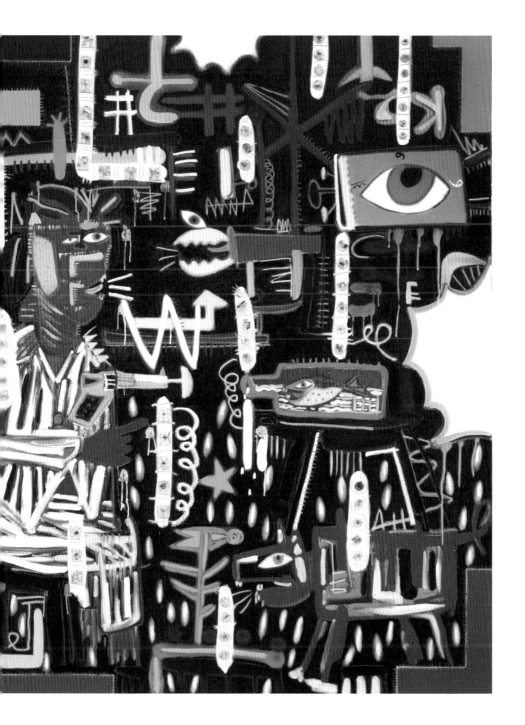

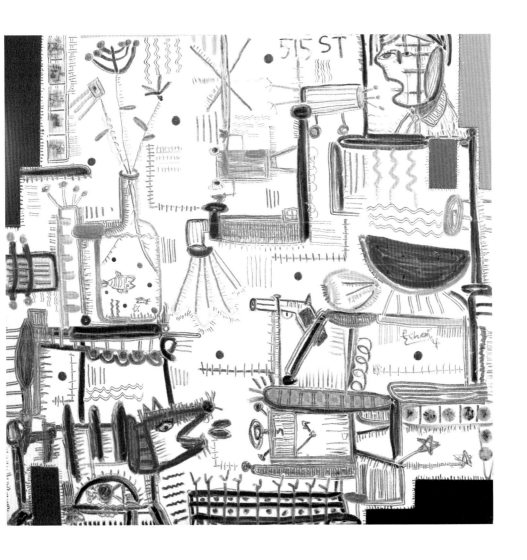

[White Play Series] from the soho
oil on canvas, 42x42inch
2010

For Choi Woolga

Choi Youngdae was born in Busan, Korea in 1955 as the youngest son of Choi Cheolsoo who was an interpreter. Because he cried too much when young, he was called 'Woolga,' meaning a crying boy. During his school days, he was much indulged in literature, especially the Russian literature and music.

On the occasion of his first solo exhibition in 1979, he put signature 'Woolga' on his works, and since then, he began to use this pen name. He was eager to study art in France, but it was too difficult for the common people to travel overseas during the days of the dictatorship called 'Reformation.'

Yun HyoYeon
[art critic]

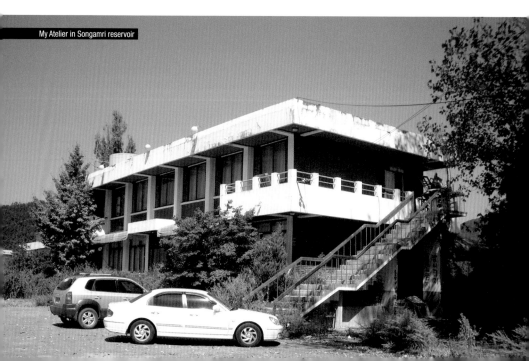

My Atelier in Songamri reservoir

In the early 80's, he would suffer from the financial difficulties, so he had to paint, while laboring to earn his living. After all in mid-80's, he would fly to Paris to study fine art belatedly or a decade later than the contemporary artists.

Before then or during the early 80's, he had been engaged primarily in the oil paintings, most of which evoked a sense of primitivism of nature. However, he felt limited for his knowledge about fine art history, while he could not suppress his desire for the contemporary fine art. After a long agony, he would conclude his life in Korea to study fine art in Paris.

However, he would doubt his identity as artist during his life in Paris, and on the threshold of 2000's, he would move his atelier from Paris to SoHo in New York. He would depart from his long practice of color plane works to be indulged in fancy free line drawing works on a full scale. He used to create various color planes on a dark and obsolete canvas with its bottom mostly colored and thereby, experiment diverse footloose line drawings by using every possible technique including color spill, spray crayon, oil pastel, and the like.

During 90's before then, he had used such media as acryl, Hanji (Korean traditional paper) and crayon, but in New York, his materials would be far more diversified; he found many new paining materials in China Town of New York. Now, his volition to no longer limit his materials and his fancy free line drawings cannot be stopped.

I am much agonizing over how I should conclude my thoughts about his today's paintings, namely those paintings in harmony with white and black. Many critics mention about his works such words as graffiti element, cave wall painting image, primitive anarchism, unconscious post-modernism, instinctive behaviors concealed by an infant consciousness, and so on. But I would like to say 'No!' in a word.

His paintings may evoke a sense of irregular modernism underlain by intricate calculation or act, or seem to be hidden in the infinite materials like Lake Baikal buried in the mountains too far from the society to be visible; he seems to operate a secret underground factory where his works are produced too easily.

Then, where does his calculative limit lie?
When we stand before his works called plays, we might be reduced to his toys.

Diagonal lines, straight lines, curves running in every direction and the numerous lines with their sizes unknown are too common lines, but why do we feel them different from other painters' lines? Despite his methods of work are too sympathetic and plausible or rather slight, why do we feel mysterious or inexplicable for the forms or phenomena of his paintings and at the same time, why can't we suppress a faint smile at them?

Despite the lines look camouflaged too naturally as if they were holding us cheap and despite the objects are too plainly absurd and strange as if they were ridiculing our human fools, they are freely in harmony with one another. How can we explain such a phenomenon? Why does everyone of us feel like understanding his paintings whether we are learned or not or young or old?

I know well that it would be a shameful miscalculation if we should try to find some philosophical element in Choi Woolga's paintings and that he has no intention to complete his works based on a philosophical theory. He has not polished and developed his thoughts through a systematic eduction in Korea, unlike other local intellectuals.

Probably, as an artist he could not but rely on his inborn instinctive consciousness, and his study of fine art theories in the mecca of art or Paris may have sharpened his inborn artistic talent. However, I cannot but erase my thought that he is taking quite a different way of artist consequently. Today, the artists who have the same consciousness as Choi Woolga, namely, Klee, Dubuffet, Haring, and the like have something in common. You may agree to my argument that all of them succeeded in creating some emotional graffiti line drawings completely off the color plane work.

On the other hand, however, I suspect that those artists' works may reflect their calculated consciousness. Conversely speaking, I doubt that they are really the products of their instinctive power. These questions could be only answered by those who are able to gain insights into the paintings produced at different times; they may well be eligible to enjoy the pleasure of finding the answers.

Didn't someone say that we could see only as much as we know?
There seems to be another Pandora box hidden in his paintings which seem to be drawn most easily.

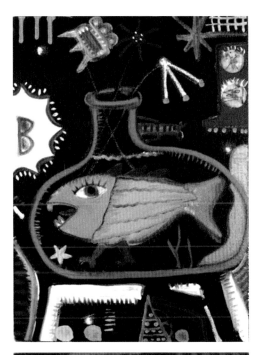

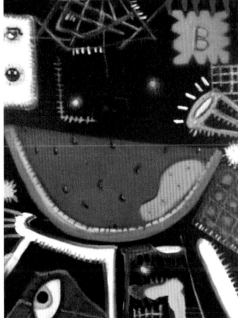

[Black Play Series] How is it
oil on canvas, 12.5x9.2inch
2010

[Black Play Series] I,m not eating more
oil on canvas, 12.5x9.2inch
2010

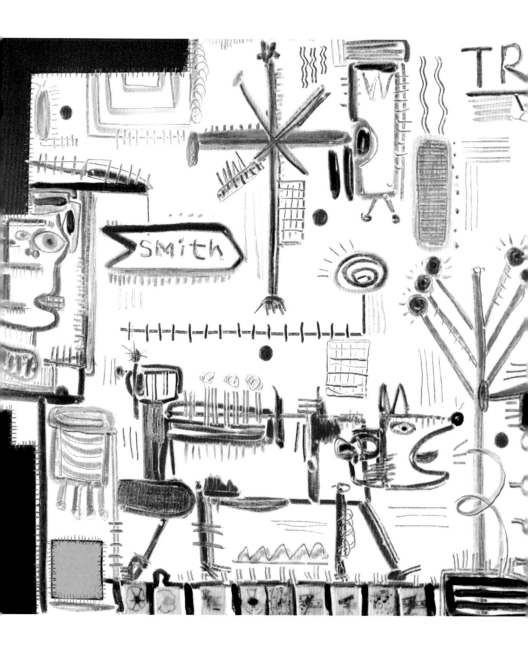

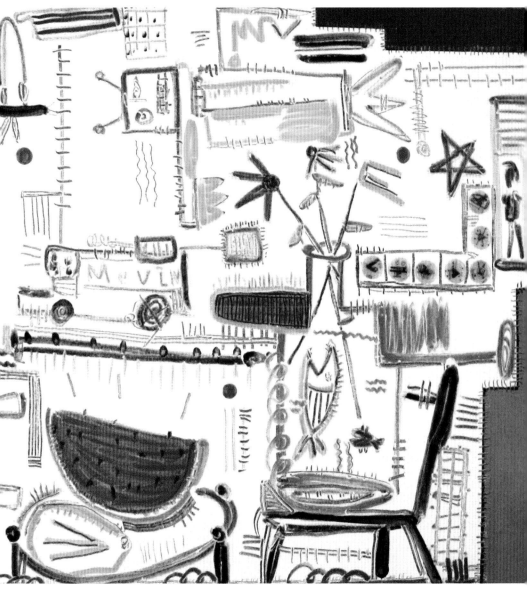

[White Play Series] Brooklyn Smith
oil on canvas, 95x150cm
2010

[XP Black Series] A briquet
oil on canvas, 48x60inch
2012

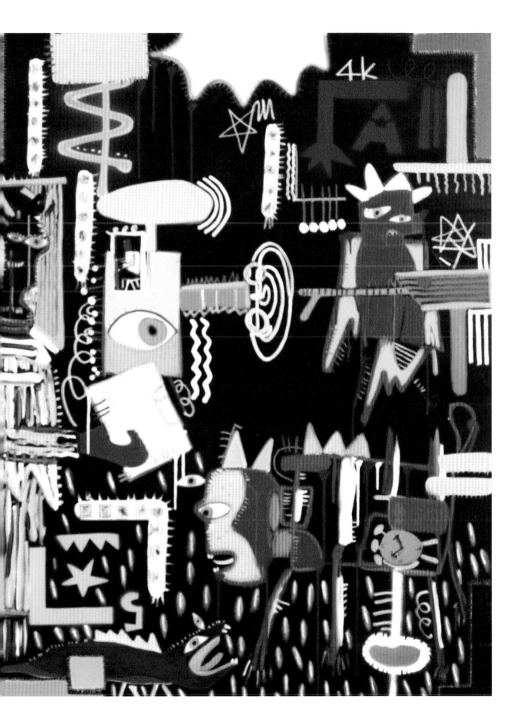

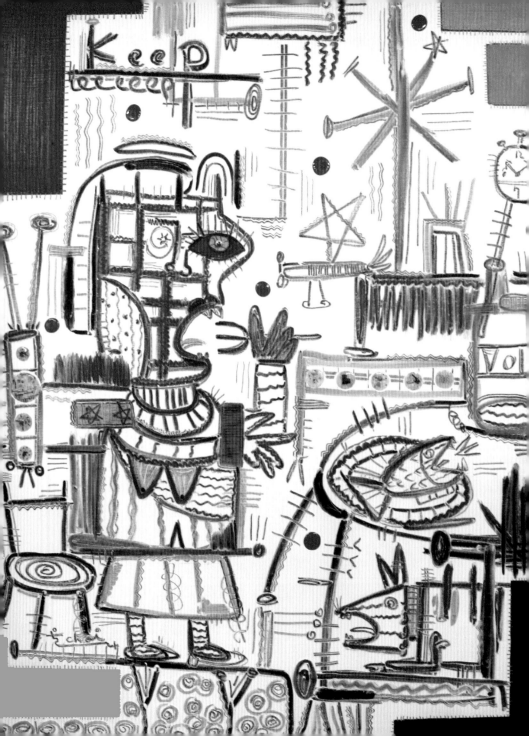

[XP White Series] the mealtime for enjoy
oil on canvas, 100x140cm
2008

[XP White Series] a female
oil on canvas, 12.5x8.2inch
2012

[XP White Series] the portrait of man
oil on canvas, 45x60cm
2008

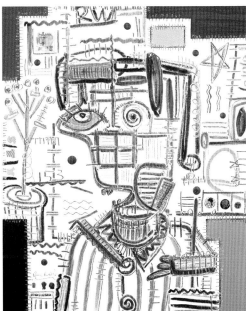

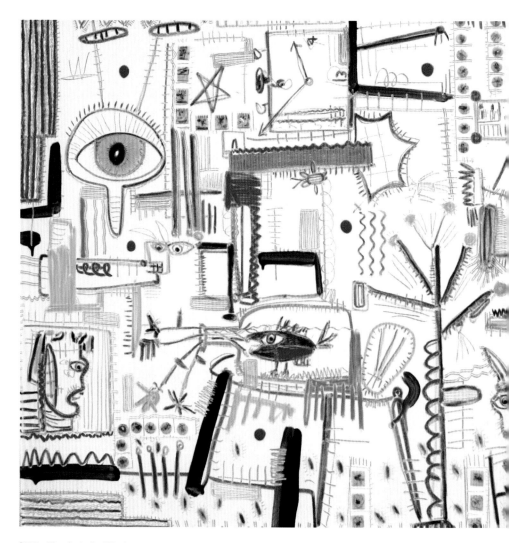

[White Play Series] will be happy
oil on canvas, 48x72inch
2012

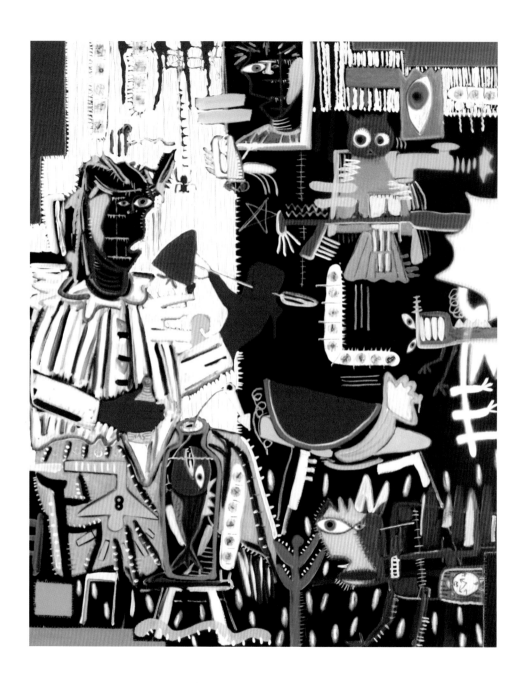

[XP Black Series] what do you eating now
oil on canvas, 60x48inch
2012

Choi Woolga, in His Dancing Everyday Life

Seo SeongRok
[art critic]

The time which has fleeted in vain does not leave any form. There remains only a memory immersed in the time.

The time when we got along with kids on a lane, the time when we read the cartoons giggling with friends, the time when we forgot to return home, looking up to the sky absent-mindedly, the time when we stole and read our sisters' love letter, the time when we fished at a brook, the time when we took a warm gruel bread from father. and the like. When we remember our childhood, the memories will float in our brain endlessly. Anybody will meet his or her past time which has disappeared leaving no forms whenever he or she searches the warehouse of memories.

Choi Woolga seems to regret such valuable memories fleet in vain. So, he picks up the stories around him swiftly as if he were writing down in shorthand. Of course, no specific images emerge and no stories unfold. Fragmental images are placed seemingly insignificantly or enumerated continuously. Closing up on them, however, we can notice that some plain everyday landscapes are contained therein. Fish are swimming, new buds are spring up, stars are dotting the night sky, a man is pulling the oar, a woman is playing piano or a man is climbing up the stairway. Besides, we can see a building or a pedestrian in the downtown.

That is, we can see to it that his paintings pick up their motifs from the stories heard in our everyday life. The stories are not all amusing or pleasant. Sometimes, he shows us angry figures, but in most cases, he excites our everyday life. It is no exaggerating to say that his canvas is colored with sort of 'impulse for play' and 'optimism.' Upon viewing his paintings, we will be pleased and amused as the artist is.

Choi Woolga is bold enough to depart from the conventional painting methods. It is

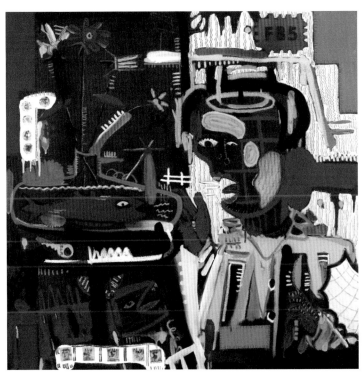

[XP Black Series]
I can't be me without lovin
oil on canvas, 100x100cm
2009

impossible to witness in his paintings such attributes as realism, light and shade, color contrast and perspective. His canvases are full of spontaneousness, improvisation and excitement. Usually, the paintings produced fast are considered to have been produced roughly, but his paintings seem to have some or other forms, being well arranged. They are not gotten into a groove, being fancy free but not confused. They might look like the paintings drawn quickly, but upon observing them closely, we can find the traces which prove that he was very meticulous during his work. Merely, the artist's gaze does not remain on a single point but spreads evenly.

His works are shaped primarily by line drawing. Just as kids rub up the pastel crayon on paper freely, so he paints on his canvas effortlessly as if some forms were flashing across his mind sometime later following his brushing work. It can be no more curious. Although there is neither center nor composition, there is an amusing everyday life contained. Impressing, pressing, entwining, rolling, striking, pasting, painting, writing, scribbling and all the other behaviors are like kids' painting activities. Just as kids

need only color pencil and paper for painting, so Choi Woolga needs only drawing chalk and canvas.

Our impression is that he probably inscribes child's innocence on his paintings. More specifically, Choi Woolga's paintings are reminiscent of the art brut master Jean Dubuffet's works or the revolting graffiti artist Jean-Michael Basquiat's works. Compared with Dubuffet whose behavior is vehement, Choi Woolga is gentle, and compared with Basquiat, he is far meek. Although his forms are solecistic, they may well be discerned more or less. His lines seem to be the results of natural drawing rather than confused automatism. He seems to paint on his canvas complacently as if he were scribbling on paper when idle. He is quite different from the painters who produce their works with vehemence, impulse or refusing gesture.

As if he were soaking his feet in a clean brook, he soaks his paintings in a pure soul. Vivid color tones, cartoon-like figures, harmonious decorations, unreserved line drawings (lines, dotted lines and circles), etc., are enlivened on his canvas, and besides, men, fish and stars inhabit his canvas space peacefully. The world he dreams of is a country with no danger. It is a world with no terrorism, being assured of human rights. Wild ducks are idle on the clean stream, and nature and men do not fight each other but co-exist peacefully. Families are not broken but small and well-off. He dreams of an extremely ordinary happiness.

Maybe, what he is thirsty for is not a fine painting but a dancing everyday happy life. For what he expresses confirms what he desires. In other words, his desire wets his works like dampish gentle rain.

The everyday life fleeting does not wait for us. We have to discover happiness in our everyday life. What kind of happiness is Choi Woolga planting in the fleeting time? And what pleasure or love is he planting in time?

[White Play Series] The Philosophy of play
oil on canvas, 48x60inch
2012

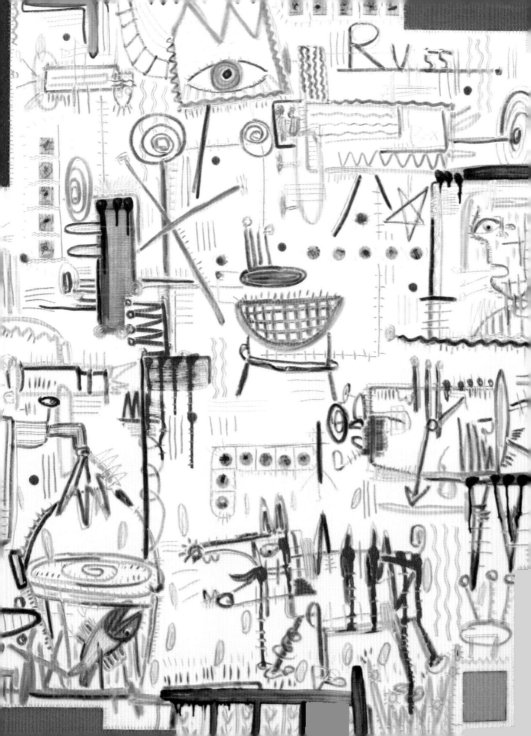

[XP Black Series] let,s me see
oil on canvas, 60x48inch
2012

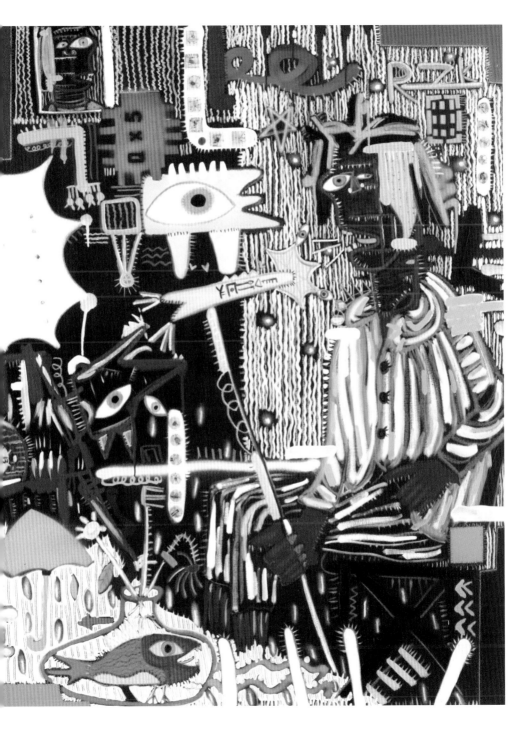

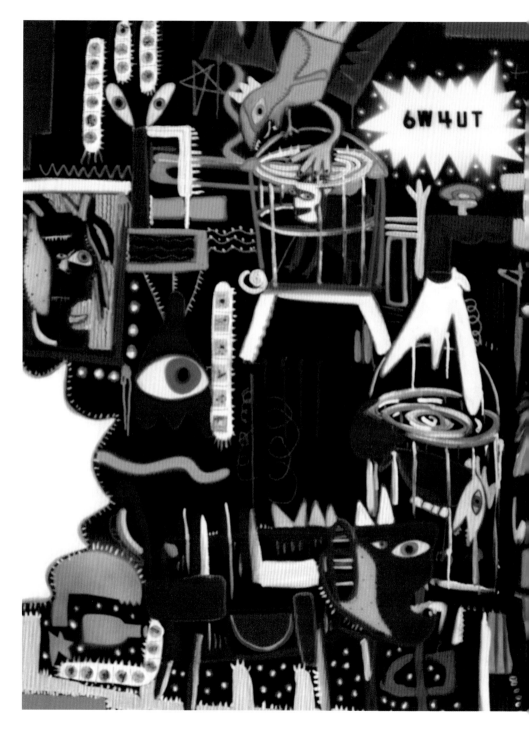

[XP Black Series] I will
oil on canvas, 48x60inch
2012

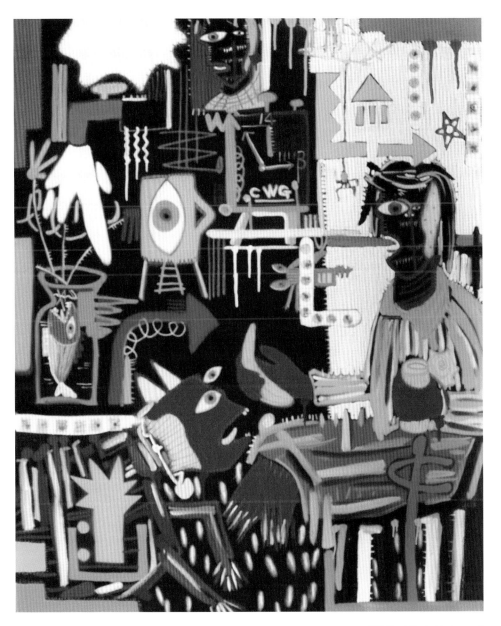

[XP Black Series] Let me eat
oil on canvas, 48x60inch
2012

[XP White Series] a Male
oil on canvas, 12.5x8.2inch
2012

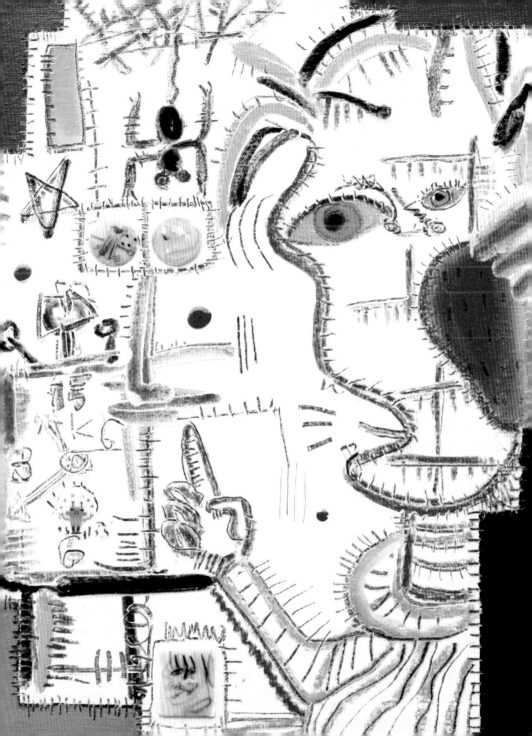

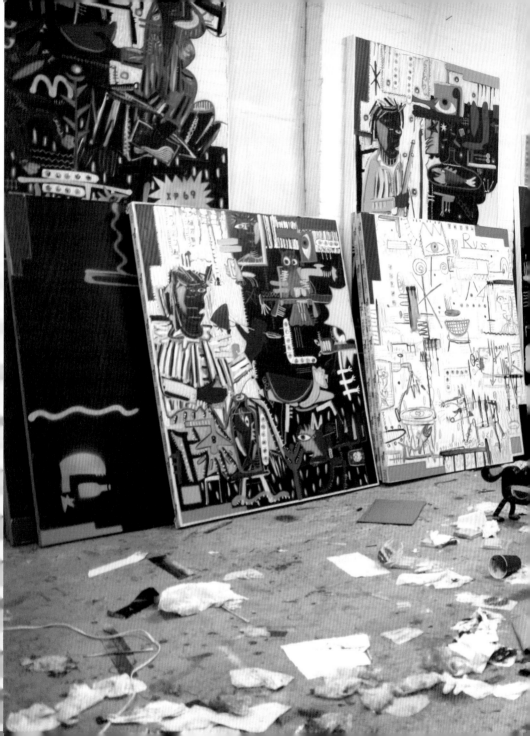

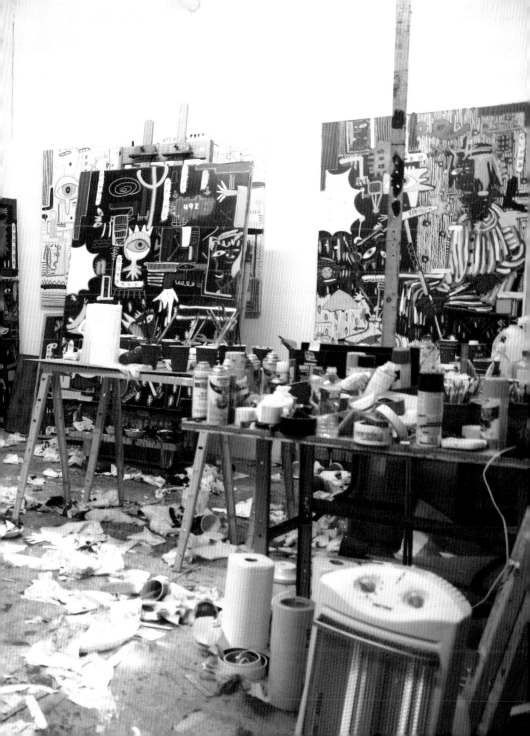

| CHOI WoolGa

1993 Ecole Boulle, National Decorative Art School (Paris, France)
1994 Ecole des Beaux Arts de Versailles (France)

Solo Exhibition

2013 Gallery Ho (New York)
 Gallery 101 (Seoul)
2012 Yace Gallery (New York)
2011 Crossing Art Gallery (New York)
 Bundo Gallery (Daegu)
2009 Gallery, Shirota, (Tokyo)
2006 Invitation (Lines Found from Black and White), gallery "Joun"(Seoul)
 Invitation, gallery "PC"(Seoul)
2005 Gallery Jean Art Center Exhibition (Seoul)
 Invitation, Gallery "M" (Daegu)
2004 Invitation (Lines Found in Cave Wall Paintings), Gallery Kita (Nara)
 Solo exhibition, "KIAF" Kita Gallery (Seoul)
2003 Invitation Gallery Commemoration "Foe" (Busan)
2001 Invited by Gallery 220, (New York)
 Invitation (Primitivism Which Should Be Explored with Lines), Gallery Kita (Nara)
1999 Invited by New York Modern Art Gallery (New York)
1998 Invitationat Gallery, Museum Kameke, (Berlin)
 Invitation Exhibition at Reu_Dex Gallery (Kyoto)
 Invitation Exhibition at Kirin Plaza Art Museum (Osaka)

1997 Invitation Exhibition Asahi Broadcasting &ABC Gallery (Osaka)

1996 Invitation Exhibition at Gallery Saint Charles Rose, (Paris)

Gallery "May" (Seoul)

1993 Gallery 'Espace Keller (Paris)

Invitation Exhibition at Gallery Espace Kelle(Paris)

Invitation, Gallery "Muehei" (Budapest)

1994 Gallery "In" (Seoul)

Gallery "Muehei" (Budapest)

1991 Gallery "DongA (Seoul)

Gallery"0901"(Seoul)

Group Exhibition

2011 Six Senses (New York)
 Korea Tomorrow - Outsider Gaze (Seoul)
 KIAF (Seoul)
 Daegu Art Fair (Daegu)
2010 Sweet & Strong (Seoul)
 Spontaneous, Space Womb Gallery (New York)
 If You See Nothing Say Something , The Invisible Dog Art Center (New York)
 KIAF (Seoul)
 "Six Senses" The space gallery (New York)
 "Collage of Memories - Korean Contemporary Art" Soka Art Center (Beijing)
2009 Korea Tomorrow - Unidentified Face Object (Seoul)
 KIAF (Seoul)
2008 Choi WoolGa & Robert Combas Dual Exbibition, gallery, Seoul
 Gallery,Fernando,Alcolea(Barcelona)
 2008, 2007Art Export (New York)
 Taiwan Art Fair (Taipei)
2007 Miami International Art Fair (Miami)
 Taiwan Art Fair (Taipei)
 Seoul Three Boxes, UNCgallery, (Seoul)
2006-2007 Shanghai International Art Fair (Shanghai)
2005 Newcollection,,National,Modern,Art,Museum (Gwachun)
 "Boxes" Exhibition, Wadakuchi museum, invited (Kyoto)
 "Interesting museum", Kyeognam Provincial Museum, invited
2004 "Boxes" Exhibition, Wadakuchi museum, invited (Kyoto)
 "The Boxes" Exhibition, star poets gallery (Tokyo)
2003-2009 KIAF (Seoul)
2001 Köln Art Fair (Köln)
2000 Invitation (Limit of Primitive Expression), gallery "Modern Art" (New York)
1998 "A Clock" Exhibition, Kobe Contemporary Museum (Kobe)
1997 Art fair Fiac&Saga (Paris)
 Good artist, Kyoto City Museum (Kyoto)

1995 Collective exhibition D, Automne pour leTtableautin (Paris)
 Association vill de Fresnes salon de November (Paris)
1993 Annual Exhibition Chene D,antin (Paris)
 Collective Exhibition Art Croissy (Paris)
 Collective Exhibition Beaux-Art (Paris)
 Group Exhibition Art Plus Art (Paris)
1992 (A Sense of Africa), Gallery "Ever" (Paris)
 Invitation (A Primitive Sense), Gallery "Espace Keller25" (Paris)
 Gallery Everart "Wall Winter" (Paris)
 Gallery Naslte "Art Plus Art" (Paris)
1991 Gallery Akie Aricci 3 Person (Paris)
 Collective Exhibition D,automne (Paris)

Publication

2013 Primitive from of B&W
2008 The Third Pictorial "Primitive & Weightlessness"
2005 The Second Pictorial "Nouvau Sauvage"
2004 "Choi Woolga Is Not A Crying Boy," written by Kim Yun-bae
2000 Painting Diary
1994 The First Pictorial Essay

*Tel: (1) 347-360-7837
*www.choiwoolga.com
*email: woolga@hanmail.net
*Atelier: 640 Fort washington 10040 New York N Y

WoolGa Choi Black + White

Editor	Lee DeaHyung
Translator	Lee MiYoung
Compilation	Jo SungYoung
Photographer	San studio, patric,kim
Designer	Shin HyunJik
Printing	DBcommunication
Published Date	2013. 02. 18

Publisher HnH Creative (2011-000181)
30-24 Dukee-Ro, Ilsan Seo-Gu, Koyang, Kyunggi-Do, Korea

ISBN 978-89-969853-1-0